D0389884

DATE DUE

The Ephemeral Museum

The Ephemeral Museum

Old Master Paintings
and the Rise of the Art Exhibition

FRANCIS HASKELL

Yale University Press

New Haven & London

Designed by Gillian Malpass

Printed in Great Britain

Library of Congress Cataloging-in-Publication Data

Haskell, Francis, 1928–2000
The ephemeral museum : old master paintings and the rise of
the art exhibition / Francis Haskell.
p. cm.
Includes bibliographical references and index.
ISBN 0-300-08534-6 (cloth : alk. paper)
1. Art – Exhibitions – History. I. Title.

N4395.H37 2000 750'.74 – dc21 00-040836

A catalogue record for this book is available from
The British Library

For

Gillian Malpass and John Nicoll

Contents

Preface and Acknowledgements

Francis Haskell turned to the task of preparing this book for the press shortly before he died on 18 January 2000. Only a few weeks before, he had been working on a new Italian edition of *Patrons and Painters*, his first book, which was published in 1962. So he may himself have reflected upon the variety of his life's work and on its underlying unity, so striking to his admirers when they look up to their bookshelves from the obituaries that have appeared throughout this year. At least one part of the present book emerges directly from his previous one, *History and its Images*, published in the spring of 1993. The final chapter of the latter includes an extended discussion of the great exhibition of *Les Primitifs Flamands* held in Bruges in 1902. However, anyone familiar with Francis's earlier books will realise that he had long been interested in how the circumstances in which works of art were displayed reflected the esteem in which they were held and influenced the ways in which they were understood. This is a major theme of *Taste and the Antique* (1981) and is frequently touched upon in *Rediscoveries in Art* (1976), where indeed the impact of the sale of the Orléans collection and the significance of the Manchester *Art Treasures* exhibition (topics taken up here) are discussed. One of Francis's earliest scholarly articles, written jointly with Michael Levey and published in *Arte Veneta* in 1958, was devoted to art exhibitions in eighteenth-century Venice. So, although no one could have predicted that he would turn his attention to the history of exhibitions, once he did so it seemed almost inevitable.

It is hard to think of any art historian better equipped to do so, for such a study involves familiarity with artistic institutions and cultural attitudes in several major European countries over the

course of four centuries, and it could have been conducted properly only by someone who combined an interest in broad issues of taste with a passion for minute particulars, by someone who was familiar with a very wide range of scholarship (to say nothing of obscure ephemera) in several languages and with an appetite for new archival research.

In 1994, the year following the publication of *History and its Images*, there appeared a volume of essays dedicated to Michel Laclotte (*Etudes sur la peinture du Moyen Age et de la Renaissance*) to which Francis contributed 'Old Master Exhibitions and the Second Rediscovery of the Primitives' (the essay itself is dated November 1993). Many of the topics of the present book are touched on there: the British Institution and the Burlington Fine Arts Club, the Rubens and the Rembrandt commemorations in the nineteenth century, the exhibition of early Sienese art and so on. Though well aware that his friend Michel Laclotte had organised some of the most interesting exhibitions of recent years, Francis made no secret of the fact that, whilst he, like all other art historians, found such exhibitions exciting, he had developed grave anxieties about the increasing frequency with which great masterpieces were being lent – and about many of the side effects of international loan exhibitions.

He knew what he was talking about because he had often served on the advisory committees of such exhibitions. His wife, Larissa, had been a curator at the Hermitage and some of his closest friends worked in museums and galleries. As Professor of the History of Art in the University of Oxford he was, *ex officio*, a Visitor (that is, a trustee) of the Ashmolean Museum, and he had also, perhaps even more significantly, served as a trustee of the Wallace Collection between 1976 and 1997. The Wallace Collection was bound not to lend by the will of its founder, and Francis was never more fervently eloquent on any topic than on our obligation to honour the wishes of deceased benefactors.

He had first given public expression to his anxieties in a review, written in June 1990, of the exhibition devoted to Titian that opened that month in the Ducal Palace in Venice and travelled later in the year to the National Gallery of Art in Washington. Re-reading this piece, published in the *New York Review of Books* for 16 August 1990, one is astonished by its polemical force. Francis denounced as 'deplorable' the decision to allow Bellini's *Feast of the Gods*, one of the greatest masterpieces of European

art (and certainly one of his own favourite paintings), to travel across the ocean to form part of an exhibition to which it had only a marginal relevance. There was plenty of evidence, he noted, to make one uneasy about transporting great works of art: 'It can be argued that in exceptional circumstances such unease should be suppressed, but when decisions to lend pictures are taken as a consequence of international politics or artistic diplomacy (that is, the hope, as presumably in this case, of winning loans of comparable significance in exchange) unease should turn to outrage.'

He proceeded to claim that 'exhibitions flourish at the expense of museums just as museums flourish at the expense of private collections'. This sounds – and was meant to sound – startling, because in the second half of the twentieth century museums have regularly hosted loan exhibitions or collaborated in mounting them, and the official line has always been that such exhibitions are good for museums. The article pointed out how museums all over Italy were closed or half-closed, yet the Titian exhibition was open every day from nine in the morning until eleven at night. He also pointed out how curatorial scholarship was being diverted from catalogues of permanent collections to those of exhibitions. And, most importantly of all, he pointed out how museums, increasingly anxious for publicity, needed to be more and more engaged in the business of mounting temporary exhibitions which provided the easiest way of obtaining it. He ended the article as he begins this book, scanning, with a frown, the air routes of the world 'jammed' – a characteristic hyperbole – with Rembrandts and Rubenses.

This review met with much dismay. I heard it dismissed in some quarters as 'elitist' – as though organisers of large international loan exhibitions had the welfare of the public as a motive. And he was accused also of hypocrisy because he was, and indeed continued to be, on advisory committees for exhibitions. Francis's position was never the simple one of objecting to all exhibitions, though it was always a principle with him to refuse to be associated with pressure on directors who were reluctant to lend. No public rebuttal was attempted of the case he made, since it would only have brought to public notice the near accidents of recent years and might have prompted public statements from other senior figures. At least one other eminent art historian – Sir Ernst Gombrich – has expressed misgivings about the transportation

of great masterpieces. But museum employees are obliged to stifle their anxieties, and relatively few academic art historians are involved in museum affairs (except, of course, as contributors to exhibition catalogues). This article must have been written during the same period when Francis was investigating the 'blockbuster' that opened in Bruges in 1902.

In 1997, while visiting the Getty Research Institute (then in Santa Monica) as the guest of the Provenance Index, Francis gave three lectures at the University of Southern California. These covered much of the material in this book. At the suggestion of Burton Fredericksen, Francis began to collect material on the pre-history of the loan exhibitions that form the early chapters here. Francis then organised all that he had written on the subject into a series of six lectures which he delivered at the Scuola Normale Superiore in Pisa and repeated at the University of Udine in the spring of 1999. Some of the work, he felt, was ready for publication, and the material in chapter seven of the present volume appeared as an article in the *Burlington Magazine* in August 1999. But Francis certainly planned to undertake more research on certain topics: among these were the relatively small loan exhibitions that were held in commercial galleries in London at the close of the nineteenth century, exhibitions in the Low Countries, and the development of the exhibition catalogue. When, at the end of 1999, he learnt that he had not long to live, he agreed that a transcript in Italian of the lectures given at the Scuola Normale could be published. He was much comforted by the thought that Tomaso Montanari would supervise this undertaking, and the agreement reflected his special esteem for the Scuola Normale, and also his personal regard for Tomaso, whose scholarship he admired and whose companionship he greatly valued.

Having made this decision, Francis agreed that what he had written might also be published as a book in English, and he devoted much of his rapidly declining energy to preparing the text for this purpose, entrusting me with the task of seeing it into print. We agreed on some structural changes (thus converting six lectures into nine chapters) and on some reordering for clarity of argument (sometimes at the expense of chronology), allowing the *Art Treasures* exhibition in Manchester and the Holbein exhibition in Dresden to receive special treatment (as chapter five). Some passages were added by me, using drafts that Francis had already prepared, and some were dictated by him (he was soon too weak

to write) to Pat Utekhin, who kindly agreed to help in this way. The concluding section of chapter four, as well as the discussion of the Manchester exhibition building and the analysis of the arrangement of the paintings in Manchester in chapter five, were added by this means. Francis was also very anxious to add material to chapter seven, on the exhibition of Italian art in 1930. Using his notes, I contributed the opening paragraphs along lines he had indicated. These additions are undeniably valuable but slightly diminish the narrative impact of the rest of the chapter – a problem he would undoubtedly have solved. In the penultimate chapter I expanded a little on the enthusiasms of Osbert Sitwell.

For the final chapter Francis had some additional information on the Dutch exhibition in the Jeu de Paume in Paris of 1921, which had been assembled for him by Everhard Korthals Altes at the recommendation of Jan Piet Filedt Kok. Only limited use could be made of it (I am grateful to my colleague Axel Rüger for help in translating some of the documents) because it would otherwise have obstructed the argument; Francis would certainly have found some other way of incorporating it. His chief concern, that the first section of the final chapter be expanded and strengthened, was attempted using sources he had indicated, notably Longhi's 'Mostre e musei' and Lord Hertford's letters to Samuel Mawson. We discussed the possibility that Kenneth Clark had been a key figure in the history of the involvement of museums in Old Master loan exhibitions, but it was only after Francis died that I realised the importance of the 1938 British art exhibition for his argument. The paragraph on this is the only significant addition made on my own initiative.

Apart from making the additions already mentioned and eliminating colloquialisms designed for the lecture hall, my chief work as an editor has been to compile the footnotes. The great majority of these Francis had himself supplied, albeit in abbreviated and sometimes slightly cryptic form. (Those that I have added I have placed in square brackets.) It is not possible to be sure where he would have felt that more supporting evidence was needed. This was a matter about which – as I well remember from our collaboration on *Taste and the Antique* – he felt passionately. In this respect, as in several others, it must be accepted that this is not a finished work – or, rather, not as finished, not as comprehensive in treatment and not as rounded in argument as it would have been if Francis himself had had longer to work on it.

There are lectures of his, including some completed nearly a decade ago, which will, it is hoped, be published in some form, but in one sense the present book is his last – and Francis described it as his last long before he knew of his fatal illness. (He had also claimed that *History and its Images* would be his final book.) In these circumstances some sort of retrospection was inevitable. He was very little inclined to write about himself, and I am not certain that he was aware, when he wrote about Michelet and Huizinga in *History and its Images* and about Huizinga again in this book, that he was identifying his own antecedents, the spiritual ancestors he most admired. What is clear is that towards the end of both books he included an examination of the structure of the intellectual world that he himself had modified – and of some of the ideas that he had rejected. The tendency in Longhi and his followers to commend Old Masters who 'anticipated' Courbet or Manet, for example, Francis identified as an impediment to a just appraisal of the past. His first book, *Patrons and Painters*, asserted what now seems obvious – but which was being ingeniously denied by some of the most distinguished critics and historians – that the finest Italian contributions to the art of the seventeenth and eighteenth century were made in support of the illusions of power of absolutist monarchs, oligarchic aristocrats and the papacy. The British had less reason than Italians to feel uncomfortable about triumphalism in art.

The courage to work on this book in the last month of his life was something that Francis would not have been able to find without the support of his wife, Larissa. It is also true that he would never in the first place have undertaken the exhausting labour involved in a project on this scale without the confidence she gave him. His debt to John Nicoll and Gillian Malpass, to whom this book is dedicated, was also of the utmost importance. The part played by Burton Fredericksen in the development of the book has been mentioned above: Francis discussed many of the issues in it with him and with Carol Togneri in California. I believe that Francis would have wished to acknowledge the scholarly work that had helped him most: the discussion of the Florentine exhibition of 1922 by Fernando Mazzocca he felt to be especially exemplary. More, I suspect, than with any of his previous books, Francis was able to benefit in the making of this one from references supplied and suggestions made by former pupils and younger colleagues, among them Tomaso Montanari

on seventeenth-century Italy, Colin Bailey on eighteenth-century France, Florian Illies on Waagen, Pascal Griener on Holbein, Jon and Linda Whiteley on nineteenth-century France and Ilaria Bignamini on Italian archival material pertinent for the 1930 exhibition of Italian art. Special mention should be made of Cao Yiqiang who, together with Tomaso Montanari, gave much assistance as well as comfort to Francis in the last month of his life.

Among Francis's papers I found the following list of people whose help he wished to acknowledge (I have added a few names; those whose help has not been acknowledged will, I hope, understand that in the circumstances it is not surprising that this has occurred): Manuela d'Afra, Julian Agnew, Giacomo Agosti, Brian Allen, Christopher Baker, Giovanni Gaeta Bertelá, Linda Borean, Xavier Bray, Duncan Bull, David Carter, Matteo Ceriana, Marco Chiarini, Keith Christiansen, Naomi Collyer, Howard Colvin, Jean-Pierre Cuzin, Patricia Eaton, Judy Egerton, Caroline Elam, Miriam Fileti Mazza, Maurizio Fagiolo dell'Arco, Peter Funnell, Caterina Furlan, Daniela Gallo, Ernst Gombrich, Christopher Green, Erin Griffey, Paul Grimke, Paul Groube, Jo Hedley, Charles Hope, Christophe Léribault, Donata Levi, Doug Lewis, Philip Lindley, Denis Mack Smith, Eunice Martin, Stefania Mason, Elizabeth McGrath, Simon McKeon, Alessandra Mottola Molfino, Marta Nezza, Silvana Pettenati, A. W. Potter, Pierre Rosenberg, Gerhard Rudiger, Sileno Salvagnino, Susanna Sarti, Nick Savage, Werner Schade, Jonathan Scott, Anne Steinberg, John Sunderland, Paul Taylor, Jan van de Wateren, Giles Waterfield, Aidan Weston Lewis, Sarah Wilson, Humphrey Wine, John Woodhouse, Richard Wrigley, Mary Yule.

Nicholas Penny
London, July 2000

Introduction

Miles above us jets speed through the skies carrying their freight of Titians and Poussins, Van Dycks and Goyas. Below, meanwhile, curatorial staff in museums and galleries scattered over much of Europe and the United States are supervising the transfer of pictures that usually hang on their walls to inaccessible and crowded storage rooms and are busy preparing large new explanatory labels. Accountants are checking the impact likely to be made on this year's budget deficit and are deploring the failure to settle for Monet or Van Gogh, while elsewhere printers work overtime to make sure that bulky catalogues are ready on schedule, hotel clerks are eagerly accepting, or regretfully refusing a spate of extra bookings, and academics are putting the finishing touches to the papers that they will shortly read at the inevitable symposium. The Old Master exhibition is by now as well established among the institutions of the western art world as are the public museum and the illustrated monograph – both of which sometimes seem to depend on the popularity of this comparative newcomer to the field for their own continuing vitality. Indeed, the holding of an Old Master exhibition to commemorate the centenary of an artist's birth or death has become a moral imperative – to be neglected at the cost of scholarly and public opprobrium.

But much more significant (though much less obvious) than the economic and political impact of exhibitions – on tourism, for instance, or on publishing or on the promotion of national or personal prestige – have been the many changes introduced by them to the ways that we now look at art. The bringing together, from public and private collections scattered across much of the world,

of many of the pictures painted by a single artist over the course of his career allows us to scrutinise his development (or lack of it) with a rigour that neither he nor his patrons can ever have envisaged (even though reproductive prints based on his major works may have been available): perfunctory drawings and rough sketches can be hung next to highly finished paintings and sculptures so as to reveal successive stages in his creative process; contrasts can be demonstrated between 'the unique hand of the master' and that of the follower or anonymous apprentice in his workshop. In addition, barely known artists, and, indeed, whole schools of art, can be introduced to the public and, as a consequence, be granted an assured place alongside others whose status has long been established by tradition, while the complexity of some iconographical theme can be illustrated by examples chosen from the *oeuvre* of painters whose lives were as decisively separated by time as they were by place. The ephemeral presentation in London, Paris or New York of exotic, and sometimes only recently excavated, sculptures – whose permanent sequestration in the museums of these or other western cities would not be possible today – can radically change our perception of even the most renowned orthodoxies; national glory can be propagated, and political causes can be promoted, by judicious displays in well-chosen exhibition galleries; dealers and forgers can make impressive profits by venturing into beautiful (or, sometimes, merely fashionable) territory, whose contours have not yet been fully mapped. Moreover, a semblance of permanence can be given to what is, by definition, only temporary through the production of superb, but misleading, catalogues – misleading, because by necessarily having to confine themselves to what can be borrowed for the occasion, while not being able to take into account such relevant new information as may emerge either from the exhibition itself, or from papers delivered at some conference arranged in connection with it,[1] these catalogues can provide only an incomplete and unbalanced view of the subjects apparently promised by their titles, while, at the same time, perhaps discouraging the market for books that might have been able to fulfil those promises.

It is true that, well before the calculated juxtapositions made possible by the Old Master exhibition, many of the revelations, distinctions and comparisons that will be explored in this book were not unfamiliar to a small number of well-travelled connois-

seurs endowed with good memories and capacious notebooks; but their observations could not have been upheld with real cogency and, above all, could not (as they can today) have been conveyed to a wide public with such assurance that even monumental works of art, still to be seen in the churches and other public buildings for which they were produced, are appraised by criteria not hitherto generally accessible. However, it took a very long time – some two generations – before even those closely involved with organising Old Master exhibitions either began to appreciate or had any desire to exploit some of the remarkable potentialities of this new invention, which first became regularly established during the second decade of the nineteenth century in England.

Well before then, however – as early as the seventeenth century – exhibitions of contemporary art had become institutionalised in various cities in Italy (usually on special saints' days) and in Paris (under the auspices of the Royal Academy of Painting and Sculpture). Their standing was ambiguous almost from the first: as a means of attracting attention to the work of young and unknown artists they were obviously welcome – necessary indeed, once the constraints imposed by a rigid system of patronage began to loosen; but by exposing artists to the criticism of malicious rivals and journalists and to the indignity of deferring to the judgment of ill-informed public opinion, they could also be deeply humiliating.[2] In any case, whatever their benefits and drawbacks, such exhibitions dominated the lives of artists from the end of the eighteenth century onwards and played an epoch-making role in the development of modern art – beginning, perhaps, with the showing of David's *Oath of the Horatii* in the Paris Salon of 1785, and continuing with such famous occasions as the 'romantic' Salon of 1824, the Salon des Refusés of 1863 and the Impressionist exhibitions from 1874 onwards in Paris, the various Secession exhibitions in Germany and Austria during the 1890s, the Post-Impressionist exhibitions in London of 1910 and 1912, the Armory show of 1913 in New York, and many more. It is, therefore, hardly surprising that their functions have been extensively discussed in recent years. In the context of the present book, however, their significance, while always present on the horizon, is only marginal.[3]

The concept of the Old Master (although not the term itself) can be traced back to Italy during the late sixteenth century. It then became recognised that, although with the deaths of Leonardo,

Raphael, Michelangelo and the other artists who had exemplified Vasari's *terza maniera*, a golden age had come to an end, the glorious achievements of its protagonists would never be dimmed. This situation was given official sanction in 1602 when a decree was issued to forbid the removal from Florence – for any reason whatsoever – of the works of eighteen deceased painters, all of whom had adorned that golden age, though by no means all of them belonged to the Tuscan school:[4] indeed, the Tuscan pioneers of the fourteenth and fifteenth centuries, from whom these great masters were held to have sprung, were now considered to be of historical interest only, and although it was acknowledged that their efforts deserved high praise, no attempt was made to retain their works in Florence. By the end of the seventeenth century, the Carracci and their followers, who were looked upon as the worthy heirs of Raphael and his contemporaries (heirs rather than superiors), were added to the ranks of artists described as 'the esteemed masters', 'les plus grands maîtres' and similar, and a few more were added from time to time – but essentially the situation remained unchanged until the last decades of the eighteenth century. A very early example of the term 'Old Masters' being used in a positive sense can be found in a sale catalogue of 1777,[5] and it turns up occasionally in the following years, but it was not until the 1790s that it became widely accepted;[6] and although the artists to whom it was generally applied were still those who had been admired over a period of many generations (for the primitives had not yet won general acclaim and most eighteenth-century painters were looked upon with some contempt), the notion of Old Master gradually came to embrace all those artists who had lived before the French revolution. It is, however, ironical that in England, where the term has most readily been adopted, it has been possible to apply it almost exclusively to painters of foreign birth, because it was not considered very appropriate for Hogarth, Reynolds and their contemporaries, who alone seemed worthy of being remembered – or at least exhibited. This distinction is made clear in the many English sale catalogues devoted to 'Old Masters and Deceased Masters of the British School'.

The Old Master exhibition is notable above all because it brings together in a clearly defined space works of art (often of the most varied kinds) that had originally been designed to be seen in wholly different locations. The obvious precedents for this lay in what was by now the well-established tradition of removing

images from the churches or temples, civic monuments or personal dwellings for which they had been commissioned in order to install them in private collections and, later, in public museums. This is a practice that, inspired by the seizure of enemy booty in wars dating back to the dawn of history, was refined in the later years of the Roman Republic, flourished during the Empire and was continued by the church treasuries and *Wunderkammern* of the Middle Ages and the Renaissance. It is in the sixteenth century that the process can first be followed in some detail – the acquisition by the French royal collection, for instance, of large paintings made for churches in Milan and Florence by Leonardo da Vinci and Fra Bartolomeo[7] – but it is only in the seventeenth that the appearance of galleries formed as a result of such displacements – by now commonplace – was recorded for contemporaries and for posterity. Although the various views, painted during the 1650s by David Teniers, of the collection of pictures assembled in Brussels by Archduke Leopold Wilhelm, the Habsburg Governor of The Netherlands, are not exact in every detail, the general impression made by them is clearly faithful enough. One of these (pl. 1) shows, closely fitted together on the same wall, a fragment of an altarpiece, painted nearly two hundred years earlier by Antonello da Messina (but in the seventeenth century attributed to Giovanni Bellini) for the church of S. Cassiano in Venice; versions of large pagan mythologies commissioned from Titian for the king of Spain; a *Descent from the Cross* attributed to Tintoretto; further altarpieces and devotional pictures by Raphael, Veronese and other great masters; landscapes; and portraits, acquired for their distinction and not for personal, family or dynastic reasons. Although other views of the archduke's gallery represent a similar variety of artists and subjects, they, like this one, have imposed a greater degree of uniformity on the appearance of the collection than was warranted by its contents, for Teniers was evidently instructed to record almost exclusively the Italian pictures.

It is curious that princely galleries of this kind were so highly admired during the sixteenth, seventeenth and eighteenth centuries, a period during which the hierarchical classification of the arts was taken for granted and the orthodoxy of religious imagery was a matter of real consequence. No one seems to have complained that, by treating portraits on the same level as history paintings and by hanging altarpieces – specially created for the

family chapels of noblemen or rich merchants who would have selected and scrutinised each saint with earnest deliberation – next to scenes of the most enticing eroticism, collectors were defying the considered teaching of churchmen and philosophers in order to create a category of art for which only aesthetic quality needed to be taken into account. It is, paradoxically, not until the nineteenth century, just when the classification of art by subject matter was in theory becoming increasingly old-fashioned, that, in practice, a growing number of thinkers began to deplore the situation that had been brought about. In 1861 Théophile Thoré declared that 'museums have never existed when art is in good health and creative vitality flourishes. Museums are no more than cemeteries of art, catacombs in which the remains of what were once living things are arranged in sepulchral promiscuity – a voluptuous Venus next to a mystical Madonna, a satyr next to a saint . . . furniture taken from a boudoir matching an altarpiece'.[8] Thoré is by no means alone in expressing such sentiments, and the museums of which he was speaking – the Louvre, for instance, whose most popular masterpieces, concentrated in the Salon Carré, correspond closely enough to those denounced by him – were the direct descendants of those private or semi-private galleries that had been celebrated in earlier centuries.

So, too, were the great majority of the first Old Master exhibitions, which were often barely distinguishable in appearance from such galleries, but which nevertheless ran counter to them in a way so fundamental that their whole nature and purpose was radically new: they were (and were designed to be) ephemeral. Thoré, writing in 1857 of the *Art Treasures* exhibition, held in Manchester that year, compared the range of works on display with those in the Louvre but then dramatically reminded his readers that there was no museum in Manchester: 'And all this brought together yesterday, will be dispersed tomorrow.'[9]

It is true that the impact made by the exhibition in Manchester (which will be discussed in chapter 5) was exceptional in its power, but Thoré's vivid observation remains valid in its essentials for all Old Master exhibitions, the feeble as much as the great. Such exhibitions provide the public with opportunities, which would not otherwise have been available, to see works of art specially assembled for their beauty or their historical importance or for some other purpose, loosely, if at all, related to the one for which they were originally created – but these opportunities are provided, like

Cinderella's ball gown, only on condition that they exist for a strictly limited period. And while it is hardly convincing to suggest that the crowds who have queued to buy their expensive tickets to gain admission have much in common with Cinderella, they share with her the heightened emotion and intensity of observation that come from an awareness that their experience of magic can be only short-lived.

Chapter 1

Feast Days and Salerooms

Rome and Florence

The earliest Old Master exhibitions bearing any relationship to what is implied by that term today were organised in seventeenth-century Rome. Their primary purpose was ceremonial and, in this respect, they conformed to the age-old custom of hanging tapestries from the windows of palaces in order to celebrate a saint's day or the processional entry of some foreign embassy into the city – for it was always appreciated (as it still is) that the public display of luxurious possessions is likely to draw attention to the wealth and nobility of their owners. None the less, the fact that paintings, rather than the far more obvious symbols of opulence used in earlier days, now began to be chosen more and more frequently for this purpose marks a significant milestone in the social history of art.

The pictures lent to these exhibitions by aristocratic or newly rich collectors were usually placed in the cloisters of churches belonging to confraternities or to foreign communities living in Rome who wished to celebrate the name day of their patron saints, and by the end of the century four regular exhibitions were held each year – in March, July, August and December – quite apart from a large number of occasional ones arranged for special events and more casual affairs spontaneously organised by a particular patron or artist. Young painters, and others recently arrived in Rome from abroad, were sometimes keen to take advantage of an opportunity to make a reputation for themselves and attract patronage, but in general more prominence was given to famous masters of the past, both because they would indicate the anti-

quity or wealth of the families lending them and because, during the second half of the seventeenth and the first years of the eighteenth centuries, when the exhibitions were at their peak, it was generally felt that modern art was no longer in as flourishing a state as it had been earlier in the century – let alone during the lifetime of Raphael and his contemporaries. In 1668, for instance, it fell to the Rospigliosi (the family of the reigning Pope Clement IX) to organise a particularly splendid exhibition in and around the church of S. Giovanni Decollato, and they decided to exclude all contemporary work. This provoked the ambitious Salvator Rosa to organise a band of supporters to go around Rome to ask people, 'Have you seen the Titian, the Correggio, the Paolo Veronese, the Parmigianino, the Carracci, Domenichino, Guido and Signor Salvatore? Signor Salvatore is not afraid of Titian, of Guido, of Guercino or anyone else.'[1] The antagonism felt by Rosa for collectors eager to show off works by deceased artists at the expense of those who were living was later to be expressed with much greater bitterness by Hogarth and became particularly acute when Old Master exhibitions began to be established on a regular basis in early nineteenth-century England.

The size, contents and arrangement of the exhibitions in Rome varied from location to location and from year to year. We are best informed about those held annually on 10 and 11 December in the cloisters of S. Salvatore in Lauro, the church of the Marchigian community, for the purpose of celebrating the miraculous arrival in Loreto of the Holy House of Nazareth.[2] The initiative for mounting these exhibitions almost certainly came from Queen Christina's favourite and art adviser, Cardinal Decio Azzolino, who was protector of the Marchigian community in Rome and titular head of their church.[3] They took place over a period of nearly fifty years, during almost all of which their preparation was entrusted – at first in part and then exclusively – to Giuseppe Ghezzi. Ghezzi, a talented painter, copyist and restorer born near Ascoli Piceno in the Marche, was also a collector (who owned Leonardo's 'Codex Hammer' and who was much in demand as a valuer) and a reliable administrator who played a dominant role in most of the artistic institutions in the Rome of his day. It was in 1676, when he was aged forty-two, that he became involved with the S. Salvatore exhibitions, only a year after they had come into being, and from his surviving (but patchy) notes it is possible to get some impression

both of the extent of his efficiency and also of the difficulties that he (like so many of his successors in a similar role during the next three centuries) had to face in trying to secure satisfactory loans.

Within a year or two of his official appointment as organiser of the exhibitions Ghezzi drew up guidelines for their installation, and he and his collaborators adhered to these throughout his period of office.[4] Sufficient quantities of damask were to be hired or, whenever possible, borrowed in order to cover gaps in the existing decoration of the church, but it was important to apply this economically: it was, for instance, not necessary to make use of it to adorn side chapels or columns. Tapestries were needed to embellish the rough brick façade (of which only a part of the lower half had yet been clad in stone), and here, too, it was desirable to get hold of them from friends rather than be forced to hire them. Above all, it was essential to make sure that the rich damasks should not become frayed through excessive handling or be exposed to too much dust. Size would have to be a prime consideration when choosing pictures, and five or six very large ones would always have to be borrowed in order to produce a striking effect at the end of each of the principal corridors. Great care must be taken to prevent their being damaged, and appropriate sums were indicated for paying the porters, guards and soldiers who were to be stationed at the church day and night for the forty-eight hours or so during which the exhibition usually remained in place. These preliminary arrangements should be made a month before the opening ceremony so that the pictures could be collected on 3 or 4 December and be set up two days later.

As he gained experience Ghezzi realised how advisable it would be to approach potential benefactors with lists of desirable loans a full year before they were required, and he also noted the names of those of his colleagues on whose powers of persuasion he could most rely to ensure favourable answers to his requests. Although he soon discovered that a promise did not necessarily amount to a guarantee, many of the leading patrician families seem to have been eager to show off their valued possessions. Sometimes, however, they imposed strict conditions. Thus Prince Pio agreed to lend his 'very famous' collection only if no pictures belonging to other proprietors were displayed alongside his. This difficulty was overcome by transferring a group of miscellaneous loans (which had, presumably, already been asked for) to the upper

loggia of the cloisters.[5] Seven years later Marchese Ruspoli, who sent 194 pictures, was also reluctant to share his glory with any rival, but he was then persuaded to allow twenty-three paintings belonging to Monsignor Olivieri to be included in the exhibition.[6] Not all lenders were so amenable, and much ill feeling was caused when in 1716 Ghezzi refused – understandably enough – to displace large altarpieces by Guercino and Guido from their conspicuous positions in order to make way for pictures by Torelli and Benefial lent by Cardinal Paolucci.[7]

The majority of pictures displayed were, naturally enough, of religious subjects – but landscapes, genre and military scenes were also very well represented, and in 1717 one of the greatest benefactors of the exhibitions, the Falconieri family, even sent a group of erotic paintings – *Venus in Bed awaiting Mars* by Annibale Carracci, *Sleeping Venus gazed at by a Satyr* (pl. 2) by Poussin and others of a similar nature, which were kept together in a section of their own called the 'arsenale'.[8]

Although contemporary works were displayed from time to time, artists of the first half of the seventeenth century dominated virtually all the exhibitions. Pictures attributed to great painters from preceding periods – Holbein and Dürer, and (above all) the Venetian masters of the High Renaissance – featured in significant quantities, but no artists earlier than Perugino and Pinturicchio seem to be recorded in Ghezzi's lists. Relatively few of the pictures exhibited can today be identified with total confidence, and even at the time many were almost certainly known to be copies, or at least studio versions, of celebrated masterpieces kept in churches or in outstanding, but unavailable collections. It is thus not easy to determine how much reliance can be placed – or, indeed, was intended to be placed – on Ghezzi's attributions, despite the fact that he enjoyed great fame as a connoisseur. It can in any case be assumed that (as was to be the case in virtually all subsequent exhibitions) it was the lender, and not the borrower, who determined under which name a picture should be shown. However, one feature of the exhibitions is so exceptional as to be very striking: none of the attributions can be dismissed as wholly fanciful – there were, for instance, no portraits by Giorgione of Luther and Calvin of the kind that were being recorded in the collection of the grand duke of Tuscany in these very years.

The annual exhibitions at S. Salvatore in Lauro were greatly admired by successive popes and their retinues as well as by a

wider public, and they did much to enhance the standing of those who contributed to them. However, unlike other exhibitions in Rome at which modern artists could – and did – establish their reputations, these ones seem to have made an impact far more through the general impression of splendour that they conveyed than through the beauty or rarity of any individual pictures to be seen in them. No catalogues were issued, and Ghezzi's guidelines contain no hint that loans were to be labelled in any way or that their arrangement should follow any logical sequence. It is, therefore, hardly surprising that only one case has come down to us of a visitor having commented on specific items. In 1704 Monsignor Filippo Maria Resta, the bishop of Alessandria, wrote to the 'eruditissimo' Ghezzi of the very great delight and amazement with which he had been able to see again, among the eighteen paintings and drawings lent to the exhibition that year by the Spanish ambassador, two little pictures by Correggio which he already knew: a *Pietà* and a *Martyrdom of St Placidus*.[9] He retailed their complicated history since they had been taken from Parma and told of the repeated consultations held with experts in half a dozen cities in order to establish their authenticity, and he claimed that this had now been confirmed beyond doubt. Resta's concentration on quality, attribution and provenance strikes a note that is as radically new as it is anomalous among surviving responses to early Old Master exhibitions, and it is a pity that we can no longer trace the two little 'Correggios' that inspired it.

The example of Rome prompted the holding of art exhibitions in Florence[10] under the auspices of the Accademia del Disegno, whose patron was the grand duke of Tuscany. Their purpose was to celebrate the feast day of their patron saint, St Luke, and they were installed partly in the chapel dedicated to the saint adjoining the cloisters of the church of SS. Annunziata and partly in the cloisters themselves. The first one to be recorded took place in 1674, but unfortunately almost nothing is known about its contents, although (as might be expected from the sponsoring organisation) much attention seems to have been paid to new work by young artists. Thereafter displays of this kind continued sporadically until in 1706 Grand Prince Ferdinand de' Medici, heir to the grand duchy, prompted what appears to constitute a landmark – albeit an isolated landmark – in the history of the Old Master exhibition. Far more space was devoted to 'remarkable works by the most distinguished deceased artists' than to those by 'the most

illustrious now living',[11] and (above all) the former seem to have been selected at least in part with the specific aim of changing the direction of modern art in the city. We know from other sources[12] that the grand prince was keen to widen the horizons of contemporary painters in Florence and, through the nineteen loans from his own collection[13] and from those of members of his entourage, he and the organisers evidently made a point of drawing attention to pictures by (or attributed to) Bassano, Titian and Veronese, as well as by Bolognese and Flemish masters.[14] The Florentine tradition was not wholly neglected, as is shown by the inclusion of a few works by Fra Bartolommeo and Andrea del Sarto, of (more surprisingly) a bronze bas-relief by Donatello and of a group of waxes and bronzes by Giambologna. Indeed, because Florence – unlike the Rome of Caravaggio, Annibale Carracci, Guido Reni, Lanfranco and Guercino – had not experienced during the first half of the seventeenth century a famous revival of painting that had retained its prestige in later decades, the 'deceased artists' to whom the city's rulers could look back with pride were to be found only in a more distant period. It is also significant that, among recent artists, the Neapolitan Luca Giordano was represented by twice as many works as was Carlo Dolci.

We know very much less about the planning of this exhibition than about the ones held in S. Salvatore in Lauro, but the available evidence strongly suggests that its aim was not so much to glorify the nobility, or even the grand prince himself, as to enable the public and, above all, artists to look carefully at pictures that would not otherwise have been generally accessible. This would hardly have been possible in the short-lived exhibitions held in Rome, and it is significant that the one patronised by Grand Prince Ferdinand remained open for 'several days',[15] thus enabling citizens to make repeated visits. The real innovation, however, consisted in the publication of a catalogue combined with a guide which described the location of every picture and thus made it very simple to discover exactly what was to be seen as one walked through the exhibition.

Although Florentine painting certainly responded to the stimulus provided by Venetian and Neapolitan art during the first decades of the eighteenth century and although the patronage of Grand Prince Ferdinand and of other enlightened collectors was undeniably important in this respect, it is difficult to estimate how much significance should be attributed to the exhibition of 1706.

Despite the important innovations introduced for the occasion, it had only a few sequels, and these took place at most irregular intervals. Further ones along similar lines and with similar catalogues were held in 1715, 1724, 1729, 1737 and 1767, but the custom did not take root as it had in Rome. Even in Rome, however, the age of the Old Master exhibition had almost drawn to a close by the middle of the eighteenth century, by which time its nature had undergone fundamental changes. Thus when in 1736 the organisers of the traditional exhibition at S. Giovanni Decollato followed the example of Florence by issuing a printed catalogue, they did so only in order to make clear that the pictures were for sale; and the same motive may have been behind the decision in 1750 of the Congregazione dei Virtuosi (which, ever since the early seventeenth century, had been mounting annual exhibitions under the portico of the Pantheon to celebrate the feast-day of St Joseph) to publish an index of the old and the modern pictures exhibited in the exhibition mounted in the portico of S. Maria ad Martyres.[16]

Paris

During the course of the eighteenth century Old Masters in churches and princely galleries in Rome and Florence, as in other major Italian cities, were more clearly identified by guide books and more easily accessible to travellers. This may help to explain the eclipse of the type of temporary exhibition that has been described. Meanwhile, however, another type of ephemeral display had become more important elsewhere: the showrooms of dealers and auctioneers provided temporary exhibitions of Old Masters equivalent to those in refurbished chapels and cloisters.

It was, for instance, probably at an auction in Amsterdam that on 9 April 1639 Rembrandt was able to see and make a drawing of Raphael's portrait of Baldassare Castiglione (pl. 3) before it was acquired by the great collector and agent of Richelieu, Alfonzo Lopez.[17] And from the first years of the eighteenth century auction houses in London, Paris and elsewhere provided the easiest opportunities for looking at pictures (both genuine and, more often, copies) by celebrated Old Masters. In Paris especially the experience could be a rewarding one thanks to the excellence of many of the catalogues and to the fact that, as in London, the contents

of a sale could usually be inspected for some days before the dispersal got under way. Countless quick but elegant and admirably informative sketches made in the margins of his sale catalogues by Gabriel de Saint-Aubin demonstrate that it was possible for a really determined artist to make records of the appearance of the more interesting pictures on view despite the inconvenience caused by the people of fashion who flocked to these occasions.[18] None the less, although pictures were liable to be removed by clients without advance warning, it is almost certain that the more slow-moving (but uncatalogued) stock displayed in the premises of dealers could be examined with greater care – as is shown in Watteau's sublime painting of the interior of Gersaint's shop, Au Grand Monarque, in which the pictures shown hanging on the walls are clearly intended to recall Old Masters, even if none of them records a specific example of one (pl. 4).

However, in 1782 and then in 1783 ceremony, pride of ownership and commerce which had hitherto, to varying degrees, been the principal motives for the occasional displays of Old Master paintings held in various European cities were, briefly and for the first time, replaced by what seems to have been a truly altruistic desire to honour those artists whose (carefully selected) works were put on view. The exhibitions concerned took place in Paris, and the man responsible for the many impressive innovations that characterised them, Mammès-Claude Pahin de La Blancherie, who had been born of a good provincial family at the end of 1752, was by then already well known in advanced literary circles in the capital. 'Small, brown and rather ugly' in appearance,[19] he embodied to an extreme degree that combination of idealism, vanity and obsequiousness which is, in all periods, not unusual (and may even be essential) for those who set out to reform the administration of the arts. He was much derided by some of his contemporaries[20] – especially those whose entrenched privileges were threatened by his proposed reforms – but there does not appear to be any evidence for some recent claims that he was a charlatan aiming to make money for himself.[21]

An early visit to America had filled Pahin with horror at the cruelties of the slave trade,[22] and on his return to France he devoted himself to the cause of emancipating the arts and sciences from the tyranny of tradition and to creating a meeting place where artists and scientists, from all over Europe and beyond, could congregate to discuss the issues that concerned them.[23] He

gave himself the somewhat high-flown title of *agent général de la correspondance pour les sciences et les arts*, but the prestige and success of his 'Salon de la correspondance' fully justified his conceit. His project was endorsed by, among others, the Baron Grimm,[24] Benjamin Franklin and Condorcet, and the numbers of distinguished men of all nationalities who were greeted by him soon rendered his own apartments too small for the gatherings, so that, within a few months of the salon's inauguration in April 1778, he was forced to move to a larger location. It was not until July 1781 that he settled – for a final six years of activity – in this third and largest quarters, the sumptuous Hôtel Villayer in the rue Saint-André des Arts. These moves, however, were not caused only by the problems of success. Pahin was faced with constant financial difficulties. In theory he was subsidised by forty '*protecteurs*', who each paid 4 *louis* a year, but although these supporters included some of the richest and most powerful men in France – the comte d'Artois and the duc d'Orléans among them – many of them seem to have needed frequent reminders when their subscriptions became due. Moreover, it was not only the rent and ceaseless hospitality that put pressure on Pahin. He was also responsible for editing a weekly journal, *Nouvelles de la république des lettres*, which first appeared in February 1779 and which, with a few brief interruptions, survived for nearly ten years. Although the *Nouvelles* covered developments in the sciences and medicine, in economics, industry and the law, as well as in music, letters and the arts, here it will be possible to concentrate only on the attention that it paid to painting – even though fragmentation of this kind inevitably distorts the very nature of Pahin's ambitions, which were designed to be comprehensive.

Pahin's most daring step was his first. Early in 1777 the recently crowned Louis XVI had, at the request of the Académie royale de peinture et de sculpture, closed down the Académie de Saint-Luc, whose exhibitions had been much resented by the official body, even though they were by now held far too irregularly to be in any way competitive.[25] In February 1779 the first issue of the *Nouvelles de la république des lettres* defiantly announced that the Salon de la correspondance would henceforth organise exhibitions of pictures by artists who did not belong to the Académie royale or that had been rejected by the official Salon, as well as of others that belonged to private collectors prepared to lend them for short

periods.[26] Lists of these pictures (among them a few Old Masters), and brief appreciations of their qualities, were published in each issue of the journal, and – as is well known – certain painters, such as Greuze, who resented the dictatorial attitude of the Academy and the two-year intervals it imposed between successive Salons, regularly exhibited under the more relaxed auspices of Pahin and his colleagues. Both French and foreign visitors frequently met in the Salon de la correspondance to discuss the pictures there, as well as the books in many different languages, mechanical objects of various kinds, scientific experiments and so on. The Academy strongly resented this rebuff to its authority, but Pahin was very skilled at winning support from the many royal and aristocratic members of his organisation, and the exhibitions were therefore tolerated (though certainly not encouraged) by the government.

In 1782, emboldened by his success, Pahin embarked on what (in retrospect) proved to have been a far more adventurous course, although he did so almost casually without at first appreciating the full implications of this new undertaking. In July he exhibited, among a smaller than usual number of works by contemporary artists, a large *Hercules and Omphale* by Noel Hallé, who had died in the previous year, but whose picture dated back to 1744, and also a modest selection of paintings by other deceased painters, all of whom belonged, or were related to the Hallé dynasty: a *Holy Family* by Daniel, Noel's grandfather, who had died in 1675; a *Finding of Moses* by Claude, his father, who had died in 1735; and one work each from three generations of the Restout family into which Noel's sister had married in 1729, giving birth three years later to the still-living Jean-Bertrand; and, finally, two sketches by the famous Jean Jouvenet (1644–1717), brother-in-law of Jean, the first of the Restout painters. Occasional pictures by members of the same families were added during the course of the next three or four weeks, and in succeeding issues of the *Nouvelles de la république des lettres* Pahin elucidated the relationship between them and claimed that by exhibiting their works he was paying 'a well-deserved homage to these Masters of our School who, in their time, constituted what could be described as *patrician* families of the Arts, who laid the foundations for their descendants of the esteem of which they too have proved themselves worthy by inheriting their talents and their virtues'.[27] Pahin's celebration of these talents and virtues must in turn have

inspired his plan to organise, in the following year, the first large-scale exhibition to be devoted principally to the Old Masters.[28] But before this came into being he had devised one more ground-breaking innovation whose consequences have been of almost equal significance: that of the retrospective exhibition confined to a single living artist and based entirely on works borrowed from private collections.

Joseph Vernet[29] had long been one of the most admired painters in France, indeed in Europe. By now, however, he was sixty-nine years old, and it was some twenty years since he had completed his most celebrated achievements, the fifteen *Ports de France* painted for Louis XV. It is true that he was still an extremely accomplished artist who could produce pictures of the highest quality; but the works that were commissioned from him – often in the most specific detail – tended to be more and more repetitive as regards both composition and subject matter – such as contrasting pairs of calm seas and storms, sunrises and sunsets, men fishing and women bathing. Moreover, with rare exceptions (among them, admittedly, the heirs to the thrones of Spain and Russia), his patrons were no longer as cosmopolitan or of the same exalted social rank as they had been in earlier years.[30] From 1777 onwards[31] his two most assiduous patrons (both of whom also became his friends) were a rich Protestant banker, Jean Girardot de Marigny,[32] and a silk merchant called M. Paupe, who operated from his shop, Au Cordon Bleu.[33]

From the collections of these, and of other admirers of Vernet (all of whom were named in the catalogue published for the occasion), forty-nine pictures and a handful of drawings were borrowed for Pahin's exhibition in the Salon de la correspondance.[34] The exhibition was inaugurated by the king's brother, the comte d'Artois, who himself lent four pictures from his apartments in Versailles.[35] But despite these extraordinary honours and the poetic eulogies that were allegedly written, and perhaps published,[36] it attracted almost no attention from the press[37] – or even from the artist himself. He failed to put in an appearance at the exhibition, as he had been invited to do, and thus caused some embarrassment to Pahin who had to explain that his absence was a consequence of his modesty;[38] he did not refer to the exhibition even in his private diaries.[39] Vernet's apparent disdain for a tribute the like of which had never yet been paid to an artist is inexplicable,[40] and it is to a writer employed by Pahin that the historian

of exhibitions is forced to turn in order to convey some impression – biased, exaggerated and historically inaccurate though it may be – of the real, extraordinary, significance of the exhibition of 1783:

> The unique, perhaps unparalleled, spectacle that has been made available in the headquarters of the *Correspondance* for the benefit of art lovers is an event that will long remain engraved in their memories. The history of painting will retain in its annals this truly precious event to accord it all the consideration that is its due. Since the sorrowful day when it was ordained in Rome that the superb picture of the *Transfiguration* painted by the divine Raphael would be exhibited in order to move the public and quicken their awareness of the loss of that great man, there has been nothing that can be compared or even contrasted with that exhibition other than the spectacle that you have made it possible for us to enjoy.[41]

Within a few weeks, however, Pahin had embarked on a yet more remarkable step. On 14 May 1783 he announced in the *Nouvelles de la république des lettres* that the exhibitions that he had organised in honour of the Restout and Hallé families, and subsequently of Vernet, had constituted no more than the prelude to a monument that he had been intending to erect to the glory of the French school as a whole. The success of these exhibitions and the readiness of owners to lend works in their possession had now convinced him of the desirability of carrying out this project, vast though it was. Preparations were far advanced, although the catalogue was not yet ready.[42] In the event he never seems to have produced a catalogue – as that word would be understood today – for the exhibition that opened a week later and remained on view for about three months (though the 'prophane vulgaire' was admitted to this Temple of the Arts only on specified days).[43] Instead, after many delays, he published a list of 197 pictures, divided into three groups – those by 'Peintres anciens', arranged in approximately chronological order (109), and those by 'peintres vivants', both *académiciens* (62) and *non académiciens et non agrées* (26), belonging to the French school 'from Jean Cousin, in 1500, including everything up to 1783'.[44] Brief biographical introductions were provided for all the dead masters and for many of the living ones, and the names of the owners of the pictures exhibited were also given. However, what distinguishes Pahin's

catalogue from its present-day counterparts is that he included in
it artists whose works he wished to display but had not yet been
able to borrow, and he indicated these by adding an asterisk to
their names. This was designed (evidently with some success) to
encourage collectors to lend relevant examples, and as a result the
contents of the exhibition changed during the period of its dura-
tion,[45] and this in turn makes it impossible to describe it with any
precision.

Only a very few of the Old Masters (and it is with these only
that we are concerned) can be identified among those shown in
the Salon de la correspondance, and the number of asterisks on
the first two pages of Pahin's catalogue makes it clear that he must
have found it very difficult to borrow the earlier pictures that he
considered necessary to illustrate the excellence of the French
school. Moreover, the fact that a significant number of surviving
works by the same artists and of the same subjects as those
recorded in the catalogue can be shown to have belonged at the
time to different collectors from those listed in it, and that others,
which have subsequently disappeared, were already very well
known because they had been engraved, strongly suggests that
Pahin must have relied on copies, or at least on studio replicas,
for many of his exhibits. However, some very distinguished names
are to be found among the lenders, and it seems likely that the
overall quality was reasonably high throughout, however opti-
mistic or erratic the attributions may have been. The exhibition
certainly included two masterpieces, Watteau's *L'Indifférent* and
La Finette (both now in the Louvre), as well as the very striking
Madame de Ventadour with Portraits of Louis XIV and his Heirs
(now in the Wallace Collection, London), whose attribution to
Largillière has only recently been challenged.[46]

The catalogue of artists represented, or hoped for, was preceded
by a very brief introduction which, along with the biographical
and critical notes on the pictures, constituted an *Essai d'un tableau
historique des peintres de l'Ecole française depuis Jean Cousin, En
1500* . . . The information and opinions provided were, for the
most part, taken from the compilations of earlier writers and –
as Pahin himself acknowledged and as a contemporary journalist
gleefully emphasised[47] – contained many inaccuracies. Pahin's
approach to the history of French art was conventional enough –
Jean Cousin (or, rather, the various artists grouped under that
name) had long been looked upon as the founding hero of the

French school[48] – but his decision, in the introduction, to characterise its principal stages not (in the tradition of Vasari) according to stylistic developments but in relation to institutional changes is of some interest. He singled out the formation in 1391 of the community of '*maîtres* Peintres'; the foundation in 1648 of the Académie Royale de peinture, sculpture & gravure – 'gravure' was his own characteristically enlightened addition to its official name; and the supremacy over all its potential rivals granted to the Academy by the king in 1777, a decision that Pahin welcomed with enthusiasm.

Such a response is perhaps surprising, for so many of his innovations would seem to have been designed to break down the hegemony over the arts exerted by the Academy. Yet, unlike the administrators of that jealous institution, he himself does not seem to have gauged the wider implications of what had been a succession of practical measures to cope with a succession of brilliant impulses, just as he saw no incongruity between his loudly vaunted cosmopolitanism and the equally intense nationalism with which he proclaimed his admiration for the French school of painting. At no stage did his reforming ambitions in the intellectual and artistic spheres lead him to become affiliated to the 'liberal opposition' that is sometimes associated with the circle of the duc d'Orléans. He went out of his way to flaunt his devotion to the king (who seems to have admired his activities) and to flatter the queen's favourite, the princesse de Lamballe.[49] Despite constant rebuffs he retained a misplaced optimism that his requests for financial support from the king and his ministers would be granted.[50] On 19 August 1783, however, the all-powerful Surintendant des Bâtiments, the comte d'Angiviller, shattered his hopes in a frigid letter which insisted that, despite the 'estime personnelle' that he claimed to have no hesitation in according to Pahin, he could find in his projects only a 'uselessness all too well demonstrated by experience . . . inconveniences, and I would even go so far as to say dangers, for the well-being and the improvement of the arts'.[51] For these and other reasons that he had explained to the king, he proposed to put an end to them. Not long afterwards Pahin settled in England, where he became increasingly eccentric and died in 1811.

The pioneering role played by Pahin certainly deserves to be recognised. But he was an exception to the general rule that, throughout the eighteenth century, the overwhelming majority of

privately owned Old Masters that became briefly available for close scrutiny by collectors and connoisseurs in the principal cities of Europe did so by passing through dealers' galleries and auction houses. To that extent these occasions qualify as exhibitions, and although the contents of many of them evidently appeared as absurd to cultivated opinion at the time as they do, two hundred years later, to the chronicler who is forced to rely on his imagination rather than his eye in order to gauge the reliability of what he reads about them,[52] others were of real significance. It is, for instance, certain that, with the forcing into exile of increasing numbers of rich émigrés following the outbreak of the French Revolution, some of the temporary displays that took place in London in the 1790s were spectacular in quality. Two stand out in particular because, although they were mounted for commercial reasons, for the first time the works of art to be sold were kept on view for a really extended period.

London

A full year before the fall of the Bastille the duc d'Orléans, who was heavily in debt and needed to raise money to further his political ambitions, had let it be discreetly known that he was interested in selling some or all of the magnificent collection of pictures that he kept in the Palais Royal in Paris to James Christie, the leading auctioneer in London.[53] Tentative explorations were undertaken in June 1790, but nothing came of them[54] until September when a contract was drawn up between Christie and the duke's agent.[55] However, it was not until another year or so had passed that, after many obstacles,[56] different arrangements were put into effect to sell the entire collection – to which a number of pictures seem to have been added from other sources[57] – in two separate batches.

The first to reach London were the ones by northern painters that had been purchased, in dramatic circumstances, by Thomas Moore Slade, a rich art collector with a particular love for Venice (and for a Venetian '*Contessa* of the first consideration'), who was at one time employed by the Admiralty and who speculated in pictures and manufacturing techniques.[58] In April 1793 Slade arranged to have his newly acquired Dutch, Flemish and German pictures displayed in Pall Mall at the very hub of the London art

market.[59] Number 125, the site chosen, had been the first home of the Royal Academy, founded twenty five years earlier.[60] In the top-lit 'Great Room',[61] where Reynolds, Gainsborough and other founder members had exhibited their latest works over a period of eleven years before moving to Somerset House, there now hung 259 pictures by, or attributed to, Rembrandt (including *The Mill*[62] and *The Cradle*[63]), Rubens (some twenty sketches and paintings, among them *The Judgement of Paris*[64] and *St George and the Dragon*[65]), Van Dyck and other celebrated masters.

Admission to the exhibition cost a shilling[66] and the public came in 'vast crowds':[67] two thousand a day during the last week. Sales were brisk: £6,000 had been spent in the first few days and that figure had been doubled within a fortnight. The prices had been fixed by Slade, but the organisation of the exhibition had been entrusted to 'Mr. Wilson of the European Museum',[68] which, despite its high-sounding name, was essentially a commercial gallery, and it was probably he who took the unscrupulous step of adding to the pictures that had genuinely been acquired from the Orléans collection at least a hundred that had been brought together from quite different sources[69] – a fact he naturally failed to mention in the slipshod handlist that was published for the occasion. It may, however, also have been Wilson who insisted that 'Purchasers must permit their Pictures to hang up in their present State, during the Time of Exhibition, which will continue until the middle of June 1793',[70] and, as has been mentioned above, this emphasis on a lengthy duration constituted a landmark in the evolution of the Old Master exhibition – and one that was of much greater significance than the quality of the pictures shown, for many (in fact, most) of the artists included were already better represented in English collections than in that of the duc d'Orléans. Indeed it was probably the fame of the collector that was mainly responsible for the excitement and success of the sale, and within a few years it was to be overshadowed by the second instalment of the dispersal of his paintings.

By far the most splendid portion of the Orléans collection – the Italian and French pictures – had been sold by him shortly before the northern ones and, after having changed hands once more, they were brought from Paris to London in July 1792 by their new proprietor, François Laborde de Méréville, the son of a rich financier, who decided to emigrate as soon as the Revolution began to threaten his position.[71] In London the collection (by now

mortgaged) was enthusiastically visited by distinguished artists and art lovers,[72] but Laborde still hoped to be able to return to France with it once the situation there had calmed down,[73] and he kept a close and optimistic eye on the various royalist intrigues that burgeoned under the Directory.[74] He even made a visit to Paris, but after only one night he had to flee to England because his plans were thwarted by the military coup of 18 Fructidor (4 September 1797) which put an end to any hope of a counter-revolution.[75] Some fifteen months later he accepted an offer of £43,000 made by the duke of Bridgewater, Lord Carlisle and Lord Gower for the purchase of all his remaining pictures.

The transaction had been suggested and negotiated by Michael Bryan, a well-connected London dealer,[76] and under its terms the syndicate of three noblemen selected many of the most splendid pictures for their own collections and arranged for the remainder to be offered for sale. In order to draw the widest possible attention to his *coup* Bryan then made plans for all the Italian and French pictures from the Orléans collection to be displayed to the public for as long as seven months before any of those acquired, either before or during that period, could be removed by their new owners.[77]

Since 1796 he had occupied chambers in the central part of Schomberg House in Pall Mall – accommodation that had earlier served for the dubious activities organised by the quack doctor Graham in his specially installed 'Temple of Health and Hymen' and for the fashionable receptions offered by the artist Richard Cosway and his wife.[78] Bryan's gallery, which consisted of one large and one small show room,[79] could provide space for only 138 of the 296 Orléans pictures. He therefore rented a hall at the Lyceum in the Strand, which had been designed by James Paine for exhibition purposes nearly thirty years earlier and considerably modified since,[80] in order to hang the remaining 158 – among them all the bigger ones.[81] Separate 'catalogues' were issued – although the term is decidedly ambitious for what are no more than handlists, similar in scope to the one issued for the exhibition of Slade's pictures: their titles fail to refer to the fact that works by French artists were included and their contents provide no information other than the names of the painters and subjects (derived from earlier publications), and they even disclaim responsibility for the originality of the works on view (although this is 'presumed').

The two sections of the exhibition opened simultaneously on 26 December 1798, and admission cost half a crown. No displays of such magnificence had been seen in London since successive consignments of pictures, tapestries and other works of art from the collection of Charles I had been sent for sale to Somerset House a hundred and fifty years earlier. It is probably because he appreciated the unique significance of the occasion that on 31 July 1799, the day it was brought to an end, the artist and diarist, James Farington took the surprising decision to make rough sketches on his catalogues of the arrangement of the pictures (most of which can still be identified) in its two locations.[82]

Visitors walking into the Lyceum would have found all four walls of the gallery covered with unframed[83] pictures, symmetrically hung, reaching almost up to the very high ceiling and descending nearly to floor level (pl. 5). Directly opposite the door pride of place was given to a large *Finding of Moses*, very Venetian in character, attributed to Velázquez, an artist scarcely known in England at the time.[84] Above this, rising well above the cornice and tilting forward towards the viewer, as were all the other pictures at this level, was a *Martyrdom of St Peter* by Mattia Preti,[85] and on each side of this were two further Neapolitan pictures by Jusepe Ribera and Luca Giordano. Probably more familiar and certainly more appealing to most visitors would have been the Venetian pictures which covered most of the rest of this wall: on the extreme left and right Veronese's *Mercury, Herse and Aglauros* and '*Wisdom accompanying Hercules*',[86] and, adjoining them, Titian's *Perseus and Andromeda* and wonderful *Rape of Europa*,[87] to mention only a few. Turning to the wall to his left the visitor would have found the centre dominated by a very large Guercino of *David and Abigail*,[88] above which, to the left and right, hung two of Veronese's four 'Allegories of Love'.[89] Also on this wall was the other 'Velázquez' in the collection – *Lot and his Daughters*[90] – matched on the other side by two paintings of Danae, one above the other, by Annibale Carracci and Correggio.[91] And, below these, just above ground level, were two late works by Poussin, the *Exposing of Moses* and the *Birth of Bacchus*.[92] At the centre of the right-hand wall, hung so low that it almost touched the floor, was Sebastiano del Piombo's extremely large *Raising of Lazarus*.[93] To the right and left of this were the two of the most beautiful of the *poesie* which Titian had painted for Philip II of Spain, *Diana and Actaeon* and *Diana and*

Callisto,[94] above which was a long horizontal Tintoretto, the *Last Judgement*, perhaps a sketch for his mural in the Ducal Palace in Venice.[95] Above this was Le Brun's *Hercules destroying the Horses of Diomedes* (pl. 7),[96] nearly three metres in height and consequently tilted well forward to avoid the ceiling. On each side of it were the other two 'Allegories of Love' by Veronese, directly facing the pair on the left hand wall. Although there were a few superb pictures (notably by Titian and Veronese) on the entrance wall, which the visitor would have seen when turning to leave, this had clearly been used primarily for the display of works of less beauty and importance: the very large *Transfiguration*, attributed to Caravaggio, which hung above the door in the centre, had not, it seems, been considered worthy of being engraved in the remarkably complete series of the Orléans collection,[97] although other pictures believed to be by him were recorded in the volume. The gallery in Pall Mall contained pictures of smaller size (pl. 6), and the Venetians occupied far less space than did the Roman school (in which Raphael had pride of place), or Poussin (memorable, above all, for the *Seven Sacraments*[98]), or the Bolognese (among whose works Annibale Carracci's *Three Marys at the Tomb* (pl. 8)[99] was much the most admired – indeed, it was the most highly valued picture in the exhibition).

Although we know most of the pictures that were hanging in Bryan's Orléans exhibition of 1798 – and just how they were hung – we must reconcile ourselves to the fact that, after two hundred years of even more dirt, chemical change and cleaning, damage, retouching and restoration than they had presumably already undergone, we shall never be able to evoke in full the appearance of his galleries or the reasons for the varying responses to what was to be seen in them. When we read of a visitor complaining of 'a general *appearance of coldness* [in the pictures] – particularly in some by P. Veronese',[100] should we conclude that they had been ruthlessly scrubbed or that the English agreed with Sir George Beaumont, a keen visitor to the exhibition, in preferring their Old Masters to be coloured 'like an old Cremona fiddle'?[101] And what can we tell about contemporary taste or the condition of the pictures on view from the comment by the painter John Opie, who had probably never seen an original Titian before, that the ones hanging in the Lyceum were 'fine', but that he wished to see them cleaned?[102] One purchaser of a *Holy Family*, now thought to be a copy of a Polidoro Lanzani,[103] fulfilled this

wish by taking off 'a thick varnish &c' and thereby convinced himself and other connoisseurs that it was one of Titian's finest works.[104]

The artistic community seems to have agreed that the Titians were the best pictures in the collection. The portrait painter John Hoppner thought that they were the only ones 'which came up to his Idea of the Masters', but he also claimed that 'on the whole on looking over the Orleans Collection, so far from being dispirited, He thought more respectably of himself & so might his fellow artists if they wd do themselves justice'[105] – a bold challenge to those Royal Academicians who felt their positions threatened by the fact that so much attention was being paid to the Old Masters. By far the most discussed, and also the most controversial, picture was Sebastiano del Piombo's *Raising of Lazarus*. Sir George Beaumont and Benjamin West had both seen it before it went on view and both were 'in raptures' with it.[106] West went so far as to claim that it was 'the finest picture in the world'[107] – a judgement that Beaumont reserved for Annibale Carracci's *Three Marys*.[108] To those artists such as Hoppner and Smirke, who considered it to be 'defective' or 'very foolish',[109] West retorted, with what was dryly described as 'a pretty *self*-compliment', that the English were 'not by a 100 years at such maturity of knowledge of art as to comprehend the excellencies of that performance'.[110] He was probably right – even if his strictures could hardly apply to Fuseli, who thought that, although 'well painted in almost every part, yet, as a picture, is not worth a Shilling, – no whole, no effect – and the Christ an Old Cloaths Man'[111] – that is, a scarecrow, on account of his rigid gestures – a provocative statement that he modified a few years later.[112] Certainly some of West's contemporaries agreed with him. Mary Berry explained that although she and her friends had stood before the picture 'for above half an hour ... thoroughly enjoying it', in general there were even fewer visitors to the Lyceum than to the gallery in Pall Mall containing the smaller paintings, 'for the pictures are all of a sort less understood and less tasted here ... and besides the Lyceum is out of the way ... and not near any of the great haberdashers for the women, nor Bond St. nor St. James's St. for the men'.[113] It was also much colder, as was noted by Lady Annabel Yorke, an assiduous visitor to the Orléans exhibitions – at which she made a few purchases – and it was evidently less well lit, for the large, crowded, frameless pictures looked dark and dirty, and the general

impression made by them was less pleasing than it had been at the Palais Royal where she had seen them before.[114]

In fact, the poor attendances, and the apparent disappointment felt by some speculators at the results of the sale,[115] may have had more weighty reasons than those mentioned by Mary Berry and Lady Annabel Yorke. The market was becoming flooded with pictures brought into England from the Continent, and although few of these could compare in quality with those to be seen in the Lyceum, they had often been welcomed with the most extravagant publicity. Of those sold in 1795 by the former French controller of finances, Charles-Alexandre de Calonne, who had settled in London for a time, the sale catalogue claimed that 'no collection offered to the Public ever abounded with that variety of Chefs d'Oeuvre than this . . . it contains no less than 10 Pictures by Titian, 3 by Paul Veronese . . . the Annunciation by that scarce Master, Michael Angelo Buonarotti . . . a Holy Family by Raphael . . .', and so on.[116] The pictures remained on view for only four days, but the prices that they fetched suggest that this was sufficient to expose the unreliability of most of the attributions, despite the presence of a small number of real masterpieces. It is thus not surprising that many people may have been somewhat wary of the Orléans exhibition, coming just three years later. It did, none the less, prove to be of enormous significance. Although the Orléans pictures had, when in Paris, been relatively accessible to well-connected artists and travellers for nearly a century, never had it been possible for so many artists and members of the general public to examine them so carefully as when they were displayed for eight months in a London saleroom: and the experience made a radical impact on collecting and taste, and even stimulated the development of connoisseurship.

Mary Berry was right to stress that 'these pictures . . . are by far the finest – indeed, the only real display of the excellency of the Italian schools of painting that I ever remember in this country'. She could have gone further and pointed out that *no one*, however old, could have remembered such a display for well over a hundred years. Virtually all the major pictures were acquired by aristocratic, banking and mercantile collectors – or, it might be more accurate to say, men who became collectors as a result of their acquisitions of these pictures. Thereby they not only themselves transformed the holdings of art in Great Britain, but prompted others to do so also. Despite all the legends about insa-

tiable art lovers among the eighteenth-century *milordi*, it was only in the 1790s that their collections began to rival those that could be seen in Paris, Madrid and St Petersburg – let alone in most of the great cities in Italy. And the memory of this astonishing exhibition continued to haunt future generations, inhibiting a taste for the 'primitives' that had just begun to develop. It is a memory that has been immortalised in some familiar phrases by William Hazlitt:

> My first initiation into the mysteries of the art was at the Orleans Gallery: it was there that I formed my taste, such as it is: so that I am irreclaimably of the old school in painting. I was staggered when I saw the works there collected and looked at them with wondering and with longing eyes. A mist passed away from my sight: the scales fell off. A new sense came upon me, a new heaven and a new earth stood before me . . . Old Time had unlocked his treasures, and Fame stood portress at the door. We had heard of the names of Titian, Raphael, Guido, Domenichino, the Carracci – but to see them face to face, to be in the same room with their deathless productions, was like breaking some mighty spell – was almost an effect of necromancy.[117]

Chapter 2

Tribute and Triumph

The spectacular displays of Old Masters held in London during the 1790s were not the only ones to emerge from the upheavals in France during that decade. At much the same time as the Orléans pictures were being put on view in Pall Mall and the Strand, the administrators of the Musée central des arts were inaugurating an even more surprising series of exhibitions in the former royal palace of the Louvre, which on 10 August 1793 – exactly a year after the downfall of the monarchy – had been re-opened as a museum. Although it is true that these displays cannot strictly be described as 'exhibitions' in the sense that has so far been given to the word, since they were certainly not intended to be temporary (although events were to ensure that this would be the fate of most of them), they did make visible to the public works of art that would otherwise have remained inaccessible. This indeed was the reason given by the administrators for their decision (first conceived three years earlier) to put on view from 15 August 1797 more than four hundred drawings and pastels (as well as a selection of portraits on enamel and marble busts) in the Galerie d'Apollon.[1]

The overwhelming majority had been selected from the eleven thousand Italian, Flemish and French drawings in the late king's collection, but some of those that had been seized in Italy and elsewhere were also included. They were framed and shown under glass, and 'pour la satisfaction de l'oeil' they were – regrettably, as was explained, but of necessity – arranged symmetrically rather than by national school and chronology.[2] High on the four walls of the gallery, just below Le Brun's richly decorated vault, hung sets of large cartoons by Giulio Romano, Pellegrino Tibaldi,

Domenichino and Mignard (copies of the frescoes Annibale Carracci in the Palazzo Farnese in Rome). The tall, thin ones were fitted into the bays between the twelve windows on the east side, from which light flooded on to those hung on the long wall facing them.[3] Below were two tiers of smaller drawings. Responsibility for this arrangement and, probably, for the choice of drawings had been assumed by the architect Léon Dufourny, administrative head of the museum, and his chief assistant. Dufourny, himself a collector, had collaborated with Seroux d'Agincourt in Rome on his great volumes devoted to the decline of art in late antiquity and its revival in the Renaissance, and he was thoroughly familiar with the arts and antiquities of Italy. He was a moderate Jacobin and, unlike Seroux, he played an active part in politics. However, like Seroux, he believed in the pedagogic value of the arts – a belief that must have been strengthened by the welcome sight of common people flocking to the exhibition, although, as one critic noted, it would have been a good idea to discourage them from coming in their clogs and working clothes, thereby raising clouds of noxious dust.[4] The catalogue he issued contained the names of the artists, the subjects represented, the techniques used and occasional references to provenance. Although incomplete, and unpublished, inventories of the royal collection could be drawn upon, it was acknowledged that the catalogue had been prepared in great haste and was bound to contain many errors, which, it was hoped, would be pointed out by members of the public so that they could be rectified in future editions and set an example for subsequent exhibitions of the kind. As pride of place had been given to the major Italian masters of the sixteenth and seventeenth centuries, followed by the French (dominated by Poussin and Le Brun) and the 'Flemish' (a denomination that included the German and Dutch schools), it is hardly surprising that the attributions were – by today's standards – on the optimistic side (none of the four Michelangelos exhibited is now universally accepted as being an original work by him, and only two of the twelve exhibited works by Rubens are). Nevertheless, in view of the nature of the exhibition (the first of its kind ever held) and its scope (ranging from a putative Masaccio to Bouchardon), the very existence of such a catalogue represented a remarkable achievement, which was, however, to be surpassed by those compiled over the following years – however morally questionable the occasions that gave rise to them.

Between May 1796 and early 1799 Bonaparte had, at first on his own initiative and later with the backing of the Directoire, used force, thinly disguised under a cloak of legality, to seize many of the most famous works of art from many of the most famous cities in Italy. A first convoy of the pictures removed from Parma, Piacenza, Milan, Cremona, Modena, Cento and Bologna[5] reached Paris in November 1796,[6] at a time when the Louvre was in a state of confusion due to the closure, a few months earlier, of the Grande Galerie for structural repairs.[7] This had obliged the administration to install a selection of its paintings in the Salon Carré during what was hoped, with rash optimism, to be a limited period while the repair work was completed.[8] Already, some two years earlier, shortage of space and the need to avoid disrupting existing arrangements had led to the Salon Carré's being used to accommodate briefly four paintings by Rubens which had been impounded from Antwerp – to the apparent dismay of the living artists who were exhibiting their works in that room,[9] just as they were doing again in October 1796 when news of the imminent arrival of the pictures from Italy reached Paris.[10] It may have been partly for this reason that this new booty was kept in storage (where it was joined, in July 1797, by a second consignment of works of art, most of them carried off from the same Italian cities as the first[11]), while, we are told, the museum's administrators

> busied themselves without interruption with the task of putting these masterpieces in a fit enough state to be shown; more than a hundred stretchers, most of them very large, have been constructed as supports for the pictures on canvas, fifty of which have been provided with magnificent gilt frames . . . those paintings which were in no condition to be seen because of the effects of smoke, dirt and old varnish [*huiles*] have been relined and cleaned.

Meanwhile, there were complaints in the press about those 'barbarians' among the curators who wanted to keep the paintings hidden, just as their predecessors under Louis XIV had concealed the royal collection in his day, and suggestions were made that they should at least be exhibited somewhere as a temporary arrangement until the Grande Galerie was ready to receive them.[12] Eventually, on 6 February 1798, after what proved to be a highly controversial process of conservation,[13] a selection of some eighty-six was displayed in the Salon Carré and remained on view until

18 June.[14] To these were added a further fifty-six Italian pictures which had been removed (in an operation that seems to have caused more trouble than the seizures effected in Italy) from the former royal collection at Versailles.[15]

The door opening on to the Salon was adorned with a trophy constructed from the arms and banners of the enemy which surrounded an inscription, 'A l'armée d'Italie' – words that brought tears to the eyes of a number of visitors.[16] In this respect the exhibition of 1798 conformed to the spirit of many earlier ones (such as those held in seventeenth-century Rome) which aimed to glorify art collectors more than the art that they collected. Such sentiments were, doubtless, not far from the ambitions of many of those involved, but they should not distract us from acknowledging that what these men actually achieved constituted, rather, a triumph of pioneering, high-minded and imaginative scholarship, even though it was sometimes of a kind that is not easy for us to reconstruct.

Although the organisers emphasised that much of the value of the exhibition sprang from the fact that famous masters could be represented by significant numbers of their pictures hanging together instead of being widely dispersed, and that this would enable useful comparisons to be made, precise evidence concerning the installation is inconclusive.[17] We do know, however, that juxtapositions were specially designed to throw light on stylistic contrasts, and that, because there was not enough room for all the pictures to be seen to best advantage at any one time, it was planned to alter the arrangements during the course of the exhibition. Fully as interesting as the much-discussed question as to how decisions were reached concerning which pictures were to be removed from Italy in the first place is the much more problematic issue as to who were the experts responsible for making a selection from them to be displayed in the Salon – and by what principles were they guided. Naturally enough, in view of prevailing taste and (still more) of the locations of Bonaparte's first victorious campaigns, pride of place was given to the Bolognese school, which contributed more than half the pictures on view, and although, as will become apparent, some spectacular pictures by other masters were also included, it was the unrivalled assemblage of Bolognese paintings that gave real coherence, as well as distinction, to the exhibition. In some cases where the artists belonging to this school were already very well represented in

France – as were Annibale Carracci, Albani and Domenichino – the authorities drew almost exclusively on the pictures by them that had recently been brought to Paris from Versailles.[18] On the other hand, Guido Reni's four great Feats of Hercules from the French royal collection were not included in the exhibition – just possibly because of their size. It was Guercino who dominated the Salon, and every single one of the twenty pictures by him to be seen in it had been acquired in Italy (in his birthplace of Cento as well as in Bologna and Modena) by the French experts accompanying Bonaparte's army. Although much attention was paid throughout the exhibition to the lessons that could be learnt from the pictures selected for it, in the case of no other artist was its didactic purpose stressed so emphatically.[19] In a brief summary of Guercino's career the catalogue noted that the pictures comprised 'much of the best of his output between the age of 22 and 72 – that is to say throughout his career as a painter. The pictures will be described in chronological order so as to give connoisseurs the opportunity to follow the progress, the vigour and the decadence of this accomplished master.' It has to be acknowledged, however, that such educational aims fell short of making any explicit criticism of pictures chosen by the commissioners: although the notes on individual pictures point to a number that are striking for their vigour, in no case is there any reference to decadence, though perhaps this is to be inferred from the discreet silence that is maintained about the last works.

The exhibition must have presented an astonishing spectacle. Barely four years after the official policy of the French state had been to prohibit the creation of devotional art and limit access to it, confining any pictures in the national collections that might excite religious 'fanaticism' to some room that would be accessible only to artists,[20] the general public was being invited to admire an accumulation of masterpieces of which some ninety per cent had been painted for religious institutions. Catholicism had not yet been officially restored, the Paris churches were still bare, but the catalogue could write of an *Annunciation of the Virgin* by Albani that it made one feel 'la grandeur du Mystère', and on the walls of the Salon hung huge altarpieces by Domenichino (the *Virgin of the Rosary*), Guercino (*La Vestizione di San Guglielmo*), Guido Reni (*La Pietà dei Mendicanti*) and many, many more of comparable fame and splendour. Not everyone was pleased with this state of affairs. The art-dealer and connoisseur Jean-Baptiste-

Pierre Lebrun, whose flag-waving sycophancy is conspicuous even by the standards of the time, regretted that these great artists had been compelled to paint such idiotic and shocking themes as 'sujets de dévotion', but emphasised that they deserved sympathy rather than blame for this.[21] Another great admirer of the Bolognese also deplored their 'insipid and disgusting' subjects, but felt that such pictures were useful for an understanding of 'the character of the nation in which these artists had worked'.[22] Yet, despite such objections and the fact that the Bolognese masters of the seventeenth century had already been subject to some disparagement, no one seems to have expressed anything but enthusiasm for their achievements and the inspiration they could offer to even the best contemporary French artists.

The advantages of the Salon Carré also met with general approval. Wilhelm von Humboldt wrote to Goethe that: 'this room is outstandingly beautiful and gets the light from above, thus it is a heavenly illumination; one will never again see these paintings in such a good light in the gallery [i.e., the Grande Galerie],' and he regretted the fact that the Salon was 'actually intended for the exhibition of the works of living artists, and in a few weeks the paintings hanging there now will be taken down and the living artists' work put up'.[23] Very occasionally there are some cautious and oblique reservations about the installation: 'The productions of the different schools have been mixed together', wrote one critic, 'and no attention has been paid to the dates of the pictures'. Although it would have been a waste of effort to pay much attention to this, as the exhibition was only a temporary one, none the less 'the true lover of art likes to sort out this chaos; he walks into the room bringing order into the schools and pictures'.[24]

The exhibition did, indeed, contain a certain number of pictures of even greater fame than the Bolognese. By far the most celebrated were Correggio's *Madonna of St Jerome* (*Il Giorno*) from Parma and Raphael's *St Cecilia* (from Bologna) which arrived in the second convoy of pictures from Lombardy. Well before the seizure of the Correggio, which was exhibited alongside three other major works by him, also removed from Parma (the *Madonna della Scodella*, the *Descent from the Cross* and the *Martyrdom of Four Saints*), Bonaparte had commented on its suitability for the museum,[25] and in the catalogue it was described as 'l'un des chefs d'oeuvres de la Peinture moderne'. The Raphael had also been awarded the unusual distinction of having been singled

out by Bonaparte,[26] who was hardly renowned for his interest in art, and the museum authorities claimed that it was among 'the first pictures in the Universe'.[27] Yet the only issue raised by the *St Cecilia* was the extent of the damage that it was believed to have suffered as a result of its preliminary restoration.[28] It was not until some years later when these masterpieces were installed – for ever, it was assumed – in the Grande Galerie that they attracted considerable attention from writers and artists alike. Today it would probably be thought that the most conspicuous single picture in the entire exhibition was the *Mona Lisa*, which now for the first time became accessible to a wide public, although the description of it by Vasari (who himself had never seen it) had always ensured its fame. Yet nothing suggests that it made any special impression or that the cult of Leonardo (to whom other works in the exhibition were attributed) originated in 1798. Lebrun never even mentions the artist in his discussion of the pictures to be seen in the Salon Carré, while Duval comments, rather oddly, that the two or three Leonardos there were not only in bad condition but were no more than 'jeux de son génie' when compared to his great frescoes. On the other hand, he regrets that the political situation had not made it possible to get hold of other Florentine pictures, because, having been painted in a free republic, they were characterised by 'grandeur, force and pride'.

Most of the pictures that had been exhibited in the Salon Carré were returned to Italy in 1815 (where they were sometimes welcomed back to their cities of origin with special exhibitions that echoed those with which they had been greeted in Paris),[29] but the catalogue remains to remind us of the very high level of connoisseurship that had been reached in eighteenth-century France. Its cheapness is almost as notable as the quality of its contents, for it was aimed as much at 'the less fortunate class' as at connoisseurs throughout Europe.[30] But although we do not therefore find in it any of the elegance that had characterised many sale catalogues during the *ancien régime*, let alone certain luxuriously illustrated publications devoted to princely collections, the scholarship is of real distinction. For the pictures from Versailles the compilers could rely on Lépicié's catalogue of the royal collection dating from 1752, although (as they pointed out) they corrected its mistakes. No serious reference book, however, existed for the pictures seized in Italy, and information about these had to be sought in original sources, such as Vasari, Malvasia and Baldinucci, and in

Luigi Lanzi's history of Italian painting (the first work of its kind) which had been published as recently as 1795–6. And, of course, much could be done only by very careful observation of the paintings themselves. Measurements were given for each picture, as was the nature of its support – canvas, panel, copper and so on – and any inscription to be detected on it. The church or gallery from which it had been removed was listed in every case and, where possible, details were supplied about the original commission and subsequent history. Each entry was introduced by a few lines giving the artist's date and place of birth, followed by a brief summary of his career (with special attention being given to his teachers). The descriptions of the pictures are remarkably complete, and serious attempts are made to elucidate difficult iconographical problems. Mention is sometimes made of preliminary drawings and of related versions as well as of reproductive prints. In their preface the compilers implied that they had not had enough time to carry out their task as thoroughly as they would have wished – but modern readers are more likely to be impressed by the comprehensiveness of what they were able to accomplish.

There is strong evidence to suggest that the original stimulus for this comprehensiveness had been provided by Bernard-Jacques Foubert, who held a number of leading posts in the administration of the museum between 1795 and 1802 and who was very closely involved in the production and sale of the catalogues. From the first he stressed that his aim was to include in them information that would 'as far as possible get rid of the dryness that is usually found in catalogues',[31] and he also insisted that the provenances of pictures seized in Italy should always be supplied.[32]

The catalogues produced for the two subsequent exhibitions, held later in the same year and in 1800, devoted to pictures removed from Italy as a result of Bonaparte's campaigns – principally from Rome, Venice, Florence and Turin – followed the same pattern as the one that has already been discussed, though they naturally included discussions of even more spectacular masterpieces, such as Raphael's *Transfiguration* and an amazing group of paintings by Veronese.

In view of the quality and fame of most of the pictures seized from Italy and taken to Paris it is not surprising that both critics and the general public tended to greet these and later exhibitions with indiscriminate enthusiasm.[33] Such enthusiasm, combined

with praise for the museum's restorers for bringing back to life masterpieces that had long been neglected by the Italians themselves and with anticipation of the benefits that French painters would derive from such nourishing fare, tends to become repetitive and monotonous, for it is unusual to find it accompanied by insights of much perception. Only very occasionally were specific issues of attribution or authenticity raised by commentators. The exhibition of 1800, however, did give rise to a vigorous controversy. Was the *Descent from the Cross*, which had been taken to the Louvre from Villeneuve-sur-Yonne, the work of a pupil of Andrea del Sarto called Andrea Sguazzella, as the catalogue suggested,[34] or by Raphael, which was the conclusion to be drawn from an engraving of the picture published by Johann-Kaspar Lavater?[35] One learned connoisseur wrote to say that Sguazzella was not nearly as unknown as had been insinuated and mentioned a number of works by him. More to the point Lebrun (whose protestations of distaste for religious art have been noted) demonstrated his superior connoisseurship by observing that it could be only a Flemish copy by some contemporary of Otto van Veen of a drawing or an engraving after Raphael. The Christ was badly drawn; the picture owed nothing to either the Florentine or the Roman school; and it was in any case quite unworthy of the museum. Lebrun was equally scathing about a number of the other pictures on view. All the so-called 'Velvet Brueghels' had been wrongly attributed. The 'Holbeins' and the 'Dou' were only copies – and so on. The author of the polemical pamphlet in which these opinions were asserted[36] expressed surprise that the museum's curators should make such extraordinary errors. What would one think of a guide telling a visitor to the Jardin des plantes that a palm tree was a lily or a humming bird a heron? And he ended by asking Lebrun why he, who was obviously so well qualified, had not been entrusted with producing the catalogue: 'Lebrun ne répondit pas à ma question'.

In fact, personal jealousies were at stake, and an overwhelming need to humiliate his rivals got the better of Lebrun's usual patriotic fervour. But this case was exceptional. Thereafter the catalogues, which continued to be issued in order to remain abreast of the movements of pictures kept in storage and put on view from time to time in the Salon Carré, as well as of others transferred to the Grande Galerie as space became available, failed to arouse controversy. It was, in any case, not until 1806 that the emperor's

victories in Germany led to the acquisition, by what was by now the Musée Napoléon, of another enormous haul of works of art. On 14 October 1807 – the first anniversary of the battle of Jena – Dominique-Vivant Denon (who, five years earlier, had been appointed Directeur Général des Musées) inaugurated an exhibition to celebrate the triumph – an exhibition larger than any that had yet been seen. To judge from the catalogue, which listed 368 pictures and more than 280 sculptures, antique and modern, every inch of available space must have been filled; but details of the arrangement, and of the new placing of those pictures already hanging in the Grande Galerie, have not come down to us. For the historian of taste, and of the growth of the museum, the event is of capital importance, though it seems unlikely that contemporaries would have been struck – as we are today – by the confiscation of a Memling from Danzig (then considered to be by Van Eyck) and of a dozen pictures attributed to Cranach; and, apart from a marvellous group of Rembrandts from Cassel, there was little to compare in importance with the works earlier removed from Italy and The Netherlands. For the historian of exhibitions – or, at least, that part of exhibitions that alone survives their dismantling – there is little to record. The standard of the catalogue of paintings is far lower than that to be found in those published nearly ten years earlier. Denon (who was nominally responsible for it) went out of his way to explain that entries had been kept as brief as possible so as not to make it too unwieldy – but in the view of contemporary connoisseurs such a policy would surely not have justified the elimination of any reference to measurements, support or provenance. Moreover, despite his claim, a significant number of the pictures are described, at great length but with very trivial comments.[37]

It is therefore with much relief that one turns to Denon's last (much smaller) exhibition in 1814, which not only marked a wholly new departure but also proved to be the last significant Old Master exhibition held in France for half a century.

In September 1810 Napoleon ordered the suppression of all the monasteries and convents in three of the Italian provinces of the French Empire; less than a year later Denon set out for Italy to investigate (among other things) what would be the artistic consequences of this decision. He had long been attracted by the possibility of adding to the masterpieces in the Musée Napoléon a selection of works by 'painters of the Florentine school, the

earliest to restore the arts in Europe'. Now he was being offered
a perfect opportunity to fill this gap in the national collection
without running into diplomatic problems or incurring any serious
expense. The notion was not in itself as original as has sometimes
been claimed. As early as the 1760s steps had been taken in
Florence to recover for the grand ducal collection a number of
fourteenth- and fifteenth-century pictures that had been widely
dispersed and to bring them together in the 'Fourth Cabinet' of
the Uffizi. It soon became possible to scrutinise (rather than
admire) such interesting precursors of the High Renaissance as
Fra Angelico, Uccello, Filippo Lippi and Botticelli. The value of
the experience was emphasised in 1782 by Luigi Lanzi, who had
been responsible for the arrangement and who was to become
famous as the historian of Italian art, much relied on by the French
when choosing pictures for the Musée Napoléon. Moreover, by
the first decade of the nineteenth century a handful of Italian,
German and French *amateurs* were beginning to form private
collections devoted to the 'primitives'.[38]

Denon's travels lasted for about five months and took him to
many Italian cities, including some that did not come under the
direct jurisdiction of the emperor. He claimed to have 'scrupu-
lously examined' more than four thousand pictures – and it is this
combination of adventure, industry and scholarship that distin-
guishes him from other innovators in the field. Of these he judged
that sixty, all by masters entirely unknown in France, would be
suitable for the museum. The government accepted his proposals,
and it was hoped that the paintings that he had chosen – as well
as a number of others – would arrive within a few months. As
early as 1811 Denon had decided that, when they reached Paris,

> I will put them alongside several fine pictures of the German
> and Flemish school of the fourteenth and fifteenth centuries
> which are already in the museum, and I have no doubt that
> an exhibition of them in some special room will be of great
> interest to artists by indicating to them the point from which
> painting was able to advance so as to produce marvels and the
> golden age [l'époque de la splendeur] of the arts in Italy.

Denon's plans for the exhibition were, however, thwarted by a
series of unexpected difficulties and delays, and the last of the pic-
tures that he had chosen (and some that he had not) were to reach
Paris only in February 1814 – not long before the Allied troops.

When, on 25 July, they were eventually put on display in the Salon Carré of what was now the Musée Royal, the first demands had already come from Italy for their return.[39] These could be brushed aside easily enough, but problems of this kind kept Denon busy, and the manner in which the pictures were laid out hardly corresponded to what he had long had in mind. As the restorers had not yet finished their job, a number of the pictures recorded in the catalogue of a hundred and twenty-three items could be handed over to the Salon only when the exhibition was already under way.

It is true that Denon was able to fulfil his aspiration of displaying Italian and northern 'primitives' in the same room, but he seems to have been unwilling to disrupt the installation of the Grande Galerie by removing from it any of the celebrated pictures by Van Eyck and Memling that had been hanging there for some years. In general, the representation of Netherlandish and German pictures in the Salon Carré must have looked no more than perfunctory – the more so as they were to be seen in the company of Giotto and other Italians whose names (though not their achievements) were well known to most connoisseurs as precursors of all those masters whom they most admired. But even these masters had to face competition from a number of others whose inclusion in the exhibition does not seem to have been anticipated. There was, for instance, a medley of seventeenth-century works, among which almost the only ones to convey some element of coherence had been painted by Strozzi, Valerio Castelli, Vassallo and a few other Genoese painters, whose colour and dazzling virtuosity may well have had a more natural appeal for art-lovers brought up on the stylistic sophistication of the *ancien régime* than the archaic rigidity of the early Florentines. Although these works came from suppressed churches and convents in Liguria it is not clear whether Denon had chosen them himself or whether they had been substituted by local officials after his departure.

Far more impressive were some of the seventeen pictures by Spanish artists which had been selected from nearly three hundred, of the most varied quality, stored in the Louvre.[40] Some of these had been noted by Denon himself on a visit to Spain many years earlier; some had been confiscated from their owners for political reasons; some had been looted by the emperor's officers and then been sold or offered to the museum; and fifty had been sent reluctantly as a 'gift' by Napoleon's brother Joseph who since 1808

had been king of Spain. Although a few dealers and adventurous travellers had begun to appreciate Spanish painting even before the French invasion and the unbridled looting that accompanied it, most of the artists represented in the Salon Carré were even less known to the Parisian public than were the early Florentines in whose company they so strangely found themselves. Moreover, the display of these few Spanish pictures can more properly be called an 'exhibition' than can any of the others that had been organised in the Salon Carré during the previous two decades, because even before it opened the newly restored Louis XVIII had apparently agreed, in private, that pictures seized from Spanish grandees should be restored to their original owners.[41] Thus Denon must have known from the first that they would be accessible for only a short period rather than finding a permanent home in the Grande Galerie.

Although there were no pictures by Velázquez, at least six great masterpieces of Spanish art were to be seen – and all of them were back in Spain within a year. Zurbáran was represented by his largest (4.73 × 3.75 m) and most ambitious altarpiece, the *Apotheosis of St Thomas Aquinas* from the church dedicated to that saint in Seville; Ribera, by his wonderfully dignified (if somewhat sinister) *Bearded Woman*; and Antonio Pereda, by his haunting *Dream of the Knight* – one of the fifty pictures selected by Goya and two colleagues for inclusion in King Joseph's gift to his brother. The other three were among the most moving of all the works of Murillo who, alone in this company, was already well known in France, and it was doubtless for this reason that they had been looted from Seville by the most notorious looter of the time, Marshal Soult, and subsequently presented by him to the museum: the *Dream of a Patrician* and the *Patrician telling his Dream to the Pope* – paintings that commemorated the founding of the church of S. Maria Maggiore in Rome – and *St Elizabeth of Hungary nursing the Sick*.[42]

It is not surprising that it was the *Dream of a Patrician* by Murillo, rather than any of the Italian 'primitives', that, in the eyes of at least one English visitor (and probably many more), eclipsed all the other pictures in the room.[43] Yet even he acknowledged that 'first in time and first in interest' was Cimabue's *Madonna and Child enthroned*, in which – despite the ill-drawn figures with their grotesquely hard features and the lamentably unsuccessful perspective – there was 'something which approaches to an air of

grandeur, both in composition and colouring. The artist thought
well, but could not work out his idea. It is the commencement of
the reviving splendor of Italy.' Nearby was to be seen Giotto's
'excellent' *Stigmatisation of St Francis* which – despite 'the absur-
dity' of the story and the 'inimitably ludicrous' attitude of St
Francis – demonstrated the progress of art in its early days.[44]
Indeed, the placing of these two pictures (both acquired from a
chapel in the Campo Santo in Pisa where they had been stored
after their removal from suppressed churches[45]) offered the most
conspicuous example of the didactic principles that lay behind the
exhibition – not least because, in general, the varying sizes of the
pictures made it impossible to hang them in strictly chronological
order.[46] Yet, despite the emphasis in the preface of his catalogue
on the overriding importance of progress, there are hints that
Denon was prepared to broaden the range of his taste beyond a
conventional admiration only for 'an art that is agreeable'. This
is certainly suggested by the superb quality of many of his acqui-
sitions, such as Fra Angelico's *Coronation of the Virgin* and
Filippo Lippi's 'Barbadori altarpiece', though it must be admitted
that he almost never makes a value judgment on individual pic-
tures but relies instead on the authority of Vasari – or, sometimes,
of Vasari's critics.

The catalogue entries were, in fact, written by Morel d'Arleux,
who had been appointed curator of drawings at the museum in
1797, two months before Dufourny's exhibition, in the planning
of which he does not seem to have had time to play a significant
role.[47] They frequently urge visitors to compare a master's works
with those of his pupils when these are to be seen either in the
Salon Carré itself or in the permanent collection in the Grande
Galerie, although no attempt is made to point out what is the
nature of the differences between them. As was habitual by now,
each picture is described in some detail, and the opinions of earlier
writers are often recorded – and sometimes challenged if they are
rendered untenable by incorrect dating: a list of birth dates is
provided in the preface. Much space is given to iconography, and
provenances are usually (but by no means always) given. Rather
surprisingly, although the nature of the support is indicated in
each case (panel for the early ones and canvas for most of those
of a later period) and inscriptions are invariably recorded, never
once does Morel d'Arleux supply measurements, as had generally
been done by his predecessors. Despite the exaggerated claims that

have been made for this catalogue,[48] it does not mark any advance on those supplied for the first exhibitions held nearly twenty years before – except in one (admittedly extremely important) respect. Paintings which were almost entirely unknown were treated with the same careful scholarship that had previously been confined to those that were already deeply admired and very famous.

It is doubtful whether (in the short term) Denon succeeded in his aim of drawing much attention to the historical significance of these unknown works. At the time that he was bringing them together the Grande Galerie was filled with some of the greatest paintings by Raphael, Correggio, Guido Reni and other painters whose names were familiar throughout the civilised world. It is hardly surprising that it was these, rather than the 'primitives', however well catalogued, that dazzled the Parisians and foreigners alike who flocked to the museum. And yet, for us today, the scholarship that was stimulated by the Old Master exhibitions inaugurated in Paris under the Directoire and continued during the Napoleonic régime remains their most impressive feature, partly because it raises none of the moral issues that trouble us when we contemplate the exhibitions themselves. These were, without doubt, the most splendid that had yet been seen anywhere, and because getting hold of many of the most famous masterpieces in Europe did not present the same problems as it has done to even the most ambitious and unscrupulous organisers of our own day, they have in some respects never been surpassed.

An extraordinary by-product of the Peace of Amiens of 1802 was the illustrated souvenir launched by Maria Cosway and Julius Griffiths which began publication in June of that year and expired soon afterwards. The plates purported to reproduce the hang within the Louvre, thus enabling the purchaser to 'form a museum within his own Apartments on the plan of the Louvre', and the text was in English and French.[49] The earliest plates by Maria Cosway, such as Plate 1, dominated by Guido Reni's large altarpiece of the dead Christ with the patron saints of Bologna from the Church of the Mendicanti in that city, probably do provide a reliable record (pl. 9). There are many convincing deviations from the strict symmetry: Raphael's *St Michael* is not as tall as Titian's *Flagellation* and the two central Titian portraits are not the same size. The later plates by François-Louis Couché are different: Raphael's *Coronation of the Virgin* is made the same size as the

Belle Jardinière which is in reality less than half as large. But the plates do evoke the incomparable 'assemblage' in which early works by Raphael could be compared with altarpieces by Perugino and with the artist's own mature masterpieces. In reality there were always practical constraints: the large paintings, such as the Guido Reni mentioned above, had to hang with much earlier works, but the display achieved what would later be the great excuse for major loan exhibitions – a renewal of enthusiasm for and a deeper understanding of the great art of the past by rational rearrangement and special concentration.

It had always been intended that the pictures seized as one of the consequences of a series of French victories would remain permanently in the museum. Had the Grande Galerie not been inaccessible for long periods because of the need for major reconstruction, it seems almost certain that they would have been installed there immediately instead of being transferred to it only as space became available. And had it not been felt advisable to draw attention, as ostentatiously as possible, to that series of military triumphs (at a time when they were by no means as assured as later seemed to be the case) they might well have remained in storage until the necessary repairs had been completed. As it turned out, it was the very drawback of the (ideally situated) Salon Carré – the fact that it had to be vacated for several weeks each year to enable living artists to continue their long-established practice of using it to show their new work to the public – that gave changing consignments of freshly arrived booty an indelible association with the temporary and, hence, with the notion of the exhibition rather than the museum. And it is not entirely by chance that, at almost the precise moment that these displays came to an end in Paris following the battle of Waterloo, the Old Master exhibition should have been born in London. Nor is it a coincidence that the movement that made that possible can be traced back to the impact made by Napoleon's Louvre on the British visitors to Paris during the peace of 1802.

Chapter 3

The First Exhibitions of the British Institution

The Old Masters that were borrowed from the Roman nobility for a day or two each year throughout much of the seventeenth century and hastily installed in the cloisters of various churches, or that, at very irregular intervals, were put on view in London and Paris during the last decades of the eighteenth century to celebrate not the martyrdom of a saint but the shrewdness of an art dealer or the victories of a military commander, established an important precedent for Old Master exhibitions as we know them today – but they did not constitute Old Master exhibitions in themselves. Some were designed to dazzle or entice the public, and others to serve as *ad hoc* expedients, lacking any thematic coherence, to mark particular occasions or to meet particular needs; even the display of 'primitives' that Denon organised in the Salon Carré to make a didactic point was thrown into confusion by the presence among them of seventeenth-century paintings from Genoa, Spain and elsewhere. It was, paradoxically, the adjoining Grande Galerie, intended by the French to constitute the core of a *permanent* museum of confiscated masterpieces that was to inspire the inauguration by the English, who dismantled it, of those *temporary* exhibitions of borrowed Old Masters that continue to flourish throughout the world with ever-increasing vitality.

Visitors to Paris from London during the short-lived Peace of Amiens of 1802, when the enrichment of the Louvre was in its early stages, and then in 1814, when it had reached its climax, were much impressed by the opportunities it offered to artists and

art lovers who wished to study many of Europe's greatest masterpieces. They were also very conscious of the absence of such opportunities at home[1] – despite the presence in England of so many superb pictures acquired by private collectors at the Orléans sales and from those princely families in Rome who had been driven by punitive taxation to sell their treasures to dealers who descended on the city like vultures. Steps were soon taken to render accessible these glorious but hidden surprises. As early as February 1804 the very rich collector Thomas Hope, who had recently returned from Paris, opened his new house in Duchess Street to the public and was much praised for his initiative, though he offended the always touchy members of the Royal Academy by sending them unsolicited admission tickets instead of personal invitations.[2] His example was followed in May 1806 by the marquis of Stafford, whose incomparable pictures in Cleveland House included many that had been the special pride of the Orléans collection, such as Titian's *Diana and Actaeon* and *Diana and Callisto*, a group of famous Raphaels and Poussin's *Seven Sacraments*.[3] Two or three years later Lord Grosvenor, owner of another superb gallery,[4] began to admit the public, as did other collectors during the following decade.

However, despite such welcome gestures, the possibilities for relaxed and careful study were limited. Admission tended to be restricted to those 'known to some members of the family, or otherwise [able to] produce a recommendation from some distinguished person, either of noble family or of known taste in the arts'. And although 'artists desirous of tickets for the season, will obtain them on the recommendation of any member of the Royal Academy', it seems that permission to make copies was not granted.[5] Nor can the requests for gratuities made by the servants have made viewing easier.

A decisive step to improve matters in this respect and others was taken in 1805 with the formation of the British Institution for Promoting the Fine Arts in the United Kingdom and its acquisition of a long-term lease on premises in Pall Mall, consisting of three large rooms which it proceeded to furnish handsomely and to decorate with controversial wallpaper of the most vivid scarlet.[6] The policies of the new body were determined by a committee of directors chosen from among the subscribers; and subscribers who contributed £50 or more a year were given the title of 'Governor' which carried with it certain privileges. Although the

directors of the British Institution (often known as the British Gallery) went out of their way to challenge the notion that it aimed to be a rival to the Royal Academy – and although a significant number of academicians were keen to take advantage of the greater opportunities (and special prizes) that it offered for the display and selling of pictures – in fact, the breaking by the new body of the effective monopoly hitherto exerted by the Academy inflicted a damaging blow to that faction-ridden organisation. The declared aims of the two establishments were similar in essentials, but the British Institution introduced two important novelties. In the first place, it was administered not by artists but by a small circle of collectors and connoisseurs, many of them members of the aristocracy; and, secondly, after the conclusion of each exhibition of contemporary painters – the first of which took place between February and July 1806 – the galleries were to be closed to the public and a selection of Old Masters was to be borrowed by the directors of the Institution for the express purpose of being studied and 'imitated' by amateur and student artists[7] – though only under the most stringent conditions, in order to avoid the risk of forgery or of upsetting any collectors who might share the feelings expressed by Mrs Piozzi a few years later that it 'would break *her* heart and ruin the value of the pictures to posterity' if those that she had agreed to lend were to be copied.[8] For reasons such as these, only certain parts of a picture could be reproduced,[9] and the directors came to the conclusion that 'the objects of the Institution may be generally obtained by Studies and Sketches, and by the Endeavour at providing companions to the pictures lent'.[10] Even when special permission had been obtained from the owner to depict the entire painting, the size of the copy had to be much reduced from the original,[11] despite the fact that, as was pointed out in the press, such precautions were hardly necessary in the case of Raphael's cartoons,[12] which the Prince Regent agreed to lend some years later.

The choice of pictures made for these embryonic Old Master exhibitions – to which access by the public was severely restricted[13] – appears at first to have been far more casual than might have considered desirable, in view of the emphasis laid on their importance as exemplars for young British artists. In 1806, for instance, the year in which the exhibitions were inaugurated, no more than three directors attended the meeting at which the issue was discussed, and they drew up a list of sixteen 'Noblemen

and Gentlemen' who were to be approached by the Secretary for loans.[14] Only one picture was to be specifically requested (Van Dyck's portrait of Lord Arundel belonging to Lord Stafford[15]), although in a number of other cases where an artist's name was given the selectors must have known from personal contacts which particular work they were hoping to borrow. However, half the potential benefactors were merely asked to lend one, two or (in the case of John Julius Angerstein) four pictures to be chosen by themselves. The resulting exhibition of twenty-three items included only four by Italian artists, of which one at least must have been wrongly attributed,[16] while the others – an unidentified landscape with figures by Annibale Carracci, *Rest on the Flight into Egypt* by Mola and *Jason and the Dragon* by Salvator Rosa[17] – can have been of only limited educational value for young artists. The Dutch and Flemish pictures were mostly of much greater importance and quality, but they hardly conformed to current notions about the foundations needed for the creation of a native school of history painting.

In subsequent years greater discrimination was shown in the choice of pictures requested for the students' annual exhibitions. In 1807, for instance, the Selection Committee named each picture that it wished to display instead of entrusting such decisions to the collectors themselves: Lord Carlisle was asked (and agreed) to lend the *Three Marys* by Annibale Carracci (pl. 8) which had been the most highly valued item at the Orléans sale some ten years earlier (and which would be the most popular work at the *Art Treasures* exhibition held in Manchester in 1857), and Lord Kinnaird was asked to lend Titian's *Bacchus and Ariadne* which had just arrived from Italy. Neither was able to comply, but most requests were granted,[18] and in the following year the king agreed that he would, from time to time, be prepared to lend pictures from Kensington Palace and Hampton Court,[19] and within two or three years of its foundation the directors of the British Institution were able to report, with considerable satisfaction, that their policy of making 'sublime Works of Art' available to students had proved to be so beneficial that 'the prejudices against living and native merit are already done away'.[20] But this apparently idyllic collaboration between the old and the new was not to last.

In addition to 'the Exhibition and Sale of the productions of British artists', the 'Exhibition of Pictures by the Old Masters' had, from the first, been one of the declared aims of the British

Institution.[21] It is not clear, however, whether its founders had envisaged displays of Old Masters to the public of a far larger size than the small presentations they put on each year for the exclusive use of artists. It seems in any case probable that it was the association with the new body of so many 'Noblemen and Gentlemen' willing to lend some of their masterpieces to it that may have prompted them to embark on a much more ambitious undertaking than anything that they had yet had in mind. In the absence of state patronage they would themselves draw on their own private collections in order to create ephemeral museums capable of rivalling, for a few months each year, any of the permanent institutions to be seen in Europe – including, perhaps, even the Musée Napoléon itself. Yet one serious obstacle stood in their way: the hostility to the British Institution and its plans that had already begun to be expressed by the Royal Academy and some of the leading artists of the day.[22] This hostility would, it was well understood, be vastly exacerbated by enhanced attention being paid to the Old Masters, and there was a risk of damage to the very cause that constituted the *raison d'être* of the Institution: that of supporting modern British art. It seems probable that it was one of the founding directors of the British Institution, Sir George Beaumont, distinguished collector of Italian, French and Flemish Old Masters and (with rather less enthusiasm) of his English contemporaries, who proposed the ideal solution:[23] a large-scale inaugural exhibition in 1813, to open in late spring or summer (so as not to interfere with the Institution's usual plans for the display of modern art which always took place in winter) and to be devoted to the painter who, although he was no longer alive, remained 'top of his admiration both as a man and as an artist'[24] and who – more to the point – had been not only British and a national glory, but the president of the Royal Academy: Sir Joshua Reynolds.

The patriotic appeal of the suggestion proved irresistible to his fellow directors, but they clearly still felt some anxiety at the prospect of taking so revolutionary a step: never before, in any country, had it been proposed that the achievements of a past master should be celebrated in this way.[25] When he came to write the introduction to the catalogue Richard Payne Knight began by insisting that it was 'not for the purpose of opposing the merits of the dead to those of the living' that the exhibition had been conceived, and he did everything he could to assuage the bruised

feelings of the young painters of the day by paying extravagant homage to English art and by pointing out that the honour being rendered to Reynolds would demonstrate to a new generation how richly hard work and talent could be rewarded – a lesson, he stressed, that would not be lost on potential patrons.[26]

Plans for the exhibition were first discussed at a committee meeting of directors in February 1812,[27] well over a year before the opening date. The Reverend William Holwell Carr, a very rich absentee cleric – who found the climate of Cornwall, the location of his lucrative parish, 'very inimical to my health' – and one of the most notable collectors and shrewdest dealers of the day[28] (though without 'any affection for *new* art'[29] or with even the remotest interest in British painting[30]), submitted a list of eighty-four desirable loans. It was agreed that he and three of his fellow directors, among them Beaumont and Payne Knight, would approach the owners of the works that he had indicated,[31] and about half of the pictures suggested by him eventually found a place in the exhibition. Further lists were drawn up over the following months as the situation became clearer,[32] but although it was planned that all the pictures to be hung should be delivered by the third week in April,[33] requests for loans continued to be made until a few days before the official opening of 7 May so that the wall space proved to be inadequate and some pictures had to be returned to their owners. Further delays were caused by the need to ask lenders for special permission to arrange for their pictures to be varnished, when this seemed necessary to the organising committee, and, as a result, a number of works had to be stored until a revised version of the exhibition could be opened in the middle of June.[34]

Most requests were readily agreed to, but the Royal Academy (characteristically) refused to lend any works by the artist in its possession because it thought 'the plan of exhibiting a collection of pictures by Sir J. Reynolds at the British Institution during the Exhibition of the Royal Academy invidious towards the Artists of the present day'. After lengthy discussions Thomas Lawrence, who 'felt uneasy at the decision of the General Assembly' persuaded its members to relent, although J. M. W. Turner remained intransigently opposed.[35] Eventually 141 pictures were put on display, although 'some other very fine specimens' of his works could not be obtained 'for Distance or other Circumstances'.[36] Special lighting had been installed at considerable expense,[37] and at 5 o'clock

in the afternoon of Saturday 8 May 1813 the Prince Regent arrived, to be escorted by the marquis of Stafford round the Institution's three densely hung galleries. After nearly two hours the prince and his retinue walked under a protective awning to Willis's (formerly Almack's) assembly rooms nearby where, to the soft airs of the duke of Cumberland's band, he presided over a banquet – to the organisation of which a good deal of thought (ranging from issuing invitations to calculating the cost of champagne 'at 7 persons to a Bottle') had been devoted during the previous year.[38] It was attended by about 'two hundred of the highest characters in the country',[39] some at two guineas a ticket and some as guests of the Institution. Thirty of the guests were members of the Royal Academy and had the satisfaction of listening to a toast proposed in honour of that establishment and the speech in response made by their president, Benjamin West (Reynolds's successor): for the directors of the Institution were doing everything possible to be conciliatory (in the face of much continuing bitterness).[40] At 9.30 p.m. the Prince Regent returned to the galleries for a further visit and to meet a large number of celebrities, who had just arrived – Lord Byron among them – and many distinguished ladies (who had, of course, not been invited to the dinner). They included Mrs Siddons, who could look up at the portrait that Reynolds had painted of her as the Tragic Muse some thirty years earlier. The prince left at 11 o'clock, but many visitors were still admiring the pictures at midnight.[41]

Thus ended a day that was recognised at the time as having been unprecedented in its significance[42] and that (as can be seen with hindsight) had constituted an essential prelude to the first chapter in the history of the Old Master exhibition. It was, however, only a prelude, because we can hardly describe as a fully qualified Old Master an artist whose posthumous exhibition was being admired by so many of those who had been his friends, patrons and sitters, as well as by 'the majority of spectators [who] were but imperfectly acquainted with his works', but who were now given a unique opportunity to compare the features of those sitters with the representations of them by Reynolds, hanging on the walls above – a little younger, of course, and unblemished, as they had always been, by any signs of 'affectation', let alone 'deformity'.[43]

The overwhelming majority of the pictures that they were also to see belonged to the last two decades of Reynolds's life, but, as

is the case in nearly all subsequent exhibitions, the scanty evidence available does not allow us to decide whether choices of this kind were determined by taste or by fortuitous circumstances. What is remarkable is a feature that distinguishes this exhibition from nearly all those that followed it for almost a century: the mere fact that most of the pictures listed in the shilling catalogue were dated.

It had been possible to do this because nearly all Reynolds's pictures had been recorded in the catalogues of the Royal Academy exhibitions at which they had first appeared and because they still belonged to the families of the sitters for whom they had been made. Furthermore, the majority of his paintings had been engraved, which must have not only facilitated their selection, but diminished any confusion concerning their subject matter. The paintings were not, however, hung by the British Institution in chronological order.

The three exhibitions galleries, each twenty-three feet wide, were situated on the first floor and were reached by a staircase that led into the Middle Room of an intercommunicating suite.[44] As the visitor entered it and turned left in order to begin his tour in the North Room (which, at 41 feet, was a little longer than the other two), he would at once see two towering portraits dominating the wall ahead of him: George III, enthroned and in his coronation robes, and the great actress Mrs Siddons in the pose of Michelangelo's Prophet Isaiah on the ceiling of the Sistine Chapel. As a complete contrast the organisers had hung on the same narrow wall three much smaller pictures, each depicting a single adolescent boy or girl probably in a semi-pastoral setting,[45] the sentiment and humour of which greatly appealed to this period. The east and west walls – to the visitor's left and right – were closely hung with portraits, but facing each other across the middle of the room[46] were two most ambitious of Reynolds's rare 'historical paintings' available in this country: the *Death of Cardinal Beaufort* and *Count Ugolino and his Children* (lent by the earl of Egremont and the duke of Dorset respectively). Adjoining these – and accentuating the horizontal axis that would have contrasted with the verticals of the full-length portraits – were more conventional mythological and fancy pictures, such as the *Death of Dido*, *Venus and Cupid* and the *Fortune Teller*.

As was much discussed at the time, it is often impossible to make a clear distinction between Reynolds's portraiture and

his historical and allegorical paintings, but on moving back to the Middle and then to the South Room the visitor would have realised that none of the figure paintings confronting him conveyed the serious aspirations of the *Cardinal Beaufort* or the *Ugolino*. They tended to be playful or sentimental or erotic or sketches for grander works such as the stained-glass window in the chapel of New College in Oxford. And, in any case, they were greatly outnumbered by portraits.

Although no visual or full written records of the arrangement of the pictures on the walls appear to survive, it would be just possible to reconstruct the hanging in our minds with reasonable accuracy from the information provided in the catalogue and our knowledge of the measurements of the relevant works. Everything suggests that the paintings were hung in accordance with social protocol, combined with the need for symmetry and a generally pleasing effect.

However, despite the slight inconvenience of occasionally having to move from room to room, a connoisseur in 1813 would, perhaps for the first time in history, have had the chance of following the development of a painter's style with real care. Whether there were any connoisseurs interested in taking advantage of this opportunity is, however, very doubtful. Nor, in this case, did the issue of the authenticity of any of the pictures on view present a serious problem.

The main questions that concerned art lovers were very different. Would Reynolds's reputation suffer as a result of too many of his works being in bad condition;[47] what were the special qualities that marked his genius; and, above all, would his 'subject pictures', which constituted the supreme test of any artist's stature but which in this case had long given rise to some uneasiness, be able to stand comparison with his portraits, whose merits were universally acclaimed – even though (through no fault of his own) the costumes and headdresses of his sitters now looked ridiculous?[48] His most extreme admirers had no difficulty in answering this last question. The *Observer* claimed that the exhibition would 'for ever set [it] at rest' and that there could be no doubt about his 'attainment of excellence in the highest department of art'.[49] Robert Hunt, writing in the *Examiner*, also thought very highly of the history and fancy pictures, because he found that the characters depicted in them were so expressive, but he maintained that they, and even the portraits, had 'faults as conspicuous as

their merits. They have generally but little beauty of pencilling, are mostly coarse in their execution, and incorrect in their drawing ... The outlines are too much generalized, and are deficient in neatness and detail of marking, and his touches, or rather his splashes, are coarse and dauby.' None the less, 'his just and forcible conceptions of character, his Shakespearian knowledge of the human heart' and many other qualities meant that 'as long as time will spare his works ... he will rank among those who have delighted and dignified mankind'.[50] However, Charles Lamb, writing anonymously in the same newspaper, was much less enthusiastic: the great historical compositions 'have not left any very elevating impressions on my mind', and even the portraits were of interest only for their charm.[51] Benjamin Robert Haydon – on whom the first impression of the exhibition 'was certainly that of flimsiness' and who was left 'less satisfied' by a second visit – made a point in his diary that struck other visitors, to the effect that, 'if left to his imagination wholly, he could do nothing, and what is as extraordinary, his characters have a meaner look than his Portraits. His Portraits have the elevation of Poetry and his characters meanness of individuality. His Ugolino is a poor starved beggar – is that the leader, the Hero, the chief? his Beaufort a grinning low life wretch.' But 'in female beauty, how delightful are his Portraits, their artful simplicity, their unstudied grace, their chaste dignity, their retired sentiment command us, enchant us, subdue us, while his children! his inimitable, unimitated children, who can approach?' Haydon ended his first visit to the exhibition with the impression that 'Sir Joshua Reynolds was certainly an extraordinary man. The exhibition does great credit to the Directors of the British Gallery. It will have a visible effect on Art; it will raise the character of the English school; it will stop that bigotted, deluded, absurd, propensity for Leonardo da Vincis & Correggios'; but, after returning, he concluded that he 'felt a sort of contempt for a man who could pass forty years in painting cheeks, noses, & eyes, with no object but individual character, and no end but individual gratification'.[52]

It is to the pen of Hazlitt that we owe by far most balanced estimate of Reynolds's painting as revealed in the British Gallery. His two articles were published more than a year after the exhibition had closed,[53] and, although never more than lukewarm in tone and often positively cold, they are the only ones that convey the impression of a visitor who had looked with real care at the

pictures on display and then tried to draw conclusions from the experience – conclusions that, in essence, retain much of their validity, despite some excessive disparagement of the artist. Durable art criticism is rare at any time, and these articles are all the more impressive when we remember that they were inspired by an exhibition of a kind that had never been held before. Hazlitt dismissed the comparisons that had been made between Reynolds and Raphael, Titian, Rubens and Van Dyke, all of whose excellencies he was said to have imitated, but he acknowledged the importance of Correggio for some of his female heads and the nature of his children and, above all, of Rembrandt (who had, of course, been infinitely superior to him): 'strong masses of light and shade, harmony and clearness of tone, the production of effect by mastery, broad, and rapid execution were in general the forte of both these painters'. He overturned – surely too hastily? – the conventional verdict that Reynolds had been 'the first who introduced into this country more general principles of art, and who raised portrait to the dignity of history from the low drudgery of copying the peculiarities, meannesses, and details of individual nature, which was all that had been attempted by his immediate predecessors' and claimed that, on the contrary, 'the superiority of Reynolds consisted in his being varied and natural, instead of being artificial and uniform. The spirit, grace, or dignity which he added to his portraits, he borrowed from nature, and not from the ambiguous quackery of rules'. Reynolds's historical and fancy pictures tended to suffer from inadequate drawing and from affectation: 'His portraits are his best pictures, and of these, his portraits of children are the next in value.' Hazlitt particularly admired not the portraits of aristocrats and glamorous heroes, but those of serious and thoughtful figures such as Dr Johnson, Baretti, Dr Burney and Bishop Newton. Hazlitt's considered judgement was that, although Reynolds had 'no claim to the first rank of genius' and did not belong with the greatest masters, 'nonetheless, his works did honour to his art and to his country'.

In fact, although the exhibition proved to be a huge success and, at least in its early stages, attracted some eight hundred visitors a day, as well as 'much fashionable company' to the candle-lit evening openings held at irregular intervals during the three months of its duration,[54] it is by no means clear that it did have a 'visible effect on Art' or 'raise the character of the English school'

in any sense that Haydon would have acknowledged. It is true that Reynolds's subject paintings steadily increased in price for a number of years: in 1821, for instance, the executor of the artist's niece, the marchioness of Thomond, spoke 'with great satisfaction of the sale of Sir Joshua Reynolds's pictures at Christie's on Friday and Saturday last. He said that *before* the sale he should have been well satisfied to have had £9,000 for the whole. They sold for more than £15,000.'[55] Within little more than a generation, however, they were more and more consigned by lovers of art to the realm of ambitious, but essentially misguided, art-historical curiosities, and this impression has not been fundamentally changed even by the attempted revaluations of recent years.[56] Ironically, it is this eclipse that was to contribute to the enhanced prestige of the painter of 'cheeks, noses and eyes', although – as a number of critics noted even at the time – the triumphs of the portraitist were in large measure due to the aspirations of the history painter. It was naturally these aspirations that were still of primary importance to the directors of the British Institution in their attempts to foster a native school of history painting. When the second edition of the exhibition closed on 14 August 1813 a number of proprietors were asked to extend their loans for a further three months so that selected students could study them with much greater care than had yet been possible. Of the twenty-four pictures requested, no less than thirteen were of historical, allegorical and genre subjects[57] – and John Constable was delighted to see that they were being charmingly copied by the young men, despite his more frequently expressed apprehensions of the inhibiting effect of too much veneration of the Old Masters.[58]

In fact, the exhibition was important not because it added much to an understanding of Reynolds, but because it added vastly to his glorification: 'It seems at length pretty generally admitted', claimed the painter Martin Archer Shee in 1814,[59] 'that England has produced from amongst her sons, one of the greatest painters of which any age or nation can boast, and there is reason to hope, that he will be no longer, like the prophet, unhonoured in his own country.' If this really was generally admitted – and claims of this kind understandably struck even some of Reynolds's keenest admirers as extravagant, not to say ridiculous[60] – the exhibition had gone a long way towards achieving its principal aim, which in the words of Payne Knight's preface to the catalogue (written

perhaps partly for reasons of diplomacy) had been 'to call attention generally to British, in preference to foreign Art, and to oppose the genuine excellence of modern, to the counterfeited semblance of ancient productions, which too frequently usurp its place'. Without the apotheosis of Reynolds, such an ambition could never have been achieved – as was stressed even more emphatically in the official report on the exhibition produced by the directors, which combined bravado with an ill-concealed sense of inferiority. They began by acclaiming 'the unassuming and dignified manners of that excellent Artist, and the exemplary suavity and gentleness of his mind' and continued by calling upon modern Europe 'to produce the Pictures of any one Individual, in this or the preceding century, who can enter into competition with our British Artist'. It was, the directors insisted, 'a primary object' of the British Institution, to remove the prejudices against British arts and British artists. It would not, indeed, be difficult to trace the origin of those prejudices

> to the implicit deference which our young travellers have been taught to pay to those foreign artists and critics, from whom they have imbibed their first rudiments of Taste. Having been taught that the bright skies of Italy, and the clear atmosphere of France, are exclusively adapted to the cultivation of the Fine Arts, and that the Boeotian climate of England is impropitious to the production of works of Talent and Taste, the prejudices thus instilled by early habits, have produced impressions in their minds hostile to the arts and artists of their native country.

The directors had no wish to withhold 'any attention that is justly due to the talents of foreign artists, who visit this counry'; but, as they defiantly proclaimed in their concluding paragraph, 'If, indeed, the vulgar and narrow prejudice, that talent is not the natural growth of the British Isles, still require refutation, we trust that it will hereafter be refuted by exhibitions in the British Gallery, of the works of our other British Artists.'[61] The question now arose as to who were the 'other British Artists', whose claims were being so boldly asserted.

The directors had already held a meeting on 13 June 1813 to discuss the exhibition for the following year. It had been agreed that it should open on the first Monday in May, and it was evidently recognised that, since there was no single painter of the stature of Sir Joshua Reynolds, the British School would have to

be represented by more than one artist. Hogarth, Gainsborough, Wilson and Zoffany were chosen but, following a split in the committee, Zoffany's name was erased from the minutes.[62] Two days later Benjamin West, whose advice on the matter had been sought, agreed with Sir George Beaumont that Zoffany's 'Theatrical Portraits were painted with much truth and ability', but felt compelled to answer in the negative when asked directly 'whether Zoffany could be considered a Great Artist'. And that settled the matter – for the time being.[63]

The selection of Richard Wilson only just survived the early and strenuous opposition of some of the most influential directors of the Institution, including the marquis of Stafford, Richard Payne Knight and the Reverend Holwell Carr.[64] Once it was decided to include him, preparations for the exhibition proceeded smoothly enough,[65] until – not much more than two weeks before the opening date – the name of Zoffany was suddenly and mysteriously added to the list of artists to be represented,[66] and it was discovered that, despite the precautions that had been taken, a number of the Wilsons already hanging on the walls were not originals but had been accepted after pressure from collectors and dealers keen to augment their value by letting them be seen in such illustrious company.[67] It was thus at the very birth of the Old Master exhibition that we come across the first indications of a practice that has continued ever since. Nor is it clear whether or not the offending pictures were removed.

As far as numbers went it was Wilson who dominated the exhibition, with eighty-five pictures (out of a total of about 221) by (or attributed to) him. Some of these were certainly of the highest quality, but the vagueness of the titles and the artist's habit of repeating his compositions make it difficult to identify more than a few with any degree of confidence. There were seventy-one Gainsboroughs, of which the overwhelming majority were landscapes and 'fancy pictures', among them some of his most beautiful and famous examples in these genres; but the dozen or so portraits included *The Blue Boy*, *The Linley Sisters* and *Dr Schomberg*. The selection of paintings by Hogarth also included some of his most splendid portraits – *Sarah Malcolm*, *Self-portrait with a Pug*, *Captain Coram*, *Mr and Mrs Garrick* and *Archishop Hoadley* – and no less than four of his series of scenes from modern life – the *Rake's Progress*, *Marriage à la Mode*, *An Election* and the *Four Times of Day*, which were already known to a

wide public in the form of etchings and engravings. The Zoffanys were confined to theatrical scenes except for *The Tribuna of the Uffizi* and *Academicians of the Royal Academy* borrowed from the king and queen. Elderly playgoers looking back with nostalgia to the glorious days of Garrick – and there were many of them – could have admired portraits of their hero by three of the artists in the exhibition (Gainsborough, Hogarth and Zoffany) at the very moment when a dazzling new actor, Edmund Kean, was beginning to take London by storm.

A far greater time span was covered by the pictures shown in this exhibition than had been the case the year before – Hogarth had painted his first pictures before the birth of Reynolds, and Zoffany had continued to work during the eighteen years that had followed Reynolds's death – and Hazlitt shrewdly pointed out that the reputations of the artists on view formed 'an intermediate link between momentary popularity and the fame of the old masters'.[68]

None of these painters carried the moral authority of Reynolds, and writers could therefore disagree among themselves without feeling obliged to flaunt their patriotism and their confidence in the future of the British school. We have seen that doubts had been expressed about the suitability of including Wilson at the earliest stage of the preparations, and to some extent the pessimism of his detractors turned out to be justified. Constable, who had been particularly looking forward to seeing his works,[69] seems to have been greatly disappointed by them.[70] David Wilkie, too, was surprised to find that 'he does not in comparison with the others support the reputation that has hitherto been allowed him. His pictures seem to want variety, and seem to have rather a flat and common appearance'.[71] Hazlitt's eloquent plea for Wilson extends only to his Italian landscapes, in which 'his eye seems almost to have drank [*sic*] in the light'. In writing about these the beauty of Hazlitt's descriptions matches the beauty of the pictures themselves, and his opinion that they 'afford a high treat to every lover of the art', and that 'in all that relates to the gradation of tint, to the graceful conduct and proportions of light and shade, and to the fine, deep, and harmonious tone of nature, they are models for the student'[72] seems to have been widely shared, for Wilson's pictures – both the genuine and the more dubious ones – were more copied than those by any of the other artists exhibited.[73] Hazlitt, however, had little time either for the British landscapes – which 'want almost everything that ought to recommend them.

The subjects are not fit for the landscape painter, and there is nothing in the execution to redeem them' – or for 'his historical landscapes' – which 'neither display true taste nor fine imagination; but are affected and violent exaggerations of clumsy, common nature'.[74]

Gainsborough also greatly disappointed Hazlitt, who had gone to the exhibition with high hopes of admiring the works by him to be seen there. In a later article he somewhat modified – but did not fundamentally revise – his first impression that, for all the artist's taste, feeling and fancy, his pictures bordered upon *manner* and were characterised by 'affectation, flimsiness and flutter in the execution'.[75] He now conceded that the ten portraits on view included one very fine one (the so-called *Blue Boy*) and that the early landscapes were superior to the later ones (it is interesting that, despite the absence of any dates, the catalogue did, on two occasions, single out works as being in the artist's early manner) on the grounds that they were much more natural. He made the same sort of distinction when judging the 'fancy pictures, on which his fame chiefly rests': despite the 'truth, variety, force and character' of some of them, too many were marred by self-consciousness, sentimentality and unvaried smoothness. Gainsborough 'wished to make his pictures, like himself, amiable; but a too constant desire to please almost necessarily leads to affectation and effeminacy'.[76] Some visitors were more enthusiastic[77] – Wilkie wrote that he 'looks admirably, and seems to rise above himself'[78] – but on the whole neither Gainsborough nor Zoffany (whose pictures, according to Hazlitt, were 'highly curious and interesting as *facsimiles* . . . of some of the most celebrated characters of the last age') caused much excitement.

Hogarth's satirical images were by far the most familiar of any of the works to be seen at the exhibition, because, of course, they had been made for engravings, and when subscribers to the anti-royalist newspaper, the *Examiner*, read in it a report that the Prince Regent had been particularly struck by *Marriage à la Mode* and the *Rake's Progress*, they cannot have felt the need to hurry to Pall Mall to appraise his taste, but would have at once appreciated this ribald allusion to the prince's own marriage and morals.[79] But for Hazlitt the various scenes that made up the *Marriage à la Mode* came as a revelation, and, in trying to convey to the public the nature of that revelation, he wrote an appraisal of such freshness and perception that, to the modern reader (as

also, one hopes, to contemporaries), it seems not only to give authority to the particular exhibition that made it possible but also to encourage the holding of further ones that would render accessible the qualities of other masterpieces already famous but still unknown.

That Hogarth was, as Hazlitt reiterated, a comic genius with an unsurpassed knowledge of human life and manners; that he was also a master of composition with extraordinary powers of invention, narrative and characterisation; that his range extended well beyond the coarse humour with which he was so often associated – all this was apparent even (or, perhaps, especially) to those of the overwhelming majority of his admirers who, like Hazlitt himself, had hitherto been able to rely only on prints for knowledge of his works. Nor did Hazlitt's first sight of the pictures of the *Rake's Progress* make much of an impression on him, for he found them inferior to the engravings with which he was familiar. But in *Marriage à la Mode* he discovered a delicacy of touch which could be expressed only through the medium of paint – a medium whose nature he well understood from his own training as an artist. Although Hazlitt was not the first or the only critic to appreciate Hogarth's stature as a *painter*,[80] no one had yet explored the implications of this aspect of his creative power so acutely or with such eloquence. He pointed out, for instance, that in the 'Morning Scene' (pl. 10) Hogarth had 'with great skill contrasted the pale countenance of the husband with the yellow whitish colour of the marble chimney-piece behind him, in such a manner as to preserve the fleshy tone of the former. The airy splendour of the view of the inner room in this picture is probably not exceeded by any of the productions of the Flemish School.' Or – to cite just one further example of the perspicacity of his observation, combined with his recognition of the acuity of other writers – in the 'Music Scene' the

> sanguine complexion and flame-coloured hair of the female Virtuoso throw an additional light on the character. This is lost in the print. The continuing of the red colour of the hair into the back of the chair has been pointed out as one of those instances of alliteration in colouring, of which these pictures are everywhere full. The gross bloated appearance of the Italian Singer is well relieved by the hard features of the instrumental performer behind him, which might be carved of wood.[81]

How far such subtleties in Hogarth's paintings were appreciated by a wider public is difficult to determine, but it does seem certain that the exhibition of 1814 played an important role in launching his reputation as one of the great English artists – as distinct from the moralist and narrator who had always been appreciated – fervently admired by Wilkie (for whom Hogarth outshone every master that had gone before him[82]), the Pre-Raphaelites and most of the other significant British painters of the nineteenth century.

Nevertheless, scattered and indirect evidence suggests that the directors of the British Institution are likely to have been disappointed by reactions to an exhibition that, as its catalogue emphasised, had been intended to glorify the old English school as well as to encourage young artists. It is true that, after a shaky start, the evening openings were well attended, even if the public tended to strike Farington as 'genteel' and 'respectable' rather than of 'high rank',[83] and that when very fashionable company did turn up 'the pictures seemed to engage but little of the attention'. This was not only because they were badly hung and badly lit,[84] but also because it was widely agreed that too many inferior works by Gainsborough and Richard Wilson had been accepted and that this policy had damaged the reputations of both these artists.[85] It must therefore have been with considerable satisfaction that, at a meeting held on 16 June 1814, the nine directors of the British Institution who attended 'resolved that the Exhibition of the ensuing year be of the best Pictures of the Old Flemish and Dutch Masters, and that the Directors present, together with the Earl of Ashburnham and Sir George Beaumont be a select Committee to prepare a list of Pictures for consideration'.[86] With this decision nine 'noblemen and gentlemen' introduced to England – and eventually to the world – a radical innovation which has flourished until our own day: the Old Master exhibition.

Chapter 4

The Old Master
Exhibition Established

Pall Mall

The 'magnificent' display[1] of 'Pictures by Rubens, Rembrandt, Van Dyke and other artists of the Flemish and Dutch schools' opened to the public in the British Institution's gallery in Pall Mall on 4 May 1815 under the most favourable of auspices. The Institution's prudent policy had fully justified itself, and its patrons now included virtually the entire royal family. Almost none of those approached refused to lend – and the Prince Regent (later George IV) sent some pictures from his own collection.[2] If there was a problem it was that too many great pictures were made available, and some difficult choices had to be made, partly on the recommendation of the coarse-featured but gentle and unassuming William Seguier, the dealer and cleaner employed by the Institution (and, later, the first keeper of the National Gallery) whose duties and responsibilities grew steadily until his death in 1843.[3]

The upper end of the North Room was dominated by the great *Charles I on Horseback* by Van Dyck lent by the duke of Marlborough,[4] and the same artist was represented on other walls of this room by such masterpieces as his portraits of the Stuart brothers and of the abbé Scaglia.[5] Most of this room, however, was given over to smaller, and particularly poetic, paintings by Rubens (such as *The Watering Place*,[6] and *Moonlight*[7]) and by Rembrandt and his circle (*Lady with a Fan*,[8] and *The Mill*[9]). The Middle and South Rooms were principally hung with Dutch

landscape and genre, and of these Gerard Dou's *Woman with a Rabbit*,[10] lent by Henry Hope, won particular admiration and was held to constitute the artist's masterpiece.

The author of the unsigned preface to the catalogue followed Richard Payne Knight's example of stressing the value of the exhibition to British artists and of making wide appeals to patriotism: 'Great examples', he wrote, a fortnight before the battle of Waterloo, 'are the true promoters of emulation, the surest conducters to excellence. Who can doubt that the genius of a WELLINGTON will create future heroes to achieve the most brilliant exploits for the glory of our country? Let us hope that the genius of *Rubens* may produce Artists to record them.' That hope was not to be fulfilled. The writer stressed repeatedly the need for 'rule and authority' even for a genius such as Rubens, for 'no opinion can be fallacious; and to the Artist, no mistake more fatal' than the notion that 'many of the great works before us may seem the result of genius without the aid of study'. Van Dyck's portraits, he continued, were superior to those of Rubens: 'That of Charles I, in this Exhibition, shews how much delicacy of execution may be combined with breadth, and with dignity: no Painter knew better how to appreciate these qualities than Sir Joshua Reynolds, and he pronounced this to be the finest Equestrian Portrait which had ever been produced'. Rembrandt

> has, perhaps, above all other masters, the merit of originality. In others, we can trace the road by which they travelled; but *Rembrandt* struck out a path of his own, which conducted him to a very high degree of perfection in his Art. In the skilful management of light and shadow, on which so much of the sentiment of a Picture depends, he is surpassed by none; and if, as has been observed, the expression of his characters is sometimes mean, it is always appropriate. In the practical part of his art, no Painter understood better the management of the background of his Picture; he could render it broad and quiet without barrenness, rich and active without disturbance, and he always made it most advantageously conducive to the general purposes of his work.

As for the painters of landscape and genre, they 'display generally the most faithful imitation of nature: they all shew what assiduity may accomplish; and some of them unite with care and industry several of the higher qualities of the Art.'

Superb pictures, edifying sentiments. But for a short time there had been perceptible omens indicating that the happy relationship between the Old Masters and modern British art might not survive for very long – despite the thrilling encouragement that must have been given to Constable, 'the most English of painters', by the chance to see so many works by Rubens hanging on the walls of the British Institution while he was working on the *Haywain*.[11]

The most trivial issues could provoke irritation. At the Royal Academy dinner on 30 April 1814 the president, Benjamin West, gave the toasts so slowly that the guest of honour, the marquis of Stafford, deputy president of the British Institution, 'went away before He could be called on to speak in reply to the toast of "Success to the British Institution"'.[12] But some fundamental questions of policy were certainly at stake. For instance, although the 'professed purpose' of the society was 'the encouragement of British Artists', it did acquire expensive Old Master paintings for the nation (the great Parmigianino altarpiece in the National Gallery, for example), and when it was proposed to offer 4,000 guineas for a picture by Raphael, this excited much indignation in Royal Academy circles.[13] And on 24 October 1816 Thomas Lawrence got the impression from a private conversation that Benjamin West was 'decidedly of opinion that the principal Directors of the Institution are hostile to the Royal Academy'. But by then a devastating blow had already been struck.[14]

Early in June 1815 Sir George Beaumont had been sent a so-called 'CATALOGUE RAISONEE [*sic*] OF THE *Pictures now Exhibiting* AT THE British Institution'. It included no indication of either the author or even the printer, and the pamphlet appeared to him to be so abusive of himself and of his closest colleagues in preparing the exhibition that he thought it would be liable to prosecution.[15] The authorship of the pamphlet was constantly discussed over the next few months and even years, but no certain answer could be provided – nor has one yet been wholly agreed upon by modern writers,[16] although most readers at the time felt that it must have been written, or at least inspired, by some member of the Royal Academy. The author made it absolutely clear that his polemic was directed against the innovation of exhibiting Old Masters because he claimed this would damage the interests of living British painters, which had been the original intention of the British Institution. The tone was mocking throughout –

facetious is a better word – and it extended both to the majority of the pictures exhibited and to the supposedly arrogant clique that had imposed them on the public. It was reported that Sir George had lost his spirit and 'seemed to be fast declining towards dissolution',[17] while other readers were indignant or amused according to their opinions about the exhibition. Some thought that the knowledge revealed about technical problems demonstrated that the author must be an artist, while others claimed that it was not well written, despite the fact that Lawrence greatly admired the style.[18] One school of thought claimed that 'it would be injurious to Art generally by weakening the confidence which had been placed in works of Art as being of indisputed permanent value. "After reading this Catalogue, who," said He, "will go home and feel as He did before an assurance of the intrinsic value of those pictures which He had till now considered unquestionable?"'[19]

There would be no point in analysing here, in any detail, the *Catalogue Raisonné* – or its sequel attacking, in similar terms, the Italian exhibition of 1816 – but it is worth pointing out that, whether rightly or wrongly, it initiated the practice of challenging the authority of the attributions so confidently given in the catalogues of Old Master exhibitions – usually by those who lent their pictures to them. In this respect, its influence has proved to be enduring. To some small extent this kind of approach has even been encouraged by the organisers of such exhibitions who have welcomed the opportunity of having their opinions tested before being cloaked in dogmatic authority. The Old Master exhibition still provides the setting for controversies in a way that a (respectable) museum only rarely does – and it owes this valuable tradition, in large part, to the abusive, embittered, heavy-handed, occasionally witty, anonymous pamphlets of 1815 and 1816.

What the author of the *Catalogue Raisonné* had had in mind was, of course, to discredit the Old Masters and their collectors so as to benefit modern art, and here, too, he enjoyed a certain success – but for a much shorter period. From about the 1830s every tactic was used by the supporters of contemporary painting to discourage connoisseurs from buying Old Masters (which, it was openly asserted or darkly hinted, might be fakes or forgeries or copies or wrecks) in order to keep buoyant the market in

modern art. New collectors seem to have been impressed by such arguments and, for a generation or two, living artists enjoyed unprecedented adulation and prosperity. For many years the exhibitions of contemporary art organised by the Royal Academy and the British Institution itself attracted far greater attendances than those devoted to the Old Masters put on by the British Institution and rival organisations – the 'tradition of the new' had a far longer ancestry – and even when (towards the end of the nineteenth century) this was no longer always the case, some bitterness remained in the modern camp at the pre-eminence given to the Old Masters.

Meanwhile, however, a splendid sequence of Old Master exhibitions continued to be mounted in London which was considered without rival in this respect. The reason was simple enough. Although the small, but exquisite, Dulwich Picture Gallery, far from central London, had been made accessible to the public in 1814 and – more to the point – a national gallery had been created in 1824, it would be at least half a century before the combined holdings of these two institutions could compare in quality and size with what was to be seen in the Louvre, the Prado, the Hermitage, the Brera, the Uffizi or in the art galleries in Dresden, Berlin, Munich and elsewhere in Europe. And yet large numbers of paintings of similar standing to any hanging in these museums now adorned the town and country mansions of rich British collectors and their heirs. Pride of ownership conspired with (or disguised as) generous or even educational instincts to make possible annual exhibitions which also did something to promote national self-esteem.

The exhibitions combined ostentatious display with genuine highmindedness, solidly backed by commercial prudence. The Tuesday evening openings when, beginning in 1819, the galleries were brilliantly lit by gas,[20] were attended by special subscribers, who included leading members of the nobility and often of the royal family, and by anyone else lucky enough to obtain tickets for these glittering occasions.[21] Less favoured members of the public paid a shilling for daytime admission, and a further shilling for a catalogue – more than enough to weed out the lower orders – and as the exhibitions remained open for more than two months each summer, costs were quickly recovered and decent profits were made. In 1817 Sir Thomas Lawrence commented that he 'never before saw so many Ladies whose Head-dresses were beautiful as

were then present'.[22] It is not irrelevant to record such apparently trivial gossip. No museum has ever been able to attract such attention to itself until the promotion, within the last two or three decades, of chic, money-seeking soirées and dinner parties – and attention was certainly needed if the Old Master exhibition was to succeed in competing with what had always been the glamour associated with displays of contemporary art.

The exhibition of 125 pictures 'of the Italian and Spanish Schools', which opened for thee months in the middle of May 1816, was dominated by Raphael's cartoons of the *Miraculous Draught of Fishes* and *St Paul preaching at Athens*, lent by the Prince Regent on behalf of the king. The cartoons had not been easily accessible to artists – let alone to the public – and they caused a sensation. Benjamin Robert Haydon, who spent many hours studying and analysing them, thought that their presence alone justified the holding of the exhibition.[23] In fact, a number of other masterpieces (but also many pictures of much less distinction) were also to be seen: 'Titian's *Europa* and *Bacchus and Ariadne* and the British Institution's own recently acquired *Consecration of St Nicholas* by Paolo Veronese. There were also some Murillos, a few small Raphaels and a group of Poussins. Though very fine, this exhibition could not compare in coherence with the one devoted to northern artists in the previous year, and – perhaps for that reason – the catalogue was not provided with the customary didactic preface.

At the annual governors' meetings the marquis of Stafford and his colleagues regularly expressed satisfaction at the benefit accruing to the 'National Taste' and to the cause of modern British art from the contemplation of the Old Masters that the Institution had been able to put on view.[24] It is, however, by no means so clear that the modern artists themselves felt so enthusiastic, and the numbers of them applying to exhibit at the British Gallery dropped significantly.[25] Indeed, more and more concessions had to be made to patriotic sentiment. Thus it was resolved that the exhibition of 1817 should be devoted to 'Deceased British Artists', and increasingly thereafter one of the three galleries was reserved for a category of this kind, even when the main purpose of the exhibition was to display foreign Old Masters; and visual records of the exhibitions were sometimes distorted to convey the impression that far greater emphasis had been placed on British art than had actually been the case. In Scarlett Davis's painting of the 1829

exhibition the two most dominant pictures are Gainsborough's *Market Cart* and Reynolds's *Holy Family* which the Institution had acquired, but most of the exhibition consisted of Dutch, Flemish, Spanish and Italian pictures, and Reynolds's self-portrait, which, in Davis's painting, excites the special veneration of connoisseurs, was not in fact included (pl. 12).[26]

Behind moves of this kind can probably be traced the indirect impact of the *Catalogue Raisonné*, whose second instalment aimed to be at least as savage as the first. Individual owners and their pictures were mocked without mercy, and it was no doubt because of this that the directors of the British Institution introduced a formula that is still often found in exhibition catalogues at the present day: 'They have ascribed each Picture to the Master under whose name it is sent in by the Proprietor'.

It has to be acknowledged that some of the criticism seems to have been well directed. We can sympathise with the reviewer of the *Annals of the Fine Arts* who wrote in 1819 that 'it argues a total indifference to classification, and almost a want of feeling, to place Raffaele between Jan Steen and Metsu'.[27] The reproach is revealing in emphasising the extent to which these early exhibitions were still looked on by their organisers as adjuncts to their private drawing-rooms with little serious consideration being given to problems of improving national taste or offering guidance to young artists. Yet all too often the author of the *Catalogue Raisonné* himself seems actually to regret the presence of good pictures in the British Gallery and positively to take delight in the fact that, when they are to be found, they can be dismissed as having been badly hung. After his bullying cant – described by himself as 'bludgeon-like blows' and 'the rough quality of our tone'[28] – the clarity of Hazlitt's trenchant criticism of the *Catalogue Raisonné*'s style and content comes as a great relief: 'a very dull, gross, impudent attack by one of [the Royal Academy's] toad-eaters on human genius, on permanent reputation, and on liberal art'. Hazlitt's articles were originally published in the *Examiner*, a weekly newspaper of decisively independent views,[29] and their essential points can be summed up in two passages: 'The only chance, therefore, for the moderns, if the Catalogue-writer is to be believed, is to decry all the *chefs-d'oeuvres* of the Art, and to hold up all the great names in it to derision ... The Catalogue-writer thinks it necessary, in order to raise the Art in this country, to depreciate all Art in all other times

and countries'; 'Patriotism and the Fine Arts have nothing to do with one another – because patriotism relates to exclusive advantages, and the advantages of the Fine Arts are not exclusive, but communicable.'

That the primary aims of the British Institution in mounting Old Master exhibitions had been to raise the standards of British taste and to promote the talents of British artists had been well enough understood (and endorsed) by the Institution – and was constantly being flung back at its organisers by their enemies whenever there seemed to be any risk of its being neglected. But, as has so often been the case with later Old Masters exhibitions, there appeared to be no reason to restrict all aims to this primary one. It became clear very soon that such exhibitions offered an excellent opportunity for buying and selling works of art without the distasteful need of having to do so through dealers or to the accompaniment of publicity. A picture lent to the exhibition one year would, in the following one, be recorded in the collection of another owner. Thus an important Rembrandt portrait and Lotto's celebrated *Lady holding a Drawing of Lucretia* (then believed to be by Giorgione) exhibited at the British Institution in 1854 by Sir James Carnegie (Lord Southesk) were acquired privately, shortly before the exhibition closed, by Robert Holford for Dorchester House,[30] and John Ruskin obtained the dean of Bristol's *Doge Andrea Gritti* by Vincenzo Catena (then believed to be by Titian) when it was showing at the British Institution nine years later.[31] It was not only private individuals who were alert to the opportunities that these exhibitions provided. The trustees of the National Gallery had purchased Van Eyck's *Arnolfini Double Portrait* after it had been shown by Major James Hay in 1841;[32] and two decades later Alexander Barker seems to have made it easy for the trustees to inspect the great Renaissance masterpieces that he was prepared to sell, by lending them to the British Institution.[33]

Such procedures took place frequently, but at irregular intervals, throughout the duration of the Institution's exhibitions, which, in general, differed from each other as little in the manner in which they had been conceived as in the varying quality of their contents. In 1848, however, an innovation was introduced that appeared to indicate a change of direction, although it was not followed up, and matters thereafter continued as before. In June of that year the directors and governors drew attention to 'a novelty to which they cannot but refer, namely, a series of

pictures from the times of Giotto and Van Eyck'. The paintings
so designated (strangely so designated) numbered fewer than sixty
and were all hung in the Middle Room. They were, for the main
part, borrowed from those collectors who had shown some, but
not an exclusive, interest in the Italian and northern 'primitives',
though only a few of these collectors had been approached.
Samuel Rogers and Charles Towneley lent fragmentary frescoes
from the Carmine in Florence – attributed to Giotto but in fact
by Spinello Aretino – and Rogers lent a number of other early
paintings assigned to Van Eyck, Fouquet and Fra Angelico. Of
the earlier pictures displayed, the late fourteenth-century Wilton
Dyptych (borrowed from the earl of Pembroke, doubtless as
much for 'historical' as for for 'aesthetic' reasons) was probably
the most beautiful, as well as the most accessible to early Victo-
rian taste – more accessible, perhaps, than many of the 'pictures
from the times of Giotto and Van Eyck' that had been painted
well after the death of Raphael, such as *Hope* by Vasari or the
Virgin and Child by Lucas van Leyden. The exhibition was
admired, but it made strangely little impact, and nothing similar
was done again.

Perhaps the most remarkable feature of the Old Masters exhi-
bitions organised by the British Institution was the harmony that
seemed to prevail between those who chose and those who lent
pictures. Neither casual gossip nor the formal (but often detailed)
Minute Books give any indication of serious disagreements. The
crisis heralded by the *Catalogue Raisonné* when the series opened
quickly died away, and, in any case, merely encouraged the
governors to proceed along the road they had already chosen.
It must have come as a surprise, therefore, when in 1867 Lord
Charlemont threatened to sue the directors because they had
decided to record a number of his loans as having been painted
by different artists from those to whom they had been assigned in
the Charlemont House catalogue: his Reynolds (*Venus chiding
Cupid*) was said to be a copy; his Zoffany (*Portrait of Moody*)
was given to Penny; his *Portrait of a Gentleman* by Govaert Flink
was said to be not by that artist; and – most significantly – his
Thirty Pieces of Silver by Rembrandt was listed as by Jan
Lievens.[34] Charlemont indignantly protested that all four had
belonged to his family since 1786 or 1796 ('I forget which') and
that 'though my pictures are not likely to be for sale, they must
not be depreciated'. What had outraged him was the fact that the
changes of attribution had been made despite the printed infor-

mation in his own authoritative catalogue. He demanded that the pictures in question should be returned to him or that the catalogue of the exhibition should be corrected.

The directors capitulated at once, and great care was taken to ensure that the conventional proviso was inserted into a revised edition of the catalogue: 'Each picture is ascribed to the Master in whose name it was sent in by the Proprietor'. Good feelings were restored – at the cost, perhaps, of some impairment to historical scholarship.[35]

Burlington House

In September 1867, the lease of the British Institution's premises in Pall Mall expired, and the galleries, on whose walls had hung so many of the greatest masterpieces in the world, were transformed into a gentleman's club in order to enable the Prince of Wales to smoke without the restrictions that had been imposed on the members of Whites Club.[36] As the expensive cigars began to glow, it appeared that regular Old Masters exhibitions in London were about to come to an end, and the attraction of billiards would replace the exhibition of masterpieces by Rembrandt and Raphael. But, after more than fifty years, the tradition had become so firmly rooted in the social calendar that, even though the number and quality of pictures in the National Gallery had at last begun to make a serious impact on art lovers, the need to continue public displays of paintings from private collections was felt to be as important as ever, and somewhat desultory negotiations for an alternative site took place with various bodies over a period of years. The exhibitions had been so highly thought of that there was no lack of offers. An approach was received from Leeds, where an Old Masters exhibition was being planned for 1868 to rival the one held in Manchester eleven years earlier. The loan of one or two of their galleries may well have seemed inadequate after the splendours of Pall Mall, and, in any case, it was not a permanent solution: 'the Secretary was instructed to express the thanks of the Directors for the offer but to decline it'[37] Much more promising was a response to a statement issued by the secretary of the Royal Academy

> expressing the high regard in which the British Institution has been held through a long period of years by the Royal Academy and Artists, as also by lovers of Art and the Public generally.

The Directors are especially gratified, that the Members of the Royal Academy consider the Spring Exhibitions of the Institution to have been of material advantage to the rising Artist, and that the Autumnal [in fact, summer] Exhibitions of the Works of Ancient Masters are of so high an importance to Artists, students and Amateurs, that the discontinuance of them would be most injurious to the best interests of the Arts and of the Artists of the day . . .[38]

Credit for solving the problem probably belongs with the Burlington Fine Arts Club, a newly founded association of collectors and connoisseurs with some of the youthful enthusiasm that had animated the British Institution half a century earlier. The club proposed that it should take over the organisation of the exhibitions but mount them in the rooms belonging to the Royal Academy. The president and council of the Academy were said to have approved the idea, but at a general meeting the academicians resolved to adopt the annual exhibitions themselves. This caused some bad feeling but there were unquestionably advantages in having the responsibility pass into the hands of a large and prestigious, public institution of royal foundation.[39] The decision was made possible because the Academy had just established itself in Lord Burlington's great mansion in Piccadilly which had been specially converted to meet its needs. The first exhibition opened there on 2 January 1870, and for many years the series remained similar in concept to those that had been held under the auspices of the British Institution. It continued to be a major public event and great paintings continued to be displayed, while the Academy maintained the cautious approach of its predecessor by including works by 'deceased masters of the British school' as well as masterpieces by Rubens and Van Dyck, Titian and Claude,[40] and by issuing catalogues that provided only the minimum of information about the pictures on view, and that firmly announced that they were always 'marked with the names placed on them by their Contributors. The Academy does not in every case vouch for their authenticity' – a sensible precaution, as it turned out.

However, there was at least one very significant difference between these exhibitions and the ones that had been held at the British Institution. Although the Royal Academy naturally had to rely on the good will of the great aristocratic families, who still owned the overwhelming majority of the pictures needed for the

exhibitions, it was no longer the owners themselves who decided what should be shown, but a small committee of academicians, who drew up lists of what they hoped to be able to borrow. And as the academicians were not interested in promoting any special theme or artist (as would be the case – or, at any rate, the excuse – for most such 'block-buster' exhibitions these days), but were concerned only to make the venture as successful as possible by displaying a reasonably balanced group of masterpieces from a wide variety of sources, the first stage of tackling their problems was not too difficult. The contents of the outstanding private collections were fairly well known; the committee made a choice of some of the more desirable works; and, about six weeks before the opening date, a letter of request, signed by the president of the Royal Academy, was sent out to their owners. In these circumstances it was fortunate that the replies received from the queen and most of the other collectors approached for the first exhibition were generally positive. Thus, Moroni's *Portrait of a Scholar* (pl. 11), only recently acquired from a Venetian collection, would for the first time be seen by the British public. In his letter agreeing to lend it, Baron Meyer de Rothschild, its new owner, wrote that 'The subject was . . . called "Michelangelo – an imaginary portrait"' and, he added:

> This is a very strange title and has often excited much doubt and curiosity. Count Corti and many others have endeavoured to verify it, but in vain. If you can give me a better version of the picture, pray do so. At all events many critics and literary men will see it in your collection and it will be discussed and perhaps new light thrown on the subject. If not, you must accept the account given to us at Venice.

The *Judgement of Solomon* at Kingston Lacy by Sebastiano del Piombo (but at that time attributed to Giorgione) was also lent, despite the fact that the application was incorrectly addressed, the owner was a minor, the painting was of very large size and the frame was both cumbersome and fragile.[41] The willingness to oblige the Academy, even at such short notice, is impressive.

However, not all proprietors were so forthcoming, and anyone who has ever been involved in organising an exhibition will find many of the letters, written more than a century and a quarter ago, very familiar in tone: the duke of Marlborough did not want to leave an empty space on his walls;[42] the duc d'Orléans could

not lend because he was having his pictures cleaned under his own supervision;[43] Lord Overstone explained that Claude's *Enchanted Castle* (now National Gallery, London) could not be safely moved;[44] the duke of Rutland 'always declined to lend any picture to Public Exhibitions from fear of the risk of damage', and, in any case, his pictures were always on public view (but as Belvoir Castle was in Rutland, this rather missed the point of the request);[45] a Mr Henry McConnell complained that his pictures had 'received so much damage from lending them to various exhibitions that I hesitate to incur the risk of lending them to the Academy'.[46] And, as the opening date grew near, some of the academicians themselves began to get cold feet. Sir Francis Grant, the president, became worried that too many pictures would be put on view,[47] and the painter Thomas Webster thoroughly disapproved of the whole idea: it was, he claimed, a waste of funds, and the National Gallery contained better examples of the great masters.[48]

However, it was the enthusiasts rather than the objectors who caused the most trouble. As soon as the Academy's intentions became known, the committee was flooded with letters from all over the country from people hoping to participate: a Mr Allchin proposed his 'very valuable painting by Rembrandt';[49] a Mr Barnard wished to lend his 'original drawing . . . by Raphael';[50] a Mr Clements offered his specimens of most of the great masters including Mantigna (*sic*), Michaelangelo (*sic*), Leonardo da Vinci, Raphael, Correggio and Titian – 'my collection being considered by judges one of the best in the country'.[51] In obviously absurd cases such as these the organisers came up with the convenient excuse that, regrettably, preparations were now so far advanced that it was too late for them to be able to accept anything more – although this sometimes led to their being badgered again in the following year: in 1871, for instance, the intrepid politician and ecclesiastical firebrand A. J. Beresford Hope refused to be deterred by discouraging messages of this kind and went so far as to send what he claimed to be a Salvator Rosa to London from his country house in Kent, whereupon the organisers admitted defeat and accepted the picture.[52]

When unsolicited offers sounded plausible, two members of the committee went to look at the relevant pictures in order to submit a report on them.[53] Obviously, then as now, many people thought of Old Master exhibitions as a convenient way of attracting publicity for pictures they wished to sell – nor were they wrong

in making that assumption. Dealers were always keen to be involved, and at least one optimistic owner hoped that the Academy itself would buy a picture that he owned – because it was too big to fit comfortably in his own house.[54] Apparently insignificant anecdotes of this kind are, in fact, of real importance. Every Old Master exhibition is the result of a series of unplanned compromises about which visitors usually remain in total ignorance. We thus run the risk of accepting that the choice of pictures to be seen in such exhibitions has been carefully calculated. Any serious historian will appreciate how misguided such an approach can be when applied to the study of war or politics, but we still need to learn that developments in taste and scholarship are equally subject to accident, and that the high-minded, or at least respectable intentions of an exhibition organiser will be diverted by unanticipated acts of whimsical vanity, shrewd greed and inflexible caution.

Despite these problems, the exhibition of 1870 proved to be a success with the critics,[55] although the receipts from admission tickets and from catalogues at sixpence each amounted to only £3,000, compared to well over £17,000 for that summer's exhibition of the works of living artists.[56] In the following year the number of pictures selected, after procedures very similar to those already described, amounted to 426, almost twice as many as in 1870, and of these no less than 129 came from one single collection, that of Lord Dudley, which included Raphael's *Three Graces* (Musée Condé, Chantilly) and the *Mass of St Gilles* (National Gallery, London), now catalogued as by the Master of St Gilles but then given to Jan van Eyck. Critics were struck by the three paintings attributed to Botticelli,[57] who was just becoming well known (Walter Pater's famous essay had been published a year earlier), but they were also entranced by four paintings attributed (all of them wrongly) to Giorgione, among which was a so-called *Golden Age*, in fact a copy of Titian's *Three Ages of Man* (Sutherland Collection, on loan to the National Gallery of Scotland). Another painting that was much admired was a *Madonna and Child with Four Saints and a Donor*, now in the Louvre as by Giovanni Bellini and studio. This belonged to Lady Eastlake, the formidable widow of the former director of the National Gallery, who had bought it for himself. She agreed to lend it on condition that it was hung, as it was in her house, between the two pictures of saints by Cima that she had also inherited from her husband.[58]

Her terms were duly accepted, but she was disappointed in her hope that some of her late husband's own works would be included in the exhibition.

Almost from the first it had been realised that it would be impossible to sustain the standards of the Royal Academy exhibitions if such large numbers of Old Masters continued to be shown each year,[59] and, indeed, as the great English collections began to be dispersed to Germany and the United States, the quality of what was to be seen in Burlington House between January and March began to decline, and the character of the exhibitions began to change, with more and more space being allotted to British art. At the same time, however, timid attempts were made to improve the catalogues; and, above all, the growth of art-historical journals throughout Europe led to increasing attention being paid in Germany, France and elsewhere to these exhibitions, and more and more attempts were made to follow the example that they had set.

Meanwhile, as early as 1877, Henry James began writing elegiac articles to record the gradual decline of what had once been among the most spectacular Old Master exhibitions ever held:

> A great multiplicity of exhibitions is, I take it, a growth of our own day – a result of that democratisation of all tastes and fashions which marks our glorious period. But the English have always bought pictures in quantities, and they certainly have often had the artistic intelligence to buy good ones . . . They have stored their treasures in their more or less dusky drawing-rooms, so that the people at large have not on the whole been much wiser; but the treasures are at any rate in the country, and are constantly becoming more accessible. Of their number and value the exhibitions held over several years past, during the winter, in the rooms of the Royal Academy, and formed by the loan of choice specimens of the old masters, have been a liberal intimation. These exhibitions give a great impression of the standard art-wealth of Great Britain and of the fact that, whether or no the English have painted, the rest of the world has painted for them.[60]

A year later he returned to the subject:

> The milk pan, if I may be allowed in such a connection so vulgar an expression, has been pretty well skimmed. The first-rate things scattered among private collections over the length and

breadth of this most richly furnished country, have, for the most part, taken their glorious turn upon the winter-lighted walls of Burlington House. There are, doubtless, some great prizes remaining, but they are not very numerous ... This year there are two other superb Rembrandts; but it is apparent that for the future (unless they begin at the top of the list again) the exhibitions must be pitched in a minor key. Today, in the absence of any great Italians, we have a room devoted to the 'Norwich School'. I do not mention this fact invidiously, for the Norwich room is very interesting ...[61]

In fact, loan exhibitions of Old Master paintings did continue as a feature of London life (pl. 13) – partly, it is true, by beginning 'at the top of the list again' (indeed, when James was writing, some art-lovers with long memories would have realised that this had already happened more than once). The Academy carried on mounting its winter exhibitions, which in the last decade of the century were complemented by smaller ones held in commercial galleries, such as the Venetian exhibition at the New Gallery in 1895, to which I shall return in the final chapter. Despite the continuity between the British Institution and the Royal Academy, much had changed. Firstly, the marked antagonism between modern artists and the collectors and connoisseurs of Old Masters had diminished – indeed, this had been a pre-condition of the Academy's taking over the exhibitions. The most obvious explanation for this was the popular and commercial success enjoyed by exhibitions of modern painting during the middle of the century. Also, the generation of powerful connoisseurs had passed: by the 1850s artists were as influential on the royal commissions set up to investigate issues of public interest concerning the fine arts as were collectors, and the acknowledged authorities were men like Sir Charles Eastlake (both president of the Royal Academy and director of the National Gallery) and J. C. Robinson (keeper of the queen's pictures), neither of whom came from a noble or even very wealthy background. In addition, modern painters were now less likely to be judged by the standards of the Old Masters, and, in any case, a less narrow definition of the canonical merits of the latter prevailed.

Paradoxically, but perhaps not surprisingly, it was in the 1870s, when the Academy had no serious idea of mounting Old Master exhibitions for the benefit of British art, that they had the most influence on painters. It is perfectly possible to measure the impact

of works attributed to Botticelli and Giorgione in the Academy's exhibitions at this period upon not only scholarship and criticism but the productions of many leading artists, such as Rossetti, Burne-Jones, Leighton and Albert Moore. William Bell Scott's description of Lord Dudley's *Golden Age* in his review of the 1871 exhibition could as easily refer to a modern as to an ancient painting: 'a land of twilight . . .', in which there is a shepherd and a shepherdess, she, 'leaning on his naked limbs without fault, looks frankly at his dreaming but strong face. She holds the double flute . . . the music has ceased thousands of years ago'. Moreover, Giorgione is clearly a model for a new 'aesthetic' painter: 'he let the sculptor look after form and the poet look after ideas. Had he been asked what he meant here or there, he would have answered that he meant nothing.'[62]

Another change lay in the public for which these exhibitions were put on. The *Daily Telegraph*, welcoming the Royal Academy's first Old Master exhibition on the eve of its opening in 1870, observed that there were now two London seasons (that is, two periods when those who lived in the country but kept town houses could be expected to be in London), and that there was also now a large, educated public which actually lived all year in London, leaving only for an annual holiday.[63] This was the 'democratisation' to which James alluded. The *Telegraph* would later ask whether the Academy should be charging for such an essential service, since the lenders were so liberal. The duke of Buccleuch and Sir Richard Wallace were major lenders to the third exhibition: 'neither the duke nor the Baronet have heretofore at any time, we believe, assumed the profession of showmen'.[64]

It was clear, too, that scholars would have liked to have seen more system in the hanging of the exhibitions: it was certainly felt that they should have had a more educational effect upon the new public. 'The hanging seems to have been governed by no clearer principle than to make each room agreeable. Chronological arrangement, or even a division into schools, may have been impossible', the *Art Journal* acknowledged in 1871, perhaps reflecting on the speed with which the exhibitions were put together. But complaints persisted:

> For the imperfectly instructed, for the novice, and the slow of apprehension, the Academicians have set up a wandering wood, a mere labyrinth of confusion and complexity. The 274 pictures

– capitally hung, we hasten to admit, in galleries as capitally lighted – fill room after room without the faintest reference to the schools, the epochs, the subjects, the styles or the nationalities to which they belong . . .[65]

A completely different model for the Old Master exhibition had by then been seen in Manchester, and another model was provided in 1871 in Dresden.

German Scholarship in Manchester and Dresden

Manchester

If the Royal Academy's winter exhibitions added little if anything novel to the successful formula established long before by the British Institution, many new possibilities might have been suggested by the exhibition entitled *Art Treasures of the United Kingdom* which had opened at Old Trafford in Manchester on 5 May 1857. It owed something to the example of the British Institution's exhibitions, but it dwarfed them in size and scope and was at once more truly scholarly and more didactic. It also provided the most dramatic illustration that there had ever been of an ephemeral museum. Soon after it opened, the French critic Théophile Thoré announced to his compatriots that the collection assembled there was 'about on the level of the Louvre. The Spanish school, the German, Flemish and Dutch schools are even richer and more splendid. The English school can be seen only there. Only as regards the great Italians of the Renaissance does the Louvre surpass Manchester.'[1] To this comment can be added the gloss that, if Lord Ellesmere, Queen Victoria's representative in Lancashire, president of the general council for the exhibition and the principal local supporter of the enterprise, had not died unexpectedly a few months before the exhibition was due to open, he would probably have agreed to lend from his own astonishing collection of Raphaels and Titians from the Orléans collection that had come to him by inheritance, and, in that case, Manchester would have been

able to rival the Louvre even in the field of the great Italians of the Renaissance.[2]

Among the 'art treasures' were photographs and tapestries, armour and ivories, historical portraits and modern British paintings as well as pictures by Old Masters (pl. 16). It was the latter that was not only the chief concern of critics such as Thoré, but the priority of the better-educated portion of the 1,300,000 visitors who, in the course of four months, flocked to the vast and hastily erected building at Old Trafford from the specially built railway station beside it (pl. 17). What particularly distinguished the loans from British collections thus assembled on the outskirts of the most famous – or infamous – modern British city was the fact that this was a German exhibition. No one ever said as much directly, but it set out to challenge many of the principles that had governed the fashionable exhibitions organised over the previous forty years by the British Institution in its galleries in Pall Mall.

The initiative for the Manchester exhibition had come (a mere eighteen months before it opened) from a group of local manufacturers and business men who looked with some envy upon the prosperity and social esteem won by London, Paris and other European cities that, earlier in the decade, had hosted international exhibitions devoted primarily to industry. The idea of concentrating on the arts had been inspired (as they themselves explained) by the bold claim that 'the art-treasures in the United Kingdom were of a character, in amount and interest, to surpass those contained in the collections of the continent'.[3] This they deduced from three recently published volumes, *Treasures of Art in Great Britain*, by Dr Gustav Waagen, director of the royal picture gallery in Berlin, who had first begun to study the subject more than twenty years earlier. In the light of hindsight, it is worth pointing out that the title chosen for Waagen's book by his publisher[4] proved to be more accurate than the one the organisers decided to give to their exhibition, *Art Treasures of the United Kingdom*, which optimistically substituted 'of' for Waagen's preposition 'in'. But in the self-confident 1850s this small discrepancy would not have been noticed, and, in any case, Waagen's pioneering and magisterial account of the works of art to be found in public and private collections scattered throughout the British Isles was the foundation stone on which the Manchester exhibition was raised, and he was to give frequent advice as to

what should be borrowed, although this did not prevent his criticising some of the attributions made in the catalogue.[5]

A large sum of money was raised locally, elaborate plans were drawn up to cope with problems of transport, security, pollution and so on, and on 2 July 1856 (only ten months from the proposed opening date[6]) a delegation from Manchester arrived in London to seek royal support, without which there would have been no possibility of securing the major loans that were required from the aristocracy. Prince Albert received the visitors warmly at Buckingham Palace and promised that the queen would contribute some of her possessions, but (like his fellow countryman Gustav Waagen who had influenced museum directors everywhere by his rational reordering of the Berlin picture gallery) he held strong views about how the pictures should be arranged and pontificated that

> the mere gratification of public curiosity, and the giving of intellectual entertainment to the dense population of a particular locality, would be praiseworthy in itself, but hardly sufficient to convince the owners of Works of Art that it is their duty, at a certain risk and inconvenience, to send their choicest treasures to Manchester for exhibition. That national usefulness might, however, be found in the educational direction which may be given to the whole scheme. No country invests a larger amount of capital in works of Art of all kinds than England; and in none almost is so little done for Art-education! If the collection you propose to form were made to illustrate the history of Art in a chronological and systematic arrangement, it would speak powerfully to the public mind . . .

These high-minded sentiments did not convince all the leading collectors among the aristocracy (who hardly saw it as their 'duty' to educate the public and many of whom, in any case, did not much care for the Prince Consort), but they certainly won round the organisers,[7] and not long afterwards they engaged George Scharf to select and classify the Old Masters for the exhibition. At the same time the building to house them began to be erected.

Although Scharf himself was born in London (pl. 15), his father was a Bavarian draughtsman and lithographer who had arrived in England only four years previously, and it was he who had been responsible for encouraging his son to embark on an artistic career, principally as a book illustrator. The young Scharf had

travelled in Italy and Asia Minor, where he acted as draughtsman for archaeological excavations. He had acquired an extensive knowledge of the history of art and had only just failed to be appointed keeper of the National Gallery at the time that he was offered the Manchester job; and when that job came to an end, he was put in charge of the newly created National Portrait Gallery which he served with outstanding success until his death forty years later.[8] Although the Manchester exhibition is remembered chiefly as one of the most spectacular assemblages of great pictures ever brought together under a single roof, it deserves to go down in history also as the first Old Master exhibition to have been directed by qualified experts open to the influence of German erudition and connoisseurship. The most obvious impact of this was felt in the choice of pictures which gave unprecedented coverage to Italian art of the Middle Ages and early Renaissance as well as bringing to light some major, but unfamiliar, works of a later period. It was, for instance, on this occasion that the public could see, for the first time, Botticelli's *Mystic Nativity* and Michelangelo's *Virgin and Child with St John and Angels*.

These were probably the pictures that attracted the most attention from connoisseurs, and the latter has been known ever since as the 'Manchester Madonna' by those who accept it, as well as by those who reject it as by Michelangelo. Another marvellous painting chosen by Scharf, this time from a wholly unknown collection, was Bellini's *St Francis* (now in the Frick Collection, New York), a picture that he had discovered on 4 February 1857 (three months before the exhibition was due to open[9]) and that was carefully studied by the great Italian connoisseur Cavalcaselle,[10] before it disappeared from view for more than half a century. Of course, the exhibition contained also much that was second or third rate, and even more that was wrongly attributed, but the attention that Scharf (who travelled around the country, deftly sketching what was to be seen in private collections) drew to hitherto insufficiently appreciated paintings of the fifteenth century played a major role in shifting public taste. And for specialists his arrangement of the pictures was almost as significant.

The building was to be a structure of glass and iron which could be rapidly assembled – also easily dismantled and recycled. Several architects were approached, and one of the rejected designs – that of Owen Jones – demonstrates what was most daring and, in a sense, disturbing about the concept of the ephemeral museum

(pl. 14).[11] The works of art look almost as though they are await-ing transit in some huge goods warehouse, an idea encouraged by the building's similarity to a railway shed and by the imaginary viewpoint. In previous art exhibitions paintings had been hung in rooms that at least recalled the palatial galleries in which people had long been used to viewing even those works that were origi-nally installed in churches.

The building as finally erected, to the design of the iron founders C. D. Young and Company of Edinburgh (under the artistic direc-tion of the local architect Edward Salomans, who was responsi-ble also for the brick structures on the entrance façade) was less radical. Views of the interior show that the spaces were not so dif-ferent to those in museums at that date, with the paintings densely hung three deep and viewed from behind a railing (pl. 16). It was, however, better adapted to one of the most daring ideas of the exhibition's organisers: the aisles on each side of the great central hall were long enough for an extensive chronological sequence and narrow enough to encourage comparison between the works on opposite walls. Down the length of the south gallery, divided into three separate rooms, Italian paintings from 1400 onwards were hung facing the works of Netherlandish, French and German painters of the same period. It was thus possible to see Fra Angelico's *Last Judgement* (pl. 18) opposite a picture attributed to his near contemporary Rogier van der Weyden (in fact, Gerard David's *Adoration of the Magi*; pl. 19), or, further on, to turn from Raphael's *Large Cowper Madonna* (now in the National Gallery of Art, Washington) to Gossaert's *Adoration of the Kings* (National Gallery, London). Scharf was the first to admit that it would have worked better had he had more time for selection and hanging, had more careful advance calculations been possible, had there not been last-minute refusals and had he been allowed to reject unsolicited contributions (he claimed that he would have liked to have returned at least *three hundred* pictures[12]) – but even when, at the end of the second gallery the arrangement had ceased to synchronise, and Rubens was facing Titian, the effect must have been fascinating.

An interest in chronological arrangement was common enough at that date, albeit rare even in public collections, but the demon-stration of 'the contemporaneous existence of opposite schools' was a novel idea.[13] Scharf relished some of the edifying jolts that his hang gave, mentioning especially the effect of a Mazzolino

coming after the High Renaissance;[14] but aesthetic considerations were not ignored by him, and he admitted that some disturbance to his scheme was caused by the need to position the queen's Van Dyck portrait of King Charles I on horseback so that it closed the vista.[15] His enthusiasm for comparison is reflected also in his comments on the opportunities provided (and missed) by the display of portraits by Gainsborough and Reynolds, and in his regret that 'foreign modern art' was not properly represented alongside the very strong exhibition of modern British painting in the north aisle.[16]

It is hard to exaggerate the significance of the implicit elevation of artists of northern Europe – hardly any of whom were represented in the National Gallery – to the level of the Italians. The whole comparative approach invited speculation as to causes: national character, local tradition, religious faith and race became matters of concern for art historians. The very phrase 'opposite schools', however, had its own problems – or should have had. Italian art had previously been divided into different schools, and now in Manchester Italian painting, like Italy itself, was aspiring to unity. And it is striking how Master Stephan, Grünewald and Memling belong together in Scharf's mind – and on the north wall.

However instructive the novel arrangement of the Old Masters was for the educated, the question of how much the exhibition benefited those who were unfamiliar with such paintings in any form was a different matter. Scharf, like all zealous educators, was much struck by what might have been achieved with more time and in different circumstances. He regretted the inadequate preparation provided for ignorant visitors, the failure to include a lecture hall, and the rejection of proper labelling (which he had volunteered on the grounds that it would diminish the sales of the catalogue which were essential to the finances).[17] He may not have been an entirely reliable witness, but he was not alone in noting that many of the labourers and their families sent or encouraged to go preferred to picnic in the gardens, or that they found it much easier to enjoy modern paintings and the marvels of the 'Indian Court' than to appreciate Old Masters.[18]

He did concede the somewhat extraordinary fact that cheap dialect tracts were published for visitors with titles such as 'Bobby Shuttle and his Woife Sayroh's visit to Manchester un' the Greight Hert Treasures Palace owt Traffort'. And the efforts made at social

'outreach' far outstripped those upon which museums congratu-
late themselves today. On one day in August entry was provided
for over 800 mechanics from the great engineering firm of Messrs
Fairbairn (Thomas Fairbairn was chairman of the executive
committee and the single most active force behind the whole
exhibition), and on one day the following month more than 2,500
operatives from the Saltaire works near Bradford were trans-
ported to Old Trafford by their employer. Also, special funds were
established to help Sunday School children attend.[19]

The morale of a manufacturing town identified with philistine,
commercial pursuits was much improved by the chance to be
associated with high culture, and those privileged to own or
educated to enjoy art could revel in the philanthropic opportunities
that the exhibition provided. Whatever its effect on the completely
uneducated, the long hours, cheap transport arrangements and
low entrance charges ensured that it was a highly popular event.

It also paid for itself. And there was no serious damage to the
exhibits – at least, none that could be detected immediately (a
matter to which I shall return). Seven pick-pockets were arrested,
and 214 walking sticks were lost.[20]

The impact made by the exhibition in England, Europe and the
United States was enormous and is reflected in countless publica-
tions. The emperor Napoleon III, and the heads of many other
foreign governments, sent special commissioners to report on it,[21]
and it would be impossible to single out all the grandees and
celebrities who went to visit it – from the king of the Belgians to
Friedrich Engels (who wrote to Karl Marx that 'there are some
very beautiful pictures here. You must come over this summer and
see it with your wife'); from the queen of The Netherlands to
Florence Nightingale and Charles Dickens.[22] The Manchester
exhibition obviously gave a formidable impulse to the holding of
Old Master exhibitions elsewhere – firstly and most notably in the
great rival modern manufacturing city of Leeds in Yorkshire in
1868 – but also elsewhere in the world.

Of course the English example had, in a very casual and
spasmodic way, been duplicated long before, although, outside
England, the word 'exhibition' was almost invariably applied only
to displays of living artists. As early as 1827 the impact of the
shows held at the British Institution had made itself felt in the
United States, for in that year the Boston Athenaeum began to
organise annual exhibitions that combined the works of living

artists and Old Masters. The only problem was that there were almost no Old Masters in America at the time, and perhaps none of the pictures ambitiously attributed by unscrupulous foreign dealers to Raphael, Correggio and other very famous names was a genuine work by these masters.

A much higher standard of quality and authenticity was attained by a series of Old Master exhibitions put on for a few years beginning in 1846, in the gallery of a large shop in Paris called the Bazaar Bonne-Nouvelle for the benefit of the Association of Artists, some of whom sent in their own works. As was to be expected, the overwhelming majority of paintings shown were French, but a few (which cannot now be identified) were attributed to Guercino, Rembrandt and Murillo in the summary hand-lists that were published for these occasions, and at least one genuine masterpiece was shown at the exhibition of 1849: Ribera's *Le Pied-bot* (now in the Louvre). But even as late as 1866, when the first really major Old Master exhibition was put on in Paris,[23] the only precedents that its organisers were able to invoke were those that had been held in England. And, indeed, this and other such displays elsewhere in Europe and the United States were insignificant compared with what had been seen in London every year since 1815, let alone in Manchester in 1857.

Dresden

In its arrangement the Manchester exhibition reflected and in turn stimulated some of the major themes of art history: the comparison between schools, the rise and decline of styles and the discovery of techniques. The intervention of the Prince Consort, as well as the initiative of Waagen and the energy of Scharf, helped to determine its shape. For Scharf, the art that made the least effective appearance in Manchester was that of sculpture: the committee would allow no plaster casts such as those that filled the Crystal Palace now it had been re-erected at Sydenham. Scharf would have liked not only casts of sculpture but copies of paintings. With these the chronological effects could have been more precisely calculated. Even as things were, he was especially pleased to have been able to display copies of the Ghent altarpiece, because it enabled him to present the 'entire series in its original order of arrangement'.[24] (The masterpiece of Hubert and Jan Van

Eyck had been dismembered since the late eighteenth century and was reassembled only after the Treaty of Versailles.) Prince Albert was also preoccupied with replicas, and his chief recreational pursuit, undertaken with his librarian, Karl Rüland, was the compilation of a photographic corpus based on J.-D. Passavant's catalogue raisonné of Raphael's works. The new invention of photography, the convenience of Passavant's catalogue and the existence of large blocks of drawings by Raphael all coincided to make this dream possible to realise. Using photographs, a far more complete idea of Raphael's entire *oeuvre* and hence of his development as an artist could be obtained, reliable touchstones of authenticity could be established and the claims of different pictures to be the original could be more precisely assessed.

As soon as such assemblies became possible on paper, it became more tempting to bring them about in reality. And this did, indeed, occur – not for Raphael but for Holbein, and not in Britain, but in Germany, in what the *Art Journal* in 1871 rightly described as 'one of the most interesting exhibitions that has ever been held in association with art'.[25]

Among the most famous paintings in Dresden, in the most famous of German picture galleries, hung an altarpiece by Holbein that represented the Virgin spreading out her cloak to give divine protection to Jacob Meyer, a prominent citizen of Basel, and the members of his family, both living and recently dead (pl. 21). This was particularly admired as a superlative German rival to Raphael's world-famous *Sistine Madonna* in the same gallery: the two paintings were even displayed so as to encourage comparison between them – the equivalent (perhaps the only modern equivalent in the great European gallery) to the idea that Scharf developed with parallel rows of pictures in Manchester.[26] However, in 1822 Prince Wilhelm of Prussia bought from a French dealer another Holbein, an extremely similar version of the same composition whose existence in Berlin was first recorded in print, very briefly, in 1830,[27] although it seems to have attracted almost no attention (pl. 22). Fourteen years later, Wilhelm gave it to his daughter as a wedding present on the occasion of her marriage to the prince of Darmstadt,[28] and in 1852 it was taken to the family collection of the grand dukes of Hesse, where it hung in the princess's sitting room. It was thus nearly inaccessible to the public at large,[29] but the princess allowed suitable art lovers to come and look at it between 12 noon and three o'clock every day,[30] and

scholars and connoisseurs increasingly seem to have agreed that the picture was a very fine original, probably superior to the revered masterpiece in Dresden.[31]

Not surprisingly this opinion, which won more and more support in the following decades, proved to be wholly unacceptable to large numbers of art lovers, and the ensuing controversy was almost certainly the most bitter and the most extended that has ever been aroused by a work of art. Matters were not helped by the fact that documentary evidence regarding the provenance of the two pictures was quite inadequate – 'they have indeed no history' said one authority[32] – and that in the Dresden gallery, owing to what was described as the 'inconceivable narrow-mindedness of the authorities',[33] it was forbidden to take photographs, while the Darmstadt picture had been photographed only recently from a drawn copy and not from the original.

In 1869, however, the public was, for the first time, given a chance to see the Darmstadt picture itself at an exhibition of Old Masters held in Munich, and the organisers (provocatively, perhaps) placed next to it the lithograph by which the Dresden picture had become known throughout the world, as well as a photograph of it, also taken not from the original, but from a drawn copy.[34] All this stimulated still further the many connoisseurs who, for a long time now, had been calling very logically but in a manner that was quite without precedent, for an exhibition at which the two versions of the *Meyer Madonna* could be hang side by side. After some delay, and a final postponement caused by the outbreak of the Franco–Prussian War, this was eventually opened in Dresden on 15 August 1871, and the pictures remained on view until 15 October.

Before discussing the result of this remarkable venture into attributionism, it should be pointed out that this was perhaps the first exhibition to be prompted not by a king or a group of noble collectors, a government or an association of artists, but by art-historical scholars – and for this reason alone it could not have taken place anywhere outside Germany. Connoisseurs learnt a great deal from the exhibitions at the British Institution and the Royal Academy but they were not planned with contests for authenticity in mind, and had the organisers known that the *Rabbi* by Rembrandt in the possession of the duke of Devonshire would reveal that the similar *Rabbi* in the collection of Lord Powerscourt was 'an inferior replica – or a picture at the best, much injured by

time, or possibly by cleaning' they would not have arranged for
both to be shown at the winter exhibition of 1877.[35]

There were many other novel features about the Dresden exhi-
bition. Taking advantage of the excitement that had been raised
by the project, the committee decided to request major loans from
various private collections so as to be able to show significant
numbers of pictures, drawings and engravings by Holbein himself,
by his father (Holbein the Elder) and by related artists. In this they
were not disappointed, and the catalogue included some 440
items. The exhibition thus constituted the first serious 'one-man'
show of an Old Master since the much more restricted one that
had been accorded to Reynolds in London nearly sixty years
earlier. It was, indeed, by far the greatest display yet mounted of
the works of any Old Master – and thus Dresden's honour would
be vindicated whichever way the verdict went as regards its claim
to own the true *Meyer Madonna*. For, in the founding year of the
German Empire, Dresden was putting on the most important
display of German art seen anywhere.

To achieve this, loans were requested from many parts of
Europe. The queen of England sent two pictures and a number of
drawings, and many other English noble families lent works from
their collections. To the best of my knowledge this was the first
time that Old Masters were transported across frontiers for the
purpose of being exhibited. It thus signals a dramatic moment in
this story.

However, it was obviously not possible to obtain 440 original
Holbeins, and the great majority of paintings and drawings by him
and his family were shown in the form of photographs – and this,
in itself, was an innovation of the greatest importance, for it gave
the visitor a chance not only to see a few works of outstanding
quality but also to gain an overview of an artist's *oeuvre* in a way
that had never been possible, except to those scholars who had
access to the photographic collection of Raphael's work assem-
bled by Prince Albert and Rüland.

But what of the two rival Madonnas, hanging side by side, each
claimed by its supporters as an original masterpiece? The contro-
versy continued, even grew in intensity: manifestos were signed on
both sides.[36] But the juxtaposition was gradually acting in Darm-
stadt's favour. The supporters of Dresden were certainly not pre-
pared to give up without a fight, and compromises were suggested:
the Darmstadt picture could be accepted as authentic, but so, too,

could the Dresden one. It was a replica, with some variants, made by the artist himself, perhaps with a little studio help. But eventually it became clear that the battle was lost, and few if any serious claims were made after 1871 on behalf of what, not long before, had been one of the most celebrated pictures in Germany.

For the connoisseur this decisive result probably remains the most impressive vindication of the Old Master exhibition in general, although it had also the paradoxical effect of creating, rather than removing, confusion about the attributions of some great works of art.[37] If a world-famous masterpiece, such as the *Meyer Madonna*, could be unthroned, why not others? And so we are faced with the bizarre situation of more and more private collectors claiming to own the original *La Gioconda* or *Sistine Madonna*, of which the versions in the Louvre, the Dresden gallery and elsewhere are said to be only copies. In any case, the Holbein exhibition had few, if any, direct sequels. International loan exhibitions of Old Masters are, and always have been, expensive and complicated affairs – far too much so to be entrusted only to connoisseurs. Increasingly they came to depend upon public or private financial backers as well as requiring the collaboration of collectors (public as much as private). Diplomacy as well as administrative skill, government support as well as good connections, insurance and eventually public-relations experts and publishers would come to play an important part. For the promotion of such exhibitions profit and politics are as necessary as scholarship and altruism, and even from the Holbein show neither profit nor politics had been absent.

London

Despite the limitations just outlined, no history of the art exhibition is complete without some reference to the remarkable achievement of a society of British amateurs – amateurs not untouched by the new professionalism associated with German museums and by the end of the century also officially fostered by the new Italian state. The Burlington Fine Arts Club was formed in London in 1866. Its original aim was to arrange informal meetings at which collectors could meet in each other's houses to look at and discuss their possessions. Soon, however, a special house was rented in Savile Row, just behind the Royal Academy, for the

purpose of putting on regular, but relatively small, exhibitions open to the public. Their contents were (after a series of rather hesitant starts) to be carefully selected and catalogued by qualified experts, and each one was to be devoted to a particular theme – either to some artist or period, or to one of the applied arts such as silverware or porcelain. It is true that, like the British Institution and the Royal Academy, the Burlington Fine Arts Club also benefited from the support of the aristocracy, but (as was at once noted with some disdain[38]) the overwhelming majority of members were chosen from a new generation of rich, middle-class collectors, and artists were also well represented. The prevailing tone was one of scholarly connoisseurship, and it marked a decisive break with the atmosphere of grandiose country house combined with third-rate commercial gallery to which the public had become accustomed. No longer, for instance, do we come across such delightfully bizarre and extravagantly optimistic catalogue entries as 'Giorgione: *Malatesta di Rimini and his mistress receive the Pope's legate*' (followed by a long, historical excursus) for a picture lent to the Royal Academy by Sir William Abdy Baronet in 1881.[39] When it appears again at the Burlington Fine Arts Club some thirty years later, it has been demoted to the much tamer (but more reasonable) ' "School of Giorgione": *The Lovers and the Pilgrim*' (pl. 23).[40]

The Burlington Fine Arts Club survived until 1951, but it is the exhibitions that it mounted in the late nineteenth century that merit attention in this connection. Their exhibition of 1894 was especially remarkable. It was devoted to a field of Italian Renaissance art that had only recently attracted any attention from scholars – 'works of the school of Ferrara–Bologna, 1440–1540' – would today be looked upon as dangerously adventurous outside Ferrara itself. It was organised by a leading Italian art historian, Adolfo Venturi, and it was described by the young Bernard Berenson (in one of his very first articles) as 'one of the finest retrospective exhibitions that has ever been seen in London'.[41] The only substantial features surviving from the past were that nearly all the objects on view were borrowed from private collections in Great Britain and that, although Venturi had done virtually all the work, it was the owners of these collections who received most of the credit. Thus Robert (known as Robin) Benson, a rich and cultivated banker,[42] not only lent five of his pictures to the show, including two of its most important ones –

Dosso Dossi's *Circe* and Correggio's *Christ taking Leave of his Mother*, he also supplied, as an introduction to the catalogue, an essay that was well informed, but distinctly old-fashioned in tone with its exalted references to Shakespeare and Beethoven and to the 'splendid jovial court of the Este', and its rejection of 'scientific' methods of connoisseurship based on comparative anatomy. And yet the exhibitions put on by the Burlington Fine Arts Club were characterised by the unprecedented rigour with which they approached the issue of attributions.

It is true that, well before this, art historians from Germany and elsewhere had not hesitated to discredit many of the bland, over-optimistic, owner-dictated attributions that were so obvious in the spectacular Old Master exhibitions held at the Royal Academy, but it was only with the arrival of the Burlington Fine Arts Club on the scene that such doubts began to be incorporated by the organisers themselves into the catalogues that they issued. This one, for instance, is littered with entries such as 'Ferrarese school', 'ascribed to Ercole Roberti', 'Unknown', 'School of Costa', and so on – occasionally with greater caution than has appeared necessary to connoisseurs in our own day, a hundred years later. And, in any case, many genuine pictures of the highest quality such as the *Widow of Hasdrubal* (now in the National Gallery of Art, Washington) and the *Pietà* (now in the Walker Art Gallery, Liverpool) had their attributions changed from one great master, Mantegna (to whom had been assigned many outstanding Ferrarese paintings), to another, Ercole de' Roberti (whose true stature was only now becoming acknowledged, though his identity still caused much confusion). Thus another vivid painting at the exhibition, the *Concert* (pl. 20) was attributed to Ercole, although a few historians were already suggesting that it was by the young Lorenzo Costa (as is generally agreed today) – an artist who was represented by a number of hitherto unknown paintings, one of which, the *Portrait of Battista Fiera* (also now in the National Gallery, London), aroused particular enthusiasm.

However, the most important innovation of the exhibition lay in the attention that it paid to scholarly documentation. It is, today, still possible for us to see for ourselves how justified Berenson was in maintaining that the version of the catalogue that was printed for subscribers only and that contained twenty-two large-scale illustrations was 'magnificent'; but it was only at the exhibition itself that one could have seen more than 250 pho-

tographs (many of them specially made for the occasion in Berlin and Venice, in Vienna and Bologna, in Paris, Milan and elsewhere) of pictures that were relevant to an understanding of those that were hanging on the walls – pictures not only by famous artists, but by others of whom no one except the most expert specialists would ever have heard: Pellegrino Munari and Panetti, Chiodarolo and Tamaroccio. These photographs were arranged in chronological order and could be consulted by anyone interested in the *Catalogue Raisonné of Works by Masters of the School of Ferrara–Bologna* that was included in the catalogue. Photographs had had to serve as substitutes for works of art that could not be borrowed in the Holbein exhibition of 1871 and again, as we shall see, in the Rubens exhibition of 1877, but this particular way of using them was, as far as I know, the most ambitious contribution to specialised art history that had yet been made anywhere – let alone by an exhibition – and it was singled out by the leading German authority in the field as one that ought to be followed for all such occasions.[43] It is worth remembering that it was in this very year that Berenson published the first of his famous *Lists* of the Italian pictures of the Renaissance – the one devoted to the Venetian school – and that it contained just one illustration.

The Ferrarese exhibition, however, which remained open from the end of May 1894 to the end of July, was visited by just 2,400 people, exclusive of the 378 members of the club[44] – and in this (as, indeed, in every way) it differed from the Manchester exhibition of forty years earlier which had attracted over a million visitors. It remained a private institution, its borrowing was restricted to British collections, and, as had long become apparent, even the most enthusiastic resort to photographs was often only a clumsy tool for resolving major problems – indeed Benson in his introductory essay had cautioned against excessive faith in their value. Nevertheless, the Burlington Fine Arts Club had conceived of a type of exhibition that was of great originality – it provided visitors not only with a chance to see masterpieces but with the opportunity to learn something about the context in which they had been created. The club's motives were also largely uncontaminated by the politics and nationalist sentiments that may be detected in the even more remarkable exhibition at Dresden. The Manchester and Dresden exhibitions were popular events animated by scholarship; the Burlington Fine Arts Club exhibitions

were scholarly undertakings whose descendants are the small 'dossier' exhibitions mounted in major galleries today.

But that is, in fact, too simple a view of things, for it should be noted that the Manchester *Art Treasures* exhibition was not merely a popular show: it contained within it several sections that could be described as exhibitions for specialists, for example the material on the prehistory and earliest practitioners of water-colour and on the evolution of the mezzotint engraving, and the display of Old Master drawings (one of the first public exhibitions of such, even if anticipated by the semi-commercial exhibitions mounted by Samuel Woodburn in the 1830s and before that, of course, by the exhibition of 1797 in the Galerie d'Apollon of the Louvre). The crowds swept past the prints and drawings on their way to hear Hallé's orchestra. These displays may be seen as the forerunners of those mounted by the Burlington Fine Arts Club. Indeed, the orchestra was just about the only aspect of the Manchester exhibition that was not highly influential.

Chapter 6

Patriotism and the Art Exhibition

The great Holbein exhibition in Dresden was, as has been mentioned, mounted in the founding year of the German Empire, and there was certainly a nationalist component to this celebration of the work of a great German artist, even if the original motive for the exhibition lay in rival claims among German collections and among international connoisseurs. Strong patriotic sentiments are easy to discern in the motives for the British Institution's Reynolds exhibition held in London in 1813, although in that case the major aim was to conciliate the jealous Academy, whose first president Reynolds had been. It should come as no surprise to any student of European history that nation-alism became increasingly obvious in European art exhibitions towards the close of the nineteenth century.

The impressive celebrations held on 6 April 1828 to mark the third centenary of the death of Dürer (following early, more subdued, commemorations in 1628 and 1728) did not, it seems, involve the display of any of his own works. Instead, a bronze monument was begun (but not completed in time) for erection in his home town of Nuremberg – the first free-standing statue ever erected to an artist[1] – countless decorations were designed by contemporary artists to record significant events in his life and at his graveside tubas burst into sound at precisely six in the morning, followed by processions, sermons and speeches – all fervently patriotic in tone.[2]

Twelve years later, even more spectacular ceremonies were held in the city of Antwerp, which had already honoured Rubens every half century since his death in 1640.[3] To the accompaniment of firing canon, ringing church bells and the playing of bands, the

inhabitants of the town – who resented researches claiming that their most famous citizen might have been born in Germany – dressed in national costume and walked in procession through streets decorated with festoons, flags and ribbons, past triumphal arches and chariots, surmounted by effigies of Rubens, Van Dyck and Jordaens,[4] to attend high mass in the cathedral (pl. 24). But, as had been the case with Dürer in Nuremberg, the art on view had not been created by the great artist himself, but by the living: prizes were awarded to pupils at the Royal Academy of Painting, and the colossal model of a proposed bronze statue, which (like that of Dürer) was not ready on time, was unveiled to the ringing of bells, the roar of canon, the singing of hymns and the making of speeches.

Although the centenaries of the births and deaths of great artists and writers of the past came to be celebrated in such ways more and more frequently as the century advanced,[5] and although it had become customary, since the middle of the 1850s, to mark the deaths of contemporary painters with retrospective exhibitions,[6] it was – as far as I know – not until September 1875 that these two functions were combined, with the opening in Florence of three important exhibitions to commemorate the birth of Michelangelo four centuries earlier. A committee had been set up in 1873 to make the arrangements, and the actual date of the first opening had been twice postponed by several months,[7] but it does not come as too much of a surprise to learn that the delegates from all over Europe who processed through the streets in the sweltering heat of mid-September found that the installation was not yet quite ready.[8] None the less, the successive openings of the exhibitions were spectacular events, graced by the presence of royalty, the lavish decoration of streets and palaces, the historical costumes that adorned the representatives of the city corporations, a series of concerts and recitals (all notable for their utterly inappropriate music[9]), non-stop banquets, and interminable lectures and speeches (which prompted an exhausted French delegate to complain that he felt just like one of Michelangelo's Captives[10]) – everything, in fact, except for the learned art-historical conference, that would now be considered obligatory to accompany a major exhibition. In the Casa Buonarroti, the relatively few original drawings by the master that remained in Florence were put on display; in the archives were to be seen large numbers of important documents concerning his life and

times; but it was in the Accademia that the principal exhibition was held.

This large and rather chaotic manifestation[11] attracted an enormous amount of attention throughout Europe and led to some significant revaluations, despite the fact that it remained open for no more than a fortnight[12] and that it seems to have contained only one authentic work by Michelangelo himself[13] – the *David*, which, two years earlier, had been taken to the Accademia from its original location in the Piazza della Signoria to save it from the weather.[14]

All the remaining sculptures could, inevitably, be exhibited only in the form of plaster casts which were presented by the English and French governments, the municipality of Bruges, the Grand Duchess Maria Nicolaevna of Russia and the authorities of other places that owned works by the artist – or claimed to do so, for, of course, many reproductions of sculptures – some of high quality and others utterly mediocre – lent both from elsewhere in Italy and from abroad had little enough to do with Michelangelo himself, as was quickly recognised even by their local admirers once they were placed in the company of copies of authentic works. Among such may be counted the *Pope Paul III* from Naples (now acknowledged as by Guglielmo della Porta) and the *Virgin with the Dead Christ* from Genoa (by Montorsoli).[15] Some visitors were dismayed by the fact that – presumably for practical reasons – almost no casts were exhibited of sculptures in the churches and collections of Florence itself,[16] but even with these gaps the exhibition must have offered one of the greatest opportunities there has ever been to gain a convincing and comprehensive panorama of the work of Michelangelo, his followers, his imitators and his forgers. This was of course possible only in the field of sculpture, for the copies and photographs of paintings and drawings, which were also included in the exhibition, were clearly of far less value in conveying the true nature of his achievements.

The celebrations to honour this great man, whose name, in the words of the committee,[17] 'is a glory not only of Italy, but of the whole world', marked the climax of a number of such occasions that had been held in various parts of Italy ever since the successful outcome of the Risorgimento; but it need hardly be said that although other cities and other nations had to concede that Michelangelo was a Florentine, they were determined at least to exploit as much of his fame as they could to suit their own

purposes. Thus the French were quick to point out that the photographs on view in the Accademia demonstrated that the quality, condition and authenticity of drawings by Michelangelo lent by the Louvre 'threw into the shade those to be seen in Oxford and even in Florence itself'.[18] And from now on considerations of nationalism tended to inspire the holding of Old Master exhibitions everywhere – though not yet to distort their nature. Moreover, since by far the majority of them were still held in London, pride of possession usually had to take precedence over pride of achievement.

In 1877 it was the turn of Belgium, which remained for many years the only country to follow the example of Italy in honouring its most celebrated artist through an exhibition of his major works.[19] This time it was the third centenary of Rubens's birth, rather than the second centenary of his death, that Antwerp chose to commemorate; and although the processions and pealing bells and roaring canons and concerts and street decorations remained similar in essence to those of the previous celebrations,[20] the decision on this occasion to mount a large display of his paintings was a new and extremely ambitious one. Far too ambitious, in fact, for it soon became clear to the organisers that it would be impossible to borrow a representative sample of his works. Although some twenty original drawings were obtained from private collectors (with the traditional caution that the committee took no responsibility for the attributions), no one had yet seriously proposed that altarpieces might be removed from churches and join masterpieces from major museums in consignments transported across frontiers in order to hang for a few weeks in some location temporarily hired for the purpose. And so a brilliant solution was devised. As had occurred with Michelangelo in Florence, the master's achievements would be shown through the medium of reproductions, for, apart from Michelangelo, Rubens was the only supreme master who could be presented in this way without making a mockery of his genius: after all, he himself had closely guided many of the skilled engravers whom he employed to make faithful prints of his paintings. One engraving – in most cases the earliest in date – was chosen for each picture, and the location and other information about the original was supplied in the catalogue. More than a thousand items were to be seen in the exhibition, and they were arranged by subject matter: Old Testament, New Testament, Religious Allegories, Works of Devotion and so

on. It thus became possible, in the words of one visitor,[21] to appreciate 'the ease with which Rubens could treat the same subject over and over again with ever varying novelty of arrangement' by glancing 'at the nineteen engravings, from as many different paintings, of the "Crucifixion", arranged side by side on the walls of the gallery'.[22]

It would, I think, be unusual for an exhibition today to lay such stress on this aspect of an artist's achievement, for the respect – or, at any rate, the lip-service – that now has to be paid to scholarship requires the organisers to concentrate above all on attributions, on chronology and on more recondite issues of iconography; and this may make it worth pointing out how imaginative was the plan conceived by the Archaeological Academy of Belgium, which had been responsible for this remarkable exhibition, in making the best of a difficult situation and demonstrating to a somewhat sceptical public that the artist's range and genius were the equal of any other European painter. The Academy's claims that it had displayed 'almost the complete totality of Rubens's paintings' and that 'no more complete series of reproductions after the works of a single master' had ever been brought together can certainly be endorsed.[23]

It was only twenty years later, in 1898, that the insuperable problems that had thwarted the original plans of the Belgian Academy were at last overcome and that *The Times* (of London) was able, without exaggeration, to describe the Rembrandt exhibition held in Amsterdam in that year as 'a thing unprecedented of its kind . . . For the first time a genuinely cosmopolitan levy has been organised; Royal personages, public galleries, old possessors and new collectors from all over Europe have vied with one another in making this exhibition unlike anything that has been done before' (pls 25, 26).[24] But not – it must be added – unlike anything that was to follow. It was, in fact, in Amsterdam – a hundred years ago – that the modern 'block-buster' was born, with 124 paintings (insured for the vast sum of £4 million sterling[25]) and 350 drawings, which were admired by 43,000 people over a period of just less than two months – enough to make a substantial profit.[26]

The exhibition, which was held in the recently built town museum (Stedelijk), did not commemorate any centenary connected with Rembrandt, but it marked the inauguration (following her eighteenth birthday) of Queen Wilhelmina of The

Netherlands – and this fact must have played a major part in encouraging loans from foreign royalty. Thus, Queen Victoria lent two pictures, and this naturally set an example to other collectors in England and Scotland, whence came as many as forty in all – a much needed contribution, as only fourteen of his works remained in Holland itself.

Thus Earl Spencer lent his portrait of Hendrickje Stoffels as Flora (now in the Metropolitan Museum of Art, New York) and the earl of Crawford his *Portrait of Titus* (now in the Boijmans-Van Beuningen Museum, Rotterdam). The emperor of Germany lent one picture, and, as a consequence, nineteen others were sent by German princes as well as by newly rich businessmen. In addition, and most unusually, a German museum contributed to the exhibition – the Berlin museum (admittedly an institution under the emperor's direct patronage) lent the *Man with Golden Helment*. Thirty-three pictures arrived from France, and two from Prince Yusupoff's gallery in St Petersburg. But the chief sensation was provided by the *Polish Rider* which had been discovered only a year previously in the collection of Count Tarnowski in Poland and had therefore never been seen before by the public or the experts.

'Naturally', commented *The Times*, 'there is nothing from America, whither some fifty genuine Rembrandts, not to mention a much larger number of spurious ones, have taken flight during the last twenty years. But happily these are not, as a rule, of very great importance compared with the chief pictures here.'[27]

Partly as a result of the publicity surrounding the exhibition itself, this imbalance was, before long, to change in the most dramatic way. And, in any case, spurious Rembrandts were not confined to America, for even at the time some acute observers noted that, despite some marvellous pictures, many of those on view could not in fact have been by him; and I suspect that scholars today would amend that word 'many' to 'most'.

Yet the exhibition was conceived and carried out by the leading Rembrandt authorities in Europe – including the great and omniscient Wilhelm von Bode, director of the royal museums in Berlin – and it is symptomatic of their approach that, in this occasion, an art-historical congress was especially organised. The scholars did not, however, have things all their own way, for prominent contemporary artists served alongside them on the committee, and they insisted that the pictures should be hung not

in chronological sequence but to enhance the overall aesthetic impact of the galleries so that strict symmetry was observed and, as far as possible, a large important work on each wall was flanked by smaller ones.

The pictures omitted from the Rembrandt exhibition seem today at least as astonishing as those that were present, but the huge impact it made can be gauged by the number of references to it in the years immediately following, when other countries were inspired by its success to mount ambitious displays of their own past glories. The problem that they faced was a difficult one. Rembrandt had gradually come to be seen as a uniquely 'national' and, at the same time, a uniquely 'serious' and 'moral', even religious, artist, as well as very prolific, one, who towered above his contemporaries. Although a somewhat haphazard Van Dyck exhibition was held in Antwerp in 1899, and although Madrid celebrated the achievements of Velazquez, Goya and El Greco in 1899, 1900 and 1902 respectively, it was generally felt – in France as in Flanders, in Germany as in Italy – that only the 'primitives' could combine the national and the moral to the same degree as Rembrandt, with the added advantage that they also demonstrated the antiquity of their country's culture. But it was very difficult to find among them any single master who was celebrated and productive enough to warrant being shown by himself. The remarkable exhibitions that sprung up throughout Europe at the turn of the century tended to be dedicated to groups of artists, partly because such shows could be far more effective than ones devoted to a single Old Master at propagating those rival nationalisms that constituted the principal ideological battle ground in the years preceding the First World War – a fact that sometimes makes it painful to read their catalogues today, despite the great contributions to scholarship often made by the exhibitions themselves. (The idea of devoting an exhibition to the 'School of Ferrara–Bologna', is typical of this period: the exhibition on this subject organised by the Burlington Fine Arts Club in 1894, described in the last chapter, was extraordinary precisely because it was held in London.)

It is true that the first important exhibition to follow the consecration of Rembrandt was devoted not to a school but to another individual artist, Cranach, and that its organiser, the director of the Dresden gallery, was motivated by a genuine enthusiasm for scholarship. His claim that artists, connoisseurs

and the lay public all agreed that his exhibition, held in Dresden in 1899, had enabled Germany to recover a true artist – a man of whom Germany could be proud – was relatively subdued, but it was this note that was to become more and more emphasised.

In February 1900 a Belgian writer on the arts proposed that an exhibition should be mounted in Brussels to celebrate the achievements of the Flemish primitives,[28] and as precedents for what he had in mind he singled out the exhibitions that had been held in Amsterdam, Dresden, Antwerp and Madrid in honour of Rembrandt, Cranach, Van Dyck and Velázquez. After many vicissitudes the exhibition he had conceived was held in Bruges in 1902, and it proved to be of great importance. The organisers were, above all, anxious to demonstrate that there had existed a vigorous and essentially autonomous school of Flemish painters who had, to a large extent, both resisted the seductions of Italy and given supreme expression to such innate characteristics of the Flemish people as piety and a spontaneous approach to the natural world. To this end, they deliberately closed the exhibition with three works by Pieter Brueghel, including the great *Adoration of the Kings* (now in the National Gallery, London), while omitting any by his elder and Italianising contemporary, Franz Floris, who was held to have 'betrayed' his native tradition by seeking inspiration in Italian art. When the president of the exhibition spoke at the closing ceremony, he felt sure that its principal objectives had been met: 'The Flemish school has revealed itself with an almost unsuspected power and richness! Is that not a patriotic task? To show the past richness and power of Flanders, does not that stimulate national sentiment? Our legitimate pride ... has made us prouder of our quality of Flemings, prouder of our name as Belgians.'

Two years later, in 1904, the French decided that they, too, must demonstrate to the world that they had had a great national school of early painters, and they held a huge exhibition in Paris, which succeeded in bringing together some wonderful and widely scattered pictures (for by now loans from abroad were coming to be taken for granted, although most museums were still very reluctant to lend). The catalogue was written by Henri Buchot, a veteran of the Franco–Prussian war. After complaining bitterly that he had unjustly been accused of chauvinism, he proceeded to denounce 'the legend of the Italian Renaissance' – a 'legend', because 'our old French art had been characterised by truth and

humanity' while the Italians were still rigidly trapped in their allegiance to Byzantine traditions. Even more absurdly he mocked the so-called Flemish school which owed any merits it might have to the example of the French. It was not, he claimed, even clear whether the brothers Van Eyck had ever actually existed!

In the same year, 1904, not one, but two, exhibitions devoted to the art of Siena were held. The first of these, organised by Corrado Ricci, was held in the wonderful setting of Siena's Palazzo Pubblico and was probably the most important Old Master exhibition that had yet been seen anywhere in Italy. The second took place at the Burlington Fine Arts Club in London, and it must have surprised visitors by revealing how rich English collections already were in this as yet little-known field. Besides leading to a vast growth in Sienese scholarship (and, as has been recently emphasised, to the formation of an enterprising new school of forgers[29]), both exhibitions drew yet further attention to the prestige of 'primitive' painting. The Germans were not going to be left out, and, also in 1904, they mounted a major exhibition of works by painters of the school of Cologne, Wesphalia and elsewhere.

How competitive such enterprises had become can be gauged from a speech made in 1906 by the man who, four years earlier, had been responsible for having inaugurated the whole series in Bruges: 'What were the consequences of these exhibitions [in Paris, Siena and Dusseldorf]?', he asked rhetorically. 'To raise still higher the success of the one in Bruges and the glory of our school ... For our painters dominated their rivals and reigned supreme. Flanders showed itself to be the richest and the most powerful of nations through the genius of her children. Rarely has ancient glory thrown a brighter light on a country'.[30]

The example set by this speech was not a happy one, but (as I shall show) it was to be followed with great enthusiasm.

Chapter 7

Botticelli in the Service of Fascism

The strongly nationalist exhibitions discussed so far had two
features in common. Each was devoted either to a single master
(Reynolds, Rembrandt, Van Dyck, Cranach, Velázquez) or to a
single school and period (the 'primitives' of Flanders, Catalonia,
Siena and so on). And each took place in some city with which it
had an obvious relationship: London for Reynolds, Madrid for
Velázquez, Bruges for the Flemish. But after the First World War
many exhibitions of wider scope but strong national character
were exported to another country (it may be that both Old Master
exhibitions and exhibitions of modern art were here following
the example of trade fairs). One of the most remarkable of such
exhibitions was that devoted to Italian art that was mounted
in London in 1930.

The annual winter exhibitions held in Burlington House, the
premises of the Royal Academy, came to an end in 1914, but after
the war there was a great desire to revive them and even to surpass
them by including foreign loans. The first of these was the exhi-
bition of Spanish paintings held between November 1920 and
January 1921. There was at that period a special enthusiasm for
Spanish Old Masters among Royal Academicians (for example,
Sargent and Lavery, both of whom were on the exhibition com-
mittee), as well as among artists and critics of a younger genera-
tion, including both Augustus John and Roger Fry. The project
was announced at the Royal Academy's annual banquet to great
enthusiasm, but it is not clear exactly with whom the idea origi-
nated. The president of the Academy, Sir Aston Webb, certainly
welcomed it and served (together with five dukes and two earls)
on the British committee.[1]

In any case, the exhibition was possible only because of the support of a Spanish committee, headed by the duke of Alba, which secured loans not only from many private but also some public collections in Spain. Notable paintings were sent from the museums of Valencia and Seville, also from the Accademia di San Fernando, and the Spanish crown lent much, including a major El Greco from the Escorial. The king of England was also a lender, and masterpieces came from Longford Castle, Luton Hoo and Apsley House. Nothing was lent by the National Gallery or the Prado – although the exhibition was hung by the director of the Prado, Aureliano de Bervière. It opened on 4 November and was a popular success, acclaimed by the critics chiefly on account of the El Grecos and especially the Goyas (Velázquez, Zurbarán and Murillo were more familiar to them). Goya's *Self-portrait at an Easel* was lent by the count of Villagonzalo, his *Swing* by the duke of Montellano, his portrait of the duke of San Carlos by the marquis de la Torrecilla. The exhibition also provoked some controversy: Spanish critics were shocked by the 'bull's blood' colour of the wall fabric and the way it was covered in holes from previous exhibitions, and they found the principle of numbering puzzling.[2] But the chief problem for both Spanish and British critics was the emphasis on modern Spanish art. The monotony of subject matter – peasant after peasant, 'apparently from the same family', with the 'same mindless smile'[3] – excited dismay, as did the sheer number of modern exhibits – 'so many of them and many so alike, yet nearly all making a vivid and fierce bid for our attention'.[4] (It is startling to discover that many of those pictures were for sale.) As a propaganda exercise it was thus a limited success, and the criticism concerning it took up some of those themes that had been so painfully aired a hundred years before in the quarrel between the academicians and the British Institution.

The exhibition was represented in some quarters, however, simply as a great triumph for Spain. The highly influential Italian art critic and journalist Ugo Ojetti, writing in *Dedalo*, chose to describe it without qualification as 'an official exhibition, a government exhibition, an act of national propaganda'.[5] Italy, he urged, should follow the Spanish example. Beauty may not rule the world, but it helps. There were 'tens of thousands of visitors; endless debates and articles; the attention of London, of the London that matters, was fixed on Spain'. It was time to stop

being fussy and feeble. Italian art was not the property of petty civil servants – 'signori funzionarii' – it was the ornament and glory of the nation, and national prestige, to say nothing of economic strength, demanded that it be sent abroad. A few months later he noted the success of modern French art and French furniture old and new in Germany and of an exhibition of Dutch Old Masters – 'il trionfo di Vermeer' which will be discussed later – in Paris. Perhaps Italian officials did not have faith in modern Italian art: 'they are wrong, but for the sake of argument let's agree. Take the art of the past. There are seven or eight centuries and a hundred local scholars to choose from'.[6] One can see that there was a readiness among a vociferous section of patriotic Italians to lend their treasures. Nevertheless, the idea of an Italian exhibition originated in Britain.

It became impossible for the Royal Academy to continue promoting international loan exhibitions, and subsequent ones were to be organised with the consent of the academicians rather than at their instigation (they also, of course, demanded a fee). The exhibition of Swedish artists of the late nineteenth century which opened early in 1924 was arranged by the 'Anglo–Swedish Society',[7] and the far more ambitious *Flemish and Belgian Art 1300–1900* three years later was organised by the Anglo–Belgian Union. This really was a 'government exhibition'. It not only had royal patronage, as did the Spanish exhibition, but was organised 'with the co-operation of the Belgian government'. The Union aimed to 'promote the friendly intercourse between two great countries, lately united in no common bond' – in other words to keep alive the alliance of the First World War. The exhibition announced itself – fairly enough – as the first 'important international exhibition of Old Masters' to be seen in London since the Spanish exhibition.[8] It immediately stimulated a Dutch exhibition of even greater strength organised by the Anglo–Bavarian Society and including spectacular loans from public collections (among them Rembrandt's *Jewish Bride* and Vermeer's *View of Delft* (pl. 52)). And it also inspired Ivy, Lady Chamberlain, the wife of Sir Austen Chamberlain, the foreign minister in the Conservative government, to promote the idea of an exhibition of Italian art.[9] She and her husband constituted an exceptional couple in the history of English political life: they shared a deep and well-informed love of travel and art about which they wrote an

engagingly enthusiastic book.[10] She loved Italy; she loved art; and she had a soft spot – to say the least – for Mussolini, and even for fascism.[11] She was a powerful woman, an indefatigable correspondent and an effective organiser – and she had a vision. It was realised on 20 December 1929.

It was then, nine days after leaving Genoa, and having been badly battered by tempestuous waves off the coast of Brittany, that the Italian ship *Leonardo da Vinci* berthed at the East India Dock in the Port of London and began to discharge what was perhaps the most remarkable cargo ever to be brought into England. It included Botticelli's *Birth of Venus* (pl. 34) and Piero della Francesca's *Duke and Duchess of Urbino* from the Uffizi, Donatello's *David* from the Bargello, Giorgione's *Tempesta* from the collection of Prince Giovanelli, Titian's *La Bella* and '*Portrait of an Englishman*' from the Pitti, Masaccio's *Crucifixion* from Naples, Piero's *Flagellation* from Urbino, Carpaccio's so-called *Courtesans* from the Accademia in Venice – to choose a few items at random. In charge of these and several hundred other works of art was the director of the Brera and Soprintendente delle Belle Arti of Lombardy, Ettore Modigliani. Obviously, his achievement in assembling these works depended upon government support, and it hardly comes as a surprise to discover that the first step taken by Modigliani when the unloading had been completed was to send a telegram addressed to 'Eccellenza Benito Mussolini, Roma': 'Happy to set your mind at rest by informing you that all five hundred packing cases have been opened and everything has been found absolutely intact.'[12]

However, according to the younger Roberto Longhi, Modigliani comported himself as if he were Sir Francis Drake, presenting to Queen Elizabeth 'i tesori della "Invincibile Armada"',[12] although in this context, Queen Elizabeth was Lady Chamberlain and the setting was the Royal Academy. Her idea for an Italian exhibition seems to have crystallised in the summer of 1927,[14] and with the help of Sir Robert Witt she chose a small committee, at whose first meeting, held in her house on 19 December, she was unanimously elected to the Chair (pl. 27).[15] Not long before, she and Witt had approached the president and secretary of the Royal Academy about the possibility of hiring gallery space. They received non-committal answers with the only really positive note coming from the president, Sir Frank Dicksee, who ended his letter to Lady Chamberlain by emphasising that he entirely agreed with

her idea that no modern art should be included: 'There would be no knowing what you might be asked to take'.[16] (Recollections of the Spanish exhibition may have been influential on them both.) This was probably the high point in the relationship between the committee and the Academy which soon deteriorated seriously. The Academy was 'surprised . . . that anyone should think that the loan of the galleries could be settled in this casual way';[17] the committee was still more surprised – indeed it was outraged – by the terms demanded by the Academy: half the net profits accruing from the exhibition in addition to £150 a week for the hire of the galleries.[18] An acrimonious correspondence ensued, and even after the exhibition had opened and was turning out to be an unparalleled success the new president felt compelled to write to *The Times* to confess that he, too, was 'surprised' at the 'absurd' behaviour of the committee, which, without having first consulted him, had apparently encouraged a number of eminent people to urge that the closing date should be postponed.[19] Lady Chamberlain quickly discovered that the main obstacles to her plans tended to come from Piccadilly and Trafalgar Square rather than from Rome.

Some rather cryptic allusions in an exchange of unpublished letters strongly suggest that she had, very sensibly, got in touch with the Italian embassy in London, and hence probably with Mussolini, well before approaching the president of the Academy or even her friends who were to be asked to join her committee.[20] Certainly Mussolini was to give the plan his enthusiastic support and, in a private letter, the ambassador was to refer to it as 'our . . . exhibition'.[21] This is not surprising. Alienating many by his constant meddling with an already dangerously unstable balance of power, Mussolini was anxious to retain the support of his friend the British foreign secretary: to gratify his wife by lending her any number of Italian masterpieces (for which he personally had no feeling whatsoever) must have seemed a blessedly trivial price to pay. Moreover, Mussolini's own prestige had still not fully recovered in England since he had been almost toppled from power three years earlier following the murder of Matteotti – as is demonstrated by Lady Chamberlain's chivvying of the Royal Academy because she feared what she coyly described as a 'change in the personnel of the Italian Government'[22] – whereas the preparation and holding of the exhibition coincided with (although it was obviously not uniquely responsible for) the climax of the

popularity, indeed the adulation, that he received in this country. Even the critic of the *New Statesman* was to declare that, 'However much we may growl about Fascism, this country is now permanently in debt to the Italian Government.'[23]

It was Mussolini who was ultimately responsible for the selection of the fifty-nine-year-old Ettore Modigliani as commissioner general of the exhibition, long after he had been undertaking all the duties of the post in an unofficial capacity. Although not (as far as is known) a Fascist, he was a natural choice. It was probably not just that he had been director of the Brera for twenty years and had had experience of mounting exhibitions at home and abroad; more influential was the fact that he had played an outstanding part in safeguarding Italian monuments during the war and had then been sent as cultural representative of the government to the Paris peace conference of 1919 charged with reclaiming 'the art treasures seized from us by Austria during the last two hundred years' – a task that he successfully carried out in the most melodramatic circumstances, which at one stage involved having to hide himself in a car and travel in disguise.[24]

Several months before Lady Chamberlain had contacted the Academy or called her first committee meeting Modigliani sent a letter from Milan to the Italian ambassador in London to discuss the mooted exhibition, about which he must have heard in private: 'You may object that I see things on too grand a scale', he wrote, 'but I am of the opinion that an exhibition of Italian art in London should really "épater" the English so as to show that although Italy has been robbed and looted for centuries she still remains a great lady when she opens up her own treasure chests.' He was therefore in favour of seeking loans only from Italy, and as a start he suggested decorating one room with Prince Trivulzio's famous tapestries of *The Months* (pl. 28), which had been designed by Bramantino and commissioned by an ancestor of the prince from a workshop in Vigevano early in the sixteenth century.[25] This was the first recommendation for a loan. It became the most frustrating, and – as will become apparent – it was to prove disastrous for Modigliani's career. It was eagerly taken up by the English, but Prince Trivulzio remained adamant in his opposition. Although he had, at an early stage of the planning, gone out of his way to emphasise how keen he was to help the exhibition, he turned down repeated requests, both pleading and indignant – from the

local prefect and soprintendente, from Mussolini and from Lady Chamberlain – to lend anything at all. This was almost certainly because Modigliani had in the meantime informed Trivulzio that the additional items in his family collection were to be 'notificati' in addition to those whose movements were already subject to restrictions by law.[26]

Although an Italian committee was eventually set up,[27] the only member of it who played a role in suggesting loans was Modigliani himself,[28] and even he was wholly subordinated to the English committee, about whose requests he was to express the strongest reservations in private: 'between ourselves', he wrote, 'they are leaking all over the place: they have included some rubbish unworthy of an exhibition of this kind and omitted other first-class and particularly interesting works that would not be difficult for me to obtain.'[29] 'Contenti loro, contenti noi', as he summed up his English colleagues in a moment of baffled resignation.[30] But these differences, which were echoed by English contempt for the hopeless inefficiency of Italian bureaucracy,[31] were to develop only later. For some months silence prevailed. It was not until 13 February 1928 that the first official announcement was made of the projected exhibition, and of Mussolini's support for it, in the form of a letter to *The Times* from Sir Robert Witt,[32] but astonishingly enough it was not until nearly four months later that the news became known to some of the authorities in Italy who were to be most closely involved with it. On 4 June the under secretary of state for education wrote directly to Mussolini to tell him that Lady Chamberlain and Lady Colefax (the well-known society hostess, who had been brought on to the committee) had arrived in Rome and were staying at the British Embassy. According to rumours they had come to organise an art exhibition. It would, the minister warned, be most dangerous for great works to travel, and there was a risk that any sent from private collections would be sold abroad. Why not propose instead one devoted to nineteenth-century and modern pictures?[33] A fortnight later it was the turn of Arduino Colasanti, Direttore Generale delle Antichità e Belle Arti, to express his hostility: he had, he insisted, known about the proposals for the exhibition for a long time, and he had at once warned everyone, including Mussolini himself, of the dangers it would pose. By now, however, it was too late, because Mussolini had already agreed to give his support – but he had done so only because Lady Chamberlain had

agreed not to ask for major works from public galleries. But, having just met Lady Chamberlain in Rome, Colasanti had been appalled when she had shown him the list of masterpieces that she was intending to ask for.[34] When he explained the new situation to Mussolini, he was told that 'political reasons' made it impossible for the Duce to go back on his promise to her, but the two men tried 'with the greatest delicacy' to convince her that the exhibition would be far more rewarding if it was confined to small pictures from private collections and provincial museums which English tourists never had the chance of seeing during their Italian holidays.[35] But this was hardly what Lady Chamberlain had in mind, and within a few months she had persuaded Mussolini to lift any embargo on the loan of major works.[36] He instructed the government to co-operate fully,[37] and he himself signed a circular that was sent to prefects throughout Italy to serve as a covering letter to accompany loan requests. 'It is my understanding', the circular began,

> that the Exhibition of Italian Art, due to open in London in January, constitutes an exceptional manifestation of *italianità* ... I request Your Excellency to engage yourself personally, in the most effective possible manner, with owners, both institutional and private, to ensure that the works of art requested should be conceded, without any exception whatsoever. Your Excellency will explain to the owners approached that the government attaches particular importance to the success of the exhibition and that I count on their co-operation.[38]

It was only now, little more than six months before the opening date of 1 January 1930, that serious action began to be taken.

Mussolini's directive meant that, with one or two exceptions, which I shall discuss later, there were no real problems about borrowing any of the leading masterpieces from any of the leading Italian museums on which the selection committee had set its heart – unfortunately there is no record of who among this group (which included Lord Balniel, Sir Robert Wilt, Archibald Russell, Roger Fry, Kenneth Clark, W. G. Constable and Charles Ricketts) were responsible for individual choices. It is true that one or two of the more independent-minded museums did what little they could to resist. Thus, Mussolini was informed by the prefect of Milan that the Poldi-Pezzoli refused to lend the famous *Portrait of a Lady* by Antonio del Pollaiuolo because its prominent location had turned

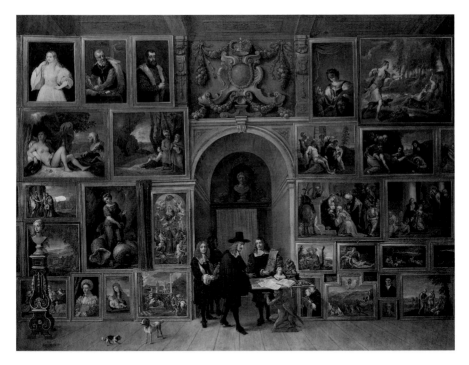

1 David Teniers, *Gallery of Archduke Leopold*. Brussels, Musées Royaux des Beaux-Arts de Belgique.

2 Nicolas Poussin, *Sleeping Venus gazed at by a Satyr*. Zürich, Kunsthaus.

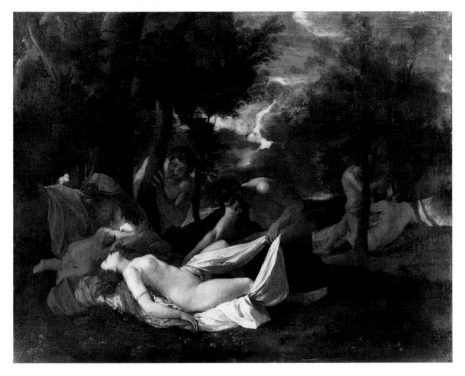

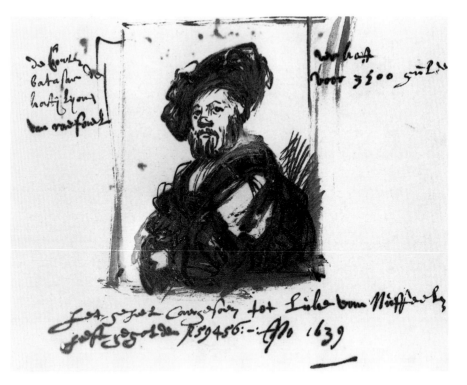

3 Rembrandt, drawing after Raphael's portrait of Castiglione. Vienna, Graphische
Sammlung Albertina.

4 Antoine Watteau, *Shopsign for the Art Dealer Gersaint*. Berlin, Schloss Charlotten-
burg.

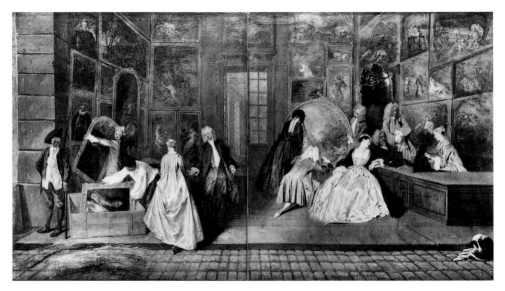

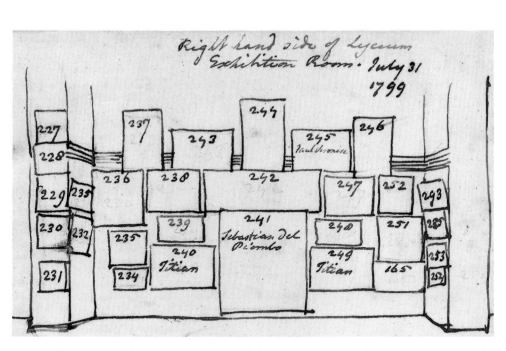

5 Joseph Farington, diagram of one side of the Great Room in the Lyceum, showing the arrangement of the Orléans pictures in July 1799. Sebastiano's *Raising of Lazarus* (no. 241; National Gallery, London) is flanked by Titian's *Diana and Actaeon* and *Diana and Callisto* (duke of Sutherland's collection, on loan to the National Gallery of Scotland). Above, two of Veronese's allegories (National Gallery, London) flank the Le Brun (no. 244; pl. 7).

6 Joseph Farington, diagram of the arrangement of the Orléans pictures in the small room in Bryan's gallery. Raphael's round *Holy Family with a Palm Tree* (no. 113; duke of Sutherland's collection, on loan to the National Gallery of Scotland) dominates one wall, and Titian's *Noli me Tangere* (no. 119; National Gallery, London) is in the centre of another.

7 Charles Le Brun,
Hercules destroying the
Horses of Diomedes.
Nottingham Castle Museum
and Art Gallery.

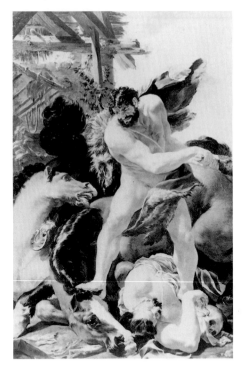

8 (*below*) Annibale
Carracci, *Dead Christ*
Mourned ('The Three
Marys'). London, National
Gallery.

9 Maria Cosway, etched and hand-coloured plate showing paintings by Raphael, Titian, Guido Reni and others, plate 1 of eleven plans remaining in the fragment of the volume *Galerie du Louvre* (1802–3).

10 (*above*) William Hogarth,
*Marriage à la Mode, IV: The
Countess's Morning Levée*.
London, National Gallery.

11 Giovanni Battista Moroni,
*Portrait of a Scholar: Giovanni
Bressani*. Edinburgh, The National
Gallery of Scotland.

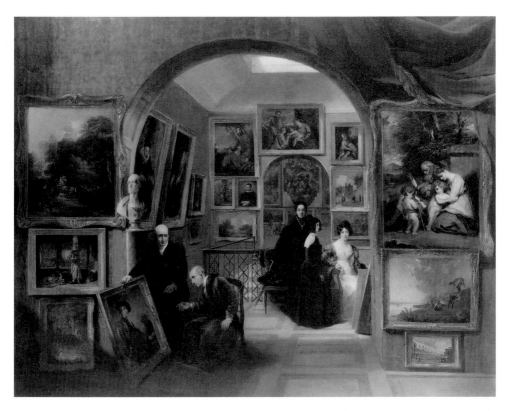

12 John Scarlett Davis, *Interior of the British Institution Gallery*, 1829. New Haven, Yale Center for British Art, Paul Mellon Collection.

13 Henry Jamyn Brooks, *Private View of the Old Masters Exhibition, Royal Academy, 1888*, 1889. London, National Portrait Gallery.

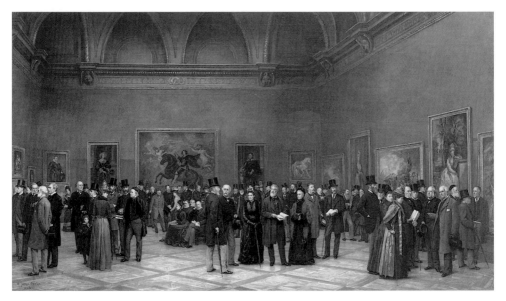

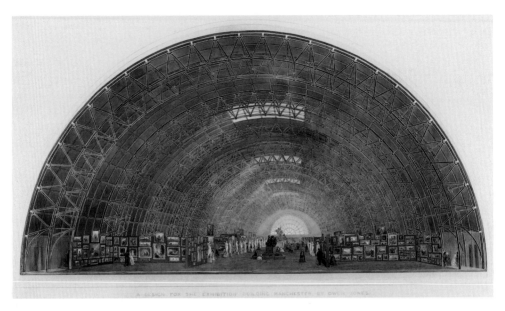

14 Owen Jones, *Design for the Exhibition Building, Manchester*.

18 Fra Angelico, *The Last Judgement* (central panel). Berlin, Gemäldegalerie, Staatliche Museen Preussische Kulturbesitz.

19 (*above*) Gerard David, *Adoration of the Magi*. London, National Gallery.

20 Lorenzo Costa, *A Concert*. London, National Gallery.

Quadro di Giovanni Holbein
dalla Galleria Reale di Dresda
Alto piedi 5 onc. 8. Largo pi. 3. onc. 8.

Tableau de Jean Holbein
de la Galerie Roiale de Dresde
Haut 5 pieds 8 pouc Large 3 pieds 8 pouc

21 Lorenzo Quaglio, engraving of the seventeenth-century copy of Holbein's 'Meyer Madonna', Dresden, Gemäldegalerie. Oxford, Ashmolean Museum.

22 Hans Holbein the Younger, '*Meyer Madonna*'. Darmstadt, Schlossmuseum.

23 Domenico Caprioli, *A Pair of Lovers and a Pilgrim in a Landscape*. Private Collection.

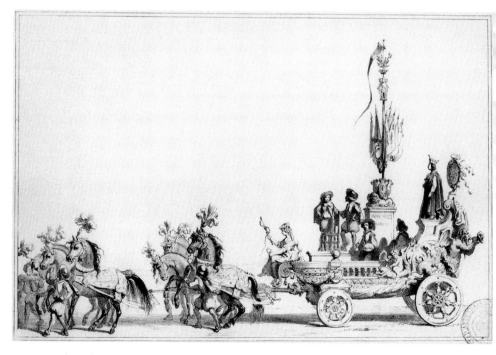

24 *Fête de Rubens, 15 August 1840. Chariot of Triumph, made on the occasion of the bicentennial Fête de Rubens after drawings by Rubens.* Antwerp, Stadtsarchief.

25 and 26 Room 30, wall A, and room 26, walls A–B at the Rembrandt-teentoonstellung of 1898.

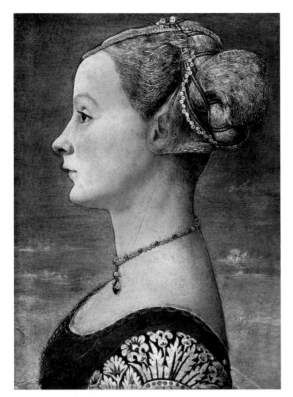

29 (*left*) Antonio del Pollaiuolo, *Portrait of a Lady*. Milan, Museo Poldi Pezzoli.

27 (*facing page top*) Lady Chamberlain standing in front of Titian's *Pesaro Madonna*, with colleagues on the hanging committee for the exhibition of Italian art at the Royal Academy, 1930: on her right, Sir Robert Witt and Charles Ricketts; on her left, W. G. Constable and Ettore Modigliani. *Nottingham Guardian*, 24 December 1929.

28 (*facing page bottom*) Benedetto da Milano, after cartoons by Bramantino, *September*, one of twelve tapestries of the Months. Milan, Castello Sforzesco.

30 (*below*) Titian, *Vendramin Family*. London, National Gallery.

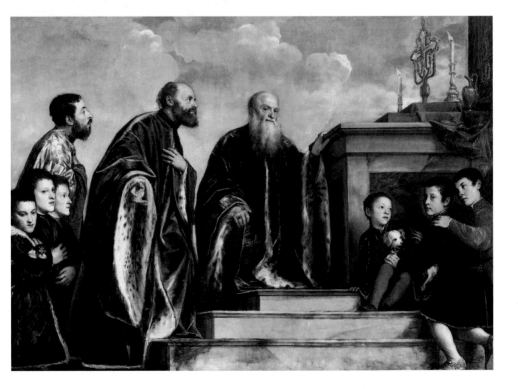

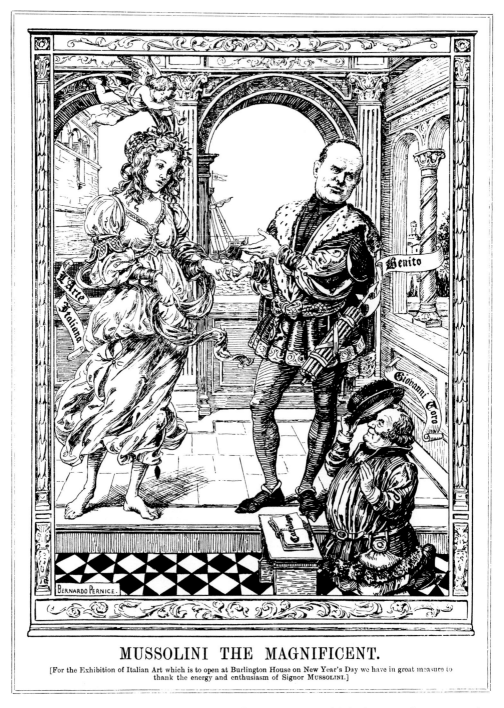

MUSSOLINI THE MAGNIFICENT.

[For the Exhibition of Italian Art which is to open at Burlington House on New Year's Day we have in great measure to thank the energy and enthusiasm of Signor MUSSOLINI.]

31 Bernard Partridge, *Mussolini the Magnificent*, cartoon published in *Punch*, 18 December 1929. ('Pernice' is Italian for partridge; 'Giovanni Toro' is John Bull.)

32 Interior of the Italian embassy, London, with the ambassador's wife, Signora Grandi, seated below the 'Botticelli'.

33 Central Italian (formerly attributed to Piero della Francesca), *Virgin and Child*. Venice, Galleria di Palazzo Cini.

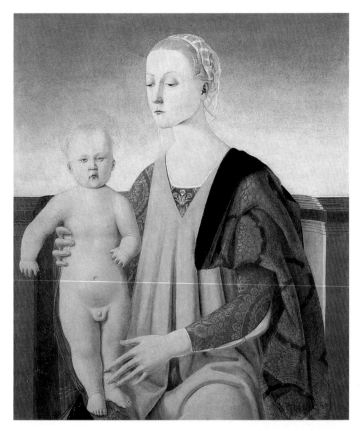

34 (*below*) Sandro Botticelli, *Birth of Venus*. Florence, Galleria degli Uffizi.

35 Master of the
Lansdowne Concert
(formerly attributed
to Palma Vecchio
and to Giorgione),
Concert. Private
collection.

36 (*below*) Otto
van Veen, *Self-
portrait,
surrounded by his
Family*. Paris,
Musée du Louvre.

37 Caravaggio, *Death of the Virgin*. Paris, Musée du Louvre.

38　G. B. Piazzetta, *Ecstasy of St Francis*. Vicenza, Pinacoteca Civica.

39 Alessandro Magnasco, *The Refectory*. Bassano, Museo Civico.

40 *(facing page top)* Augustus John, *Symphonie Espagnole*, as reproduced in the *Illustrated Souvenir of the Palace of Art at the British Empire Exhibition* (Wembley, London, 1924).

41 *(facing page bottom)* Robert Humblot, *The Card Players*. Private collection.

42 Francesco Guardi, *View of the Lagoon*. Milan, Museo Poldo Pezzoli.

43 Louis Le Nain, *Repas des Paysans*. Paris, Musée du Louvre.

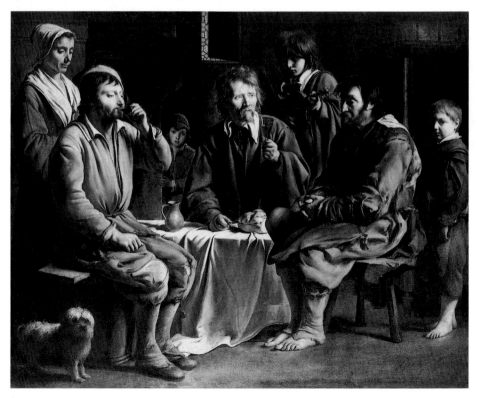

44 Philippe de Champaigne, *Young Girl with a Falcon*. Paris, Musée du Louvre.

45 *(below)* Jean Michelin, *The Baker's Cart*. New York, The Metropolitan Museum of Art, Fletcher Fund, 1927 (27.59).

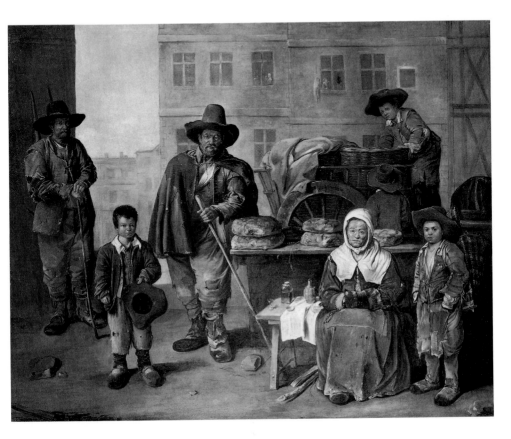

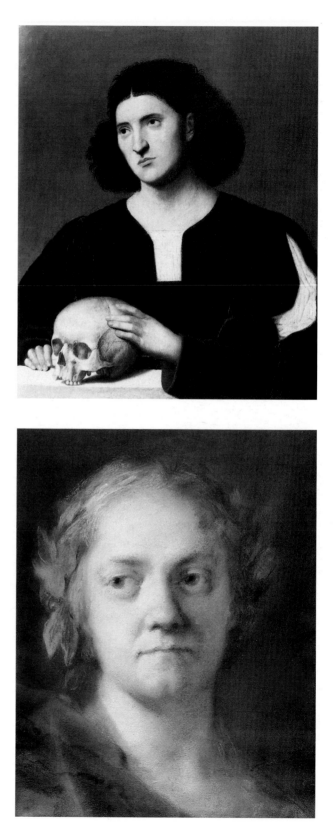

46 Bernardino Licinio,
*Portrait of a Young Man
with a Skull*. Oxford,
Ashmolean Museum.

47 Rosalba Carriera,
Self-portrait. Venice,
Gallerie Accademia.

48 Master of the St Ursula Legend, *Ursula leaves, in a Company of 11,000 Virgins, the King and Queen of Burgundy (her parents) and a High Dignitary*. Bruges, Stedelijke Musea.

49 Jan van Eyck, '*Lucca Madonna*'. Frankfurt am Mein, Städelsches Kunstinstitut.

50 and 51 The Dutch rooms in the Hudson-Fulton exhibition at the Metropolitan Museum of Art, New York, 1909.

52 (*above*) Johannes Vermeer, *View of Delft*. The Hague, Mauritshaus.

53 Marcel Proust outside the Jeu de Paume, Paris, on his visit to see Vermeer's *View of Delft*.

it into a symbol of the collection as a whole (pl. 29).[39] To this Mussolini replied that the English had wanted this picture more than any other in the museum, and he trusted therefore that the director would change his mind[40] – as he quickly did,[41] with the result that the picture retained its prestige by being used to adorn the poster of the London exhibition.

But even token resistance was exceptional. Whatever their directors may have felt in private, the Pitti[42] and the Naples gallery could make no public objection to sending Raphael's *Donna Velata* or Giovanni Bellini's *Transfiguration*, to add just two more very celebrated pictures to those already referred to. It had, however, been agreed that the Soprintendenti could turn down requests for pictures that were not considered fit to travel, and presumably this is the reason why Domenico Veneziano's *St Lucy* altarpiece in the Uffizi galleries did *not* come to London, despite the fact that all its five predellas were borrowed: two from the Fitzwilliam Museum in Cambridge, one from the Contini collection in Florence,[43] and one each from the Kaiser-Friedrich Museum in Berlin and a private collection in New York, thus enabling scholars to reconstruct their original arrangement.[44] The arrival of these last two pictures raises points of some interest. Berlin agreed to lend everything that the committee had asked for except a Raphael, but – as the British ambassador explained to Lady Chamberlain – the Prussian minister for the fine arts did so on the understanding that there was 'every prospect of reciprocity in the future of the loan of pictures'[45] – an issue that was raised again and again during the course of the exhibition, but that was taken no further for a generation. That the *St John* predella came from New York was almost certainly owing to the efforts of Lady Colefax, whose presence on the committee must have been a recognition more of her cultivation of rich and distinguished Americans than of Italian art,[46] and she is, indeed, known to have played a significant role in securing loans from the United States.[47]

Social connections of this kind were clearly important. From Claridge's the duke of Alba sent a note to Lady Chamberlain to let her know that he had spoken to the king of Spain who had agreed to lend Tintoretto's *Washing of the Feet*, then in the Escorial, if it was in a fit state to travel,[48] and Lady Chamberlain quickly resorted to that useful tactical move (so familiar to anyone who has been involved in the organisation of an exhibition) of

writing, in slightly exaggerated terms, to other potential lenders that 'King Alfonso is lending pictures from the Escurial'.[49] The fact that the Tintoretto never actually came to London may perhaps have been owing to the fact that the king's own situation was becoming so precarious – he was forced to leave Spain in 1931 – that he was no longer in a position to fulfil his promise. One does also wonder whether either Lady Chamberlain or King Alfonso had had any idea of how large a painting it was.

It was, however, London rather than Berlin or Madrid that presented Lady Chamberlain with her most tiresome problems. Negotiations with the Royal Academy about respective shares of the hoped-for profits were still dragging on – indeed, they were about to become so bitter as to threaten a breakdown[50] – when in June 1929 the first serious attempts were made to borrow from the National Gallery its latest acquisition, Titian's *Vendramin Family* (then known as *The Cornaro Family* (pl. 30)). This was in the process of being bought from the eighth duke of Northumberland, who, before the sale, had (so it was said) refused to lend it to the exhibition,[51] but his views were by now irrelevant because the National Gallery was apparently forbidden by law to lend any of its pictures. However, within a fortnight of becoming prime minister, Ramsay MacDonald, who was both a trustee of the National Gallery and an honorary president of the exhibition, offered to introduce a bill to Parliament that would allow an exception to be made in this case. The trustees of the National Gallery did not accept his offer, but decided to take legal advice about the extent of their powers. However, when they were informed that, because of a legal technicality, they did have the right to lend their picture to Burlington House, they could not make up their minds as to whether they wanted to do so. Lengthy discussions among the trustees ensued, and the votes (which exceptionally included proxy votes) were fairly evenly divided. Ramsay MacDonald and Joseph Duveen (who had himself been trying to buy the Titian) supported the proposal, but they met formidable opposition from their chairman, Lord Crawford – whose son Lord Balniel, like him a dedicated lover of the arts, was on the selection committee of the exhibition. Crawford was, in fact, opposed to allowing loans on any occasion, and some of his arguments still carry great weight: the danger of travel for vulnerable works of art and the removal of pictures from a museum in which they could be seen free to a location that

charged for entrance. But his quite particular dislike for Lady Chamberlain's project can be sensed in the exaggerated language with which he denounced the inconvenience the loan of the Titian would cause: 'I do not', he wrote on 2 August 1929, 'feel much influenced myself by the fact that the Italian government is sending good pictures for the exhibition: on the contrary I feel that it is all the less needful for us to sacrifice one of our best works'; and then, on 16 October, one day after the final vote had at last gone against him, he concluded his rhetoric with an observation that, as far as I know, was unique at the time: 'Frankly and without any disguise I stand for Britain first, and I regret that we should denude ourselves in order to boost a movement which is political in its fundamentals'.[52] Lord Crawford need not have been so dismayed, because the loan of the 'Cornaro Titian' was not allowed to set a precedent.

In August, while uncertainty still prevailed as to whether the National Gallery was to be 'denuded' of the picture for a couple of months, Lady Chamberlain felt emboldened enough by Mussolini's decisive support to approach the one museum in Italy over which he had no control, the Vatican. The moment was a promising one because the Lateran Treaty, concluded a few months earlier, had at last put an official end to the conflict between the Italian state and the papacy, and Dino Grandi (the foreign minister) went out of his way to send Lady Chamberlain a set of photographs of the ceremony, signed by Mussolini and the Vatican secretary of state, Cardinal Gasparri, in addition to the unsigned set she had already received.[53] This may have seemed a good omen. A few weeks later she made arrangements for Modigliani and W. G. Constable to call on the curator of the Vatican museums[54] and followed this up with a letter to Cardinal Gasparri himself. Unfortunately, we do not know what she asked for, but this hardly matters because after he had shown her letter to the pope he wrote back to say that it was impossible to oblige her: nothing had ever been lent before – indeed, when, during the war, the French had asked to borrow Raphael's *Transfiguration*, this had been refused. To agree to the English request not only would create a precedent for other countries but would disappoint visitors to the Vatican who expected to be able to see all the masterpieces listed in the catalogue.[55] Somewhat disappointed, but expressing her understanding of the pope's decision, Lady Chamberlain then came back with an alternative proposal:

We have in our National Gallery the central panel of an altar-piece by Cossa. The wings are in private collections and the predella ... is in the Vatican Gallery. We have succeeded in obtaining the loan of the two wings from their present owners. If His Holiness will consent to lend the predella the Trustees of the National Gallery will lend the centre and for the brief space of our Exhibition the altar-piece would be reunited and the whole as conceived and executed by the artist could be seen together by the art lovers of the world. Surely such a unique case can never form an embarrassing precedent nor will the absence of this small panel be marked by visitors amidst all the wealth of the Vatican galleries.[56]

The letter is a very mysterious one. At that time the National Gallery's painting of *Saint Vincent Ferrer* (then often believed to represent St Hyacinth) was, by common consent, considered to be the central panel of a triptych, of which the two wings had, since 1893, been in the Brera, the museum of which Modigliani himself was director and, by no stretch of the imagination, a private collection. Moreover, it was not until 11 November, three weeks after Lady Chamberlain had drafted her request to Cardinal Gasparri that the National Gallery was officially approached about the possible loan of the central panel[57] – although informal soundings must presumably already have been taken.

By now two new developments had occurred: Lady Chamberlain had evidently discovered the true location of the wings, and the Brera had agreed to lend them; and the Vatican had once again explained that it could not lend anything from its own collections. However, in order not to disappoint the English committee and to make possible its laudable plan of reconstructing what was believed to be the original appearance of the whole altarpiece, the pope specially commissioned a copy of the predella which was to be presented to the National Gallery.[58] In these circumstances the National Gallery agreed to lend its own panel to Burlington House,[59] and all seemed to be satisfactory – so satisfactory that in its January issue the *Burlington Magazine* published – in advance of having seen the exhibition, of course, and without any comment in the text – a photo-montage of the unframed Cossa 'triptych' (i.e., the London and Brera panels and the Vatican predella) as being among 'a few of the many paintings which, for one reason or another, may be expected to appeal especially to those who read

this journal'. However, by then, yet another extraordinary development had taken place. We read in a letter from the director of the National Gallery that 'A curious thing has happened. It appears that Modigliani in his wrath at His Highness the Pope for not letting his Exhibition have the Saint Hyacinth predella refuses to show the copy which the Pope has sent and also refuses *our* Cossa. It is very childlike if not childish. I thought that by no means all Italians would accept Mussolini's concordat with the Vatican.'[60] Whether or not Modigliani's response was motivated by petulant anti-clericalism, as seems to be suggested here, or whether (as is just possibly implied in another letter[61]) he merely felt that the Brera wings would not harmonise with the modern copy of the predella is not clear; but the episode certainly caused great embarrassment. W. G. Constable was instructed to thank the Vatican but on no account to explain that the predella would *not* be exhibited at Burlington House,[62] and Lady Chamberlain told the British legate to the Holy See to inform Cardinal Gasparri that the National Gallery had refused to lend its own panel[63] – a statement that was the direct opposite of the truth, but that was presumably designed to avoid offending the pope. Thus, as it turned out, it was a decision of the committee (or, more specifically, of Modigliani) that was responsible for the whole ambitious project falling through, and Cossa was represented at Burlington House only by two studio drawings.

Within Italy itself it was, of course, private collectors who were in a stronger position to refuse loans than were government-controlled museums – although even they could often be won round if enough pressure was applied. Thus the committee was particularly keen to borrow a (still puzzling) picture attributed to Piero della Francesca, now in the Cini collection in Venice, but then in the possession of the marchese di Villamarina in Rome (pl. 33).[64] At first he refused to lend it on the grounds that its condition made it unsuitable to travel, but the Italian government, including Mussolini himself, showed a direct interest in the affair,[65] and the picture duly arrived at Burlington House – only to be recorded in Kenneth Clark's catalogue with the words: 'no authoritative critic believes this to be a work of Piero himself . . . [and] Berenson's theory that this is an early work of Signorelli can hardly be maintained'.

An exact opposite to the case of the Villamarina 'Piero' was that of the Papadopoli Tiepolos in Venice. This artist was due to be

represented by some superb 'history' pictures, but the English committee had particularly wanted two (admittedly very fine) genre scenes which are now attributed to Giandomenico, the *Minuet* and the *Charlatan*, both now in the Barcelona museum. The family had offered to lend them and had the support of the government, but they were prevented from doing so by the local Soprintendente who feared – rightly, as it turned out – that they wanted to sell them abroad.[66]

There was one private owner in Italy whom even Mussolini could not intimidate – although efforts were certainly made to embarrass him. Victor Emmanuel III had been declared a patron of the exhibition as soon as arrangements to hold it had been made public. However, on 5 November 1929, less than two months before it was due to open, Ugo Ojetti, who was himself on the Italian committee, and who had long cherished the hope that an exhibition of this kind would take place, was sitting next to him at dinner and recorded in his diary that His Majesty knew absolutely nothing about the exhibition or the fact that works by Botticelli, Piero, Verrocchio and Donatello were already being moved from Florence. 'What do you think about it?' asked Ojetti. 'Many people are against it.' To which the king replied: 'I am very much against it' ('Io sono contrarissimo').[67] Victor Emmanuel's ignorance was feigned, but his opposition was perfectly genuine. A few weeks earlier Modigliani had written in some alarm to the prefect of Turin to emphasise that the extreme generosity over loans shown by the king of England made it essential that the Italian royal family should send at least one masterpiece and had suggested that Pannini's view of Palazzo del Quirinale would be ideal. To this the minister of the Royal Household had answered that, unfortunately, this was impossible, as the picture was attached to the wall, although the king would be happy to lend something else. Modigliani was understandably not very convinced that no screw driver could be found in the royal palace, and he also pointed out that no other picture belonging to the king was worthy of representing 'our beloved Sovereign'. His refusal to lend would create a most painful impression in London, and – owing to his 'squisitissima sensibilità' – he himself would surely realise this. Could not the heir to the throne try to intervene?[68] Evidently not, because the Pannini never came, although the king did eventually lend one book-binding and three drawings (two

of them by Leonardo) which belonged to the nominally 'Royal Library' of Turin.

However, the last and most conspicuous setback was far more sensational and resulted from a failure of nerve on Mussolini's own part. The story is best told in the words of the British ambassador in Rome writing to Lady Chamberlain on 11 November 1929 to report on his meeting with the foreign minister, Dino Grandi:

> what he told me about the Titian [the *Sacred and Profane Love*] was less satisfactory. I had said how much we would appreciate in England the kindness of the Italian Government in allowing this picture to leave the Borghese. Grandi interrupted me saying 'you must not go so fast; it is by no means certain that the picture will be allowed to leave, Mussolini wants to send it, and will do what he can, but the idea provoked a regular explosion at the *Belle Arti*, and the opposition to allowing it to leave is so strong that I doubt if even Mussolini can overcome it. He has already overridden all the art authorities here with regard to so many pictures that he may have to give way in this case'.

The ambassador ended by saying that 'it would be no good insisting further with Mussolini, who is doing all he can'.[69]

The incident clearly rankled with Lady Chamberlain who was not the kind of person to act on such prudent advice. On the day before the private view, she received a further letter from the ambassador, marked 'Strictly Private':

> I had rather a shock on receiving yesterday a telephone message from Signor Mussolini to say that he greatly appreciated the kind references in your letter but saw no reason whatsoever for sending a special message on the occasion of the opening of the Exhibition. I saw Grandi to-day and asked him what this message meant, saying that I could not possibly return such an answer to you. All we wanted was a message of good will and a few words would suffice.
>
> Grandi said that he had already tried to induce Mussolini to send the message but had failed. Finally I managed to draw from him, though he gave them with much reluctance, the real facts of the situation. It appears that Mussolini is thoroughly fed up

with the whole question of the pictures and can't bear any mention of them. In the first place he had to overcome the practically unanimous opposition of all the art authorities in letting the pictures go. Next there has been a difficult question as to who was to pay for the transport to London, all the departments refusing to do so. Eventually Mussolini had to send for the Minister of Communications and force him to pay. Then he was much criticised when there seemed a danger to them in the 'Leonardo da Vinci'. But what has upset him most is an article in an American paper giving the report, which went the round of Wall Street, that the pictures had been sent to London as security for a loan. The anti-Fascist paper in Paris, the 'Libertà' took this up and made the most of it. You know how Mussolini reacts to the press, and he became quite furious. Last of all he has received a request from America to send the pictures on there when London has finished with them and this has both irritated and embarrassed him.

However, I armed Grandi with a copy of the charming cartoon in 'Punch' showing Mussolini presenting 'Primavera' to John Bull [pl. 31], and he promised to see Mussolini again to try to induce him to send the message . . .[70]

Mussolini was *not* charmed – perhaps he was irritated that the ambassador could not even identify the correct Botticelli – nor can Lady Chamberlain have been gratified when, a fortnight later, he did get around to sending a telegram – not to her, but to the president of the Royal Academy, which had done everything to put spokes in her wheels.[71]

What emerged from all this activity, confusion, ill feeling – and breathtaking display? Most obviously, an exhibition the like of which had never been seen before. Inevitably, everyone therefore said that nothing like it would ever happen again – only to be proved quite wrong as invariably happens in such cases. Within five years the *Birth of Venus* and the *Tempesta* set off on their travels once more, accompanied on this occasion by Titian's *Venus of Urbino*, Leonardo da Vinci's *Annunciation*, Raphael's *Sposalizio*, Michelangelo's *Doni Tondo* and so on, their destination being the Petit Palais in Paris. The abundance and richness of the spectacle, claimed the French press, made it superior to that which had been seen in London.[72] Perhaps it was.[73]

The London exhibition opened on New Year's Day, 1930.

On the occasion of the private view arranged for members of the National Arts-Collection Fund, which (after hard bargaining carried out on its behalf) was awarded some £15,000 of the profits,[74] the traffic block extended to Harrods, and bus drivers at Cricklewood complained that they were an hour late.[75] The exhibition, open from 9.30 a.m. to 7 in the evening, was visited by nearly 540,000 members of the public (more than twice the number that had gone to the Dutch exhibition the year before), and its closing date was extended by two weeks. The press was, in general, enthusiastic, although it was reported that 'this exhibition, even more, perhaps, than previous ones, has raised a great deal of indignation in the breasts of perfectly sincere amateurs and lifelong students of Italian art'.[76]

Of about six hundred paintings on view, well over half had been lent from public and private collections in Italy (which also sent major sculptures by Verrocchio and Bernini, as well as illuminated manuscripts, drawings and works of decorative art). A quarter of the pictures came from collections in the United Kingdom, some thirty from the United States, and the remainder from France, Germany, Austria and elsewhere in Europe. The arrangement was basically chronological, but the most spectacular fifteenth- and sixteenth-century masterpieces were hung together in the main central gallery. The exhibition's title, *Italian Art 1200–1900*, gives a misleading impression both of its contents and of the impact that it made. The Italian committee had, from the first, been very keen to devote space to nineteenth-century pictures, and a room was duly set aside for them; but almost no one seems to have spent any time there, despite the presence of some works of real quality by Telemaco Signorini, Giovanni Fattori and Costa. Much more surprising is the indifference shown to painting of the seventeenth and eighteenth centuries, which had won widespread recognition at the celebrated exhibition held in Florence eight years earlier. It is true that the London selection was somewhat erratic, but it included such masterpieces as Caravaggio's *Rest on the Flight into Egypt* from the Palazzo Doria-Pamphilj in Rome, Magnasco's *Garden Scene* from the Palazzo Bianco in Genoa and Tiepolo's magnificent *Portrait of a Doge* from the Querini Stampalia in Venice. I have come across no evidence to suggest that the London exhibition played any part in stimulating a taste for the seicento in England of the kind that was already well under way in Italy and Germany: although the Royal Library lent many magnificent

drawings (which were catalogued, and presumably chosen, by A. E. Popham), they did not include a single one by Guercino. To all intents and purposes it was dominated by Berenson's view of a renaissance that ended with the death of Michelangelo, but that enjoyed a brief afterlife in eighteenth-century Venice.

Naturally, even within conventional limitations, a balanced representation of the Renaissance could not be achieved. One critic pointed out – with less than total accuracy – that to judge from what was to be seen in Burlington House, 'Cosimo Tura would appear to be one of Italy's greatest painters', and one would hardly be aware of the existence of Leonardo da Vinci.[77] The organisers were fully aware of this sort of problem. For example, there was an anxious moment when, as plans reached their very final stage, a series of refusals made it appear that Palma Vecchio would hardly be shown at all because Lord Lansdowne refused to lend his *Concert* (pl. 35) unless it was catalogued as by Giorgione – which Modigliani refused to do.[78]

Scholarly weaknesses were most evident in the catalogue (of which more than 151,000 copies were sold), described by Kenneth Clark (its principal compiler) as 'by a long chalk, the worst catalogue of a great exhibition ever printed'. The few pages of his autobiography devoted by Clark to what he called this 'infamous' exhibition[79] are entertaining and informative, but they are so coloured by retrospective guilt at having entered the art world by agreeing to take part in what was 'basically a piece of Fascist propaganda' that they are also misleadingly dismissive about his own capabilities as well as those of his colleagues. He may have been right about the vanity of W. G. Constable, 'an industrious official at the National Gallery', who was, as it were, lent by the trustees to the exhibition committee at the request of Lady Chamberlain,[80] but certainly nothing that I have read in the extensive papers of Ettore Modigliani and nothing that I have heard from those who knew him[81] gives any support whatsoever to the charge that he was 'a ridiculous figure by any standards'. He was to behave with dignity, although with a sense of utter despair, when in 1935, he was suddenly dismissed from his post in Milan following an intrigue that I have not been able to elucidate but that seems to have been engineered by Prince Trivulzio, owner of the famous, un-lent tapestries,[82] and 'exiled' to Aquila in the Abruzzi, only to lose his job altogether when Mussolini's anti-Jewish laws were put into effect not long afterwards.

In England it was Roger Fry whose public standing was, after that of Lady Chamberlain, most enhanced by the exhibition – though the juxtaposition of their names is a curious one. He was everywhere: at embassy and prime-ministerial banquets, lecturing at the Academy, broadcasting for the BBC,[83] writing an introduction for the monster, unmanageable, commemorative catalogue, contributing scholarly articles to the *Burlington Magazine*. His defence of the exhibition was unequivocal. To those – and we should remember that they included Mussolini – who worried about the risk of moving fragile pictures around the world he answered:

> I hope I may not be accused of iconoclasm when I declare that the worship of the masterpieces of ancient art may be carried too far and may even involve dangers to the objects of such work. The religion of art, like other religions, is liable to excesses of zeal ... Pictures ... may almost be said to need change of air and change of company. Immensely important as the material preservation of a picture is, its importance depends on the picture continuing to exercise its vital function of a source of spiritual life. And from that point of view if, as we have good reason to hope, no material damage will have been done to these incomparable works, how greatly their real value will have been increased.[84]

Fry's articles – like those of a few other art historians writing in the learned journals of the time – need to be mentioned not so much because of the validity or otherwise of their attributions, but because they demonstrate that, as was the case with the *Art Treasures* exhibition at Manchester in 1857, the large exhibition contained within it a number of smaller ones appealing to a smaller public. Thus Fry devoted a significant proportion of his articles to the half of a room devoted to the earliest Italian masters,[85] and in particular to 'that extraordinarily interesting and peculiar school of Rimini which flourished so brilliantly in the first half of the fourteenth century and disappeared later on so completely'. Yet despite the beauty of some of these pictures, it was not the early Baronzio who brought in the crowds, nor (whether rightly or wrongly) have Fry's researches into his development been much taken into account in the extensive literature on early Riminese art that has come into being since the London exhibition.

Although Mussolini's personal commitment had begun to falter

in the wake of Lady Chamberlain's relentless onslaughts, his motive for supporting the exhibition was clearly political: the promotion not so much of fascism itself as of fascism's intimate ally, *italianità* (the word he constantly used when bullying reluctant owners to lend their pictures). The Italian press made no bones about the relationship between these two ideologies: 'These masterpieces', wrote the *Corriere della Sera*,[86]

> are so many ambassadors which speak the universal language of art. With this language they will be able to support the Italian cause in face of the most obstinate calumniators, the sceptics, and those who are indifferent, and to make it remembered that Italy was always the first to blaze the trail of civilisation and of progress . . . The exhibition at Burlington House is a portentous sign of the eternal vitality of the Italian race which enabled it to be always and everywhere in the vanguard, leaving to others the freedom only to imitate . . .

The mounting of Old Master exhibitions to flaunt national prestige was already a well-established custom – in London and Paris, for instance, and in Antwerp, Bruges, Amsterdam, Dresden and elsewhere – but it was more unusual to promote them in foreign countries – the modern equivalents (as the *Corriere della Sera* had recognised) of those sumptuous embassies, whose official 'entries' had been designed to dazzle the capitals of Europe in earlier centuries. And London was indeed dazzled by the exhibition at Burlington House. The part played by Mussolini in giving so much pleasure to so many people was fervently acknowledged by politicians, by the press and by the public. Whether Mussolini himself and his advisers felt that so much trouble and expense (not to mention so many risks) had achieved a commensurate propaganda victory is less certain. He may well have felt that, after having first played the role of a man of power doling out largesse to pleading clients, he had somehow lost control of the situation and had ended by conveying the impression that it was he who was paying tribute to associates who had outmanœuvred him. It was, in any case, a victory that was to be effaced quickly enough. Within a few years the invasion of Abyssinia and the imposition of sanctions led to a crisis in Anglo-Italian relations that memories of Giorgione, Piero della Francesca and Botticelli in Burlington House could do little to mitigate, though Lady Chamberlain's gratitude to the Duce seems to have remained unimpaired. The

only direct evidence we have of an attempt to exploit the impression made by the exhibition on London society is gratifyingly trivial.

In 1932 Dino Grandi who, as foreign minister, had been deeply involved in the arrangements for the exhibition and had received more than his fair share of letters from Lady Chamberlain, was appointed Italian ambassador in London. On his arrival he was horrified to find the state rooms of the embassy looking like those in 'a second-class liner', and it was Modigliani who was entrusted with converting them into something 'worthy of Fascist Italy in the capital of the British Empire, as was the wish and intention of the Duce'.[87] Special financial grants were made, and pictures optimistically attributed to the greatest masters were borrowed. It was one of these that was given the place of honour: a version of a detail of the picture that had caused the greatest sensation at the exhibition, Botticelli's *Birth of Venus* (in the Uffizi). A vase of fresh lilies was placed in front of this every day (pl. 32), and – so Grandi assures us – his embassy became the most beautiful and the most hospitable of all the embassies in the United Kingdom.

Chapter 8

The Redirection of Taste in Florence and Paris

Florence 1922

A radical change took place, somewhere around 1900, in the relationship between private collectors, museums and exhibitions. Old Master exhibitions had been inaugurated in England in 1815 as a means of letting the public see pictures that would otherwise have remained inaccessible in town and country mansions. This situation remained unchanged for nearly a hundred years, and even though the finest contents of these houses were becoming severely depleted during the last two decades of that period, very impressive loans from private sources could still be arranged. However, the National Gallery in London was also skimming off the cream from among the great treasures that were still in the hands of an aristocracy more and more affected by death duties and the collapse in agricultural rents, and, by law, the National Gallery was allowed to lend only to public galleries in the United Kingdom. The Royal Academy and other exhibition sites were private.

A rather similar process was taking place throughout Europe, although it was less noticeable, because many of the museums that we think of as being public in fact still belonged to the ruling sovereign. In 1900, for instance, the Royal Academy put on a great Van Dyck exhibition. Nearly all the pictures in it came from English private collections, including that of the queen, but one magnificent portrait, that of Lord Wharton (today in the National Gallery of Art, Washington), was sent from the Hermitage in St

Petersburg. This was possible because the nominal owner of the pictures in that museum was the emperor of Russia. Some German princes could exert similar power over local museums and castles, but their number was diminishing, and everywhere severe restrictions were imposed on the lending of pictures from those museums that were controlled by central governments or municipalities. Although it was sometimes possible to borrow works of art from such institutions for exhibitions within national frontiers, it was very rare to be able to obtain such loans from abroad. Thus, in 1902 the museums of Antwerp and Brussels reluctantly lent some of their treasures to the Flemish exhibition in Bruges, but it was only after enormous difficulty that the curators of that exhibition managed to borrow a Memling from the Musée des Beaux-Arts in Rouen.[1] Two years later the French were surprisingly successful in borrowing the two separated wings of Fouquet's 'Melun diptych' from the museums of Antwerp and Berlin for their exhibition of 'primitives'; but the Louvre itself could lend to its own exhibition only because the Pavillon de Marsan, in which it took place, belonged to the same set of buildings as the museum! In 1910 there was an uproar when the Louvre, after turning down five requests for other loans, finally agreed to lend one (admittedly fine) picture by a minor Flemish artist (Otto van Veen's *Self-portrait, surrounded by his Family* (pl. 36)) to an exhibition in Brussels. The art historian Louis Dimier wrote indignantly: 'What we have agreed to do today for Brussels we will not be able to refuse to other friendly towns. If the municipality of Milan organises an exhibition of Lombard paintings, there is no reason why they should not ask us to send *La Gioconda*.'[2] Little could he have guessed that it was to Tokyo rather than to Milan that *La Gioconda* would one day be sent.

It was not until after 1918 that museums began to lend pictures to international exhibitions on a regular basis, though the National Gallery in London resisted pressures to do so until the 1950s and was notably moderate in what it allowed to travel for three decades after that. Had this general change in policy not been made, Old Master exhibitions – in the form we know them – could never have survived into the twentieth century, let alone have multiplied in the way that they have.

Perhaps no single picture illustrates this change more dramatically than Caravaggio's huge *Death of the Virgin* (pl. 37) which, astonishingly enough, the Louvre agreed to lend to what was the

first major international Old Master exhibition to be held after
the First World War, the *Mostra della Pittura Italiana del Sei e Set-
tecento* in the Palazzo Pitti in Florence in 1922. From Otto van
Veen to Caravaggio was quite a step, one perhaps made possible
by post-war obligations and a sense of special circumstances. Sur-
prisingly, the archives of the Louvre reveal no trace of any protests
from within the museum or, indeed, controversy outside.[3]

From one point of view at least, this exhibition can be thought
of as the most important one of the entire twentieth century. It
achieved what almost every exhibition sees as its principal aim:
it permanently altered the public's perception of the history of
European art. The official commemorative volume, published two
years after the close of the exhibition, was entirely justified in
its boastful claim that 'From the royal palace of the Pitti, Italian
painting of the seventeenth and eighteenth centuries has been
reinserted, and in the most imposing manner, into the history
of European painting. Never again will it be possible to drive it
into oblivion.'[4] It is true that, for at least a generation before 1922,
many people had been fully aware of the fact that the splendour
of Italian art had not come to a sudden and final end with the
death of Tintoretto in 1594 and that very important research had
already been devoted to later periods. Moreover, Italian pictures
of the seventeenth and eighteenth centuries had been selling well
during the previous decade or so and had been much praised in
fashionable journals. It is also true that not very many of the best
of the more than a thousand pictures exhibited at the Pitti were
wholly unknown, partly because – as was pointed out by an
English critic at the time – a high proportion of them had been
borrowed from churches and museums, in view of the fact that
the Italians 'are not easily persuaded to reveal' the contents of their
private collections.[5] It was essentially the cumulative impact
made by some of the finest masterpieces of Italian baroque and
rococo painting that was so immediately impressive, just as it is
the somewhat surprising orientation given to the exhibition that
now makes it so historically fascinating. This is, indeed, one of
the very few Old Master exhibitions that modern scholarship has
investigated: Fernando Mazzocca has illuminated the cultural
background brilliantly.[6]

The idea for an exhibition of Italian seventeenth-century paint-
ing to be held in Palazzo Pitti had been suggested to the munici-
pal authorities of Florence in 1919, shortly after the king had

presented this royal palace to the nation, and eight years after it had provided the setting for a famous exhibition of Italian portraiture. Later, Ugo Ojetti, the exhibition's presiding spirit (and responsible also for the portrait exhibition), explained that after he and his colleagues had begun to work on the project they came to the conclusion that it would have to be extended into the eighteenth century, partly because there would otherwise be no natural point at which to end.[7]

The exhibition was designed to celebrate the victory recently won by Italy, fighting alongside her western allies, against Austria. Above all, however, its aim (which was not specifically acknowledged) was to restore national pride – a task that grew more and more urgent as it became clear how disappointing the fruits of that victory had turned out to be – by demonstrating that Italian art had remained at the very centre of European culture long after it generally been supposed – by the Italians themselves, as well as by foreign historians – to have died out towards the end of the sixteenth century. The exhibition would prove that, on the contrary, Italian painting – and it is essential to note that the exhibition was of Italian painting, not of Venetian or Tuscan or Neapolitan painting, or so on – that Italian painting had been marked by the most powerful ambition and an extraordinary exuberance, a brilliant sparkle, a wide range of subject matter and stimulating regional variety throughout the baroque and rococo periods. In the heated controversy that preceded the opening of the exhibition the seicento had been described as 'the century in which our painting is least Italian, the century that marked the start of that decadence, the grim consequences of which we see today'.[8] But, responded the organisers, would it be possible any longer to consider Italian painting of the seventeenth and eighteenth centuries as decadent, as a falling away from the Renaissance rather than as its logical conclusion, its culmination? Would it be possible any longer to deny the sincerity of pictures such as Caravaggio's *Calling of St Matthew* (S. Luigi dei Francesi, Rome) or Piazzetta's *Ecstasy of St Francis* (pl. 38). Would not people now, at last, be in a position to appreciate the obvious fact that the great schools of painting that had developed during the seventeenth century in Spain, Flanders, England and elsewhere were themselves deeply indebted to those very Italian artists whose fame they had surpassed? And, despite the impression of chaos that emerged from a superficial acquaintance with Italian painting of

the baroque – a chaos that it was the purpose of the exhibition to reduce to order – would it not become apparent that a logical progression could be traced from the masters of the early seventeenth century to Tiepolo and Guardi, the two 'ultimi prodigi dell'arte veneziana'?[9]

These were the guiding principles that lay behind the choice, and also the presentation, of the pictures. It was natural enough to give precedence to Caravaggio who, for a generation or so, had won increasing admiration from younger art historians, and without whose presence no re-evaluation of the seicento would have been possible. But the organisers were determined to emphasise that, despite his own revolutionary rhetoric, Caravaggio was, in fact, 'l'ultimo classico'. Although in 1921 Lionello Venturi had written of his art that it was unusual to find so open a rebellion and such a violent one,[10] it was a very different kind of appraisal, made by the same art historian, that was quoted in the entry on Caravaggio in the catalogue: 'his artistic language is eternal, granitic, like the language of the mountains'.

Some twenty paintings believed to be by Caravaggio had been borrowed for the exhibition, but by the time they reached Florence their number had been reduced to fifteen. Indeed, the catalogue as a whole had to be hastily revised by a small committee of experts, and the second, amended edition was published at about the time of the March on Rome. Although it was greeted by an English writer as 'the best ever compiled for a loan exhibition of this magnitude held in Italy'[11] and although it was well illustrated, no measurements were given for the pictures and the novelty of the whole enterprise is revealed by the many weaknesses in its scholarship. Longhi was later to recall that Ojetti did not welcome suggestions for new attributions (or could it be that he did not welcome new attributions from Longhi?), and that when he was forced to concede that some picture could not be by the master under whose name it had been catalogued, he used to insist that the original name should none the less be retained, but prefaced by an 'attribuito a' or 'scuola di'.[12] A beautiful picture that had been seen in Florence at the portrait exhibition ten years earlier (as a Caravaggio) but that could not be asked for in 1922 as it belonged to Prince Liechtenstein's collection in Vienna[13] was Orazio Gentileschi's *Lute Player* (now in the National Gallery of Art, Washington). There could, of course, be no collaboration with Austria, from which Ettore Modigliani had recently returned

to Italy with many of the 'treasures of art pillaged . . . in the last centuries', but Austria's ally, Germany, with whom Italy had not gone to war agreed to send Caravaggio's *Amore Vincitore* from Berlin. Nevertheless, it was the hitherto almost invisible altarpieces removed from their dark chapels in the Roman churches of S. Luigi de' Francesi and S. Maria del Popolo, where they had never been properly seen in living memory, that naturally made the most remarkable impact – and one that was remembered years afterwards by those who had experienced it. And although modern scholarship and new discoveries have greatly increased our knowledge of Caravaggio, it is universally agreed that it was at the exhibition of 1922 that his true stature first became generally known.

The same cannot be said of his contemporaries. It was considered essential to eliminate anything that could be remotely thought of as 'academic', and for this reason Annibale Carracci, who – both in the seventeenth and eighteenth centuries and again today – has been seen as the founding father of the painting that dominated Europe during the age of the baroque, was represented by precisely three pictures, not one of which is still universally attributed to him, whereas Alessandro Magnasco, to us an essentially minor though extraordinarily fascinating painter, was given sixteen pictures, more than any other artist except Tiepolo and Guardi, each represented by some two dozen. Magnasco had been 'discovered' just before 1914: as early as 1912 Longhi was already referring to him as 'one of the greatest Italian artists' and comparing him with El Greco. Collectors eagerly bought up his pictures, and dealers put on exhibitions devoted to him in Berlin, Paris, Munich and, after an interval caused by the war, Milan.[14] He was thus well known to connoisseurs and to the market, but (in this – and only in this – like Caravaggio) it was the exhibition of 1922 that consecrated his fame. In so doing it distorted the balance of the exhibition, and, in some circles, Magnasco came to be looked upon as symbolic of Italian baroque art in general.

Among the visitors to the exhibition in the Palazzo Pitti was the English writer and aesthete Osbert Sitwell, a man who prided himself on his advanced and cosmopolitan taste and whose father owned a castle in Tuscany. Sitwell described the exhibition enthusiastically as 'one of the most important artistic events of recent years',[15] and in 1924 he and his brother, Sacheverell, who was eagerly cultivating a taste for the exotic, approached a number of

friends in London to found a society, whose purpose would be 'to restore Italian seventeenth- and eighteenth-century painting and sculpture to the position which they had formerly occupied for so long in the mind of Western Man'. They arranged small annual exhibitions, which were usually held at the premises of leading art dealers, at each of which they showed about thirty pictures. The first of these, held at Agnew's in 1924, included Carlo Dolci's portrait of Sir John Finch (now in the Fitzwilliam Museum, Cambridge) and Salvator Rosa's *La Fortuna* (now in the J. Paul Getty Museum, Los Angeles) which, like all other pictures in their annual exhibitions, were then in British private collections. At their second exhibition, a year later, were to be seen Caravaggio's *Boy with a Lizard* (now in the National Gallery, London) and Annibale Carracci's portrait of Turrini (Christ Church, Oxford). Also in 1925, Osbert Sitwell was one of the organisers of the Burlington Fine Arts Club's exhibition of *Italian Art of the Seventeenth Century*, to the fine catalogue of which he supplied a spirited essay on painting, and Archibald Russell, a rather more sober note on drawings (of which he was a notable collector). Russell did not approve of all aspects of the Italian baroque: he described Luca Giordano as an artist 'lavishly endowed by nature with nearly every artistic qualification but brains'.[16] Sitwell, however, adored Giordano and praised especially his great frescoes in the Escorial:

> Here by the artist's aid, the unfortunate King could for a while forget the moth and the dust, could forget the marble tomb that was waiting for him below, in the company of all sorts of flying angels, and fantastically garbed persons, whose only duty was to amuse him. The sombre grey walls and ceilings became a-flutter with silks and brocades, and with the reflected drumming lights cast up by water.[17]

One cannot say that this passage – camp in the manner of Ronald Firbank and, indeed, William Beckford – suggests a very serious attitude towards Giordano's subject matter. Nevertheless, it was the imaginative character of his work that appealed to Sitwell. The name he and his brother gave to their own exhibiting society was the Magnasco Society; this must have been partly because of the bizarre subjects that Magnasco painted, but Sitwell also believed that Magnasco had been inspired, albeit indirectly, by El Greco and that he, in turn, influenced Tiepolo, which made him seem a

more central figure than he was (pl. 39). Reflections of Sitwell's enthusiasms are easily found in contemporary British painting, for example in *Symphonie Espagnole* by Augustus John which was shown at the British Empire exhibition in the Palace of Arts at Wembley in 1924 (pl. 40).[18] Here Magnasco and Luca Giordano are combined with El Greco and a tourist's impressions of Spanish culture with astonishing verve – and very bad taste.

By contrast, and perhaps surprisingly, no attention is paid in the catalogue of the Florentine exhibition to Magnasco's subject matter – the tortures, the ecstatic groups of monks, the Inquisition and the festivities, which have been of such interest to cultural historians in recent years. Magnasco was acclaimed – as were a number of other artists, such as Lyss, Feti and Maffei – only for the vivacity of his brush strokes which, it was argued, had played an essential role in opening up the road that led to the great masters of eighteenth-century Venice. His 'nervosi capricci' would also, it was hoped, be among the revelations of the exhibition that would provide inspiration for a new, national, Italian art of the twentieth century. Ojetti claimed that the exhibition would give living artists the joy 'of finding in Italy, of finding even in these two centuries of Italian art, examples and teachers more reliable, more sound [*più sicuri e più saldi*] than those that it is fashionable to seek out over the Alps [*oltre monte*]'.[19] The leading Italian artists had for some decades certainly looked to Paris for inspiration. But it is also true that even those who did so – Gemito, for instance, or Boldini, or later still Filippo de Pisis – could acknowledge an affinity with earlier Italian artists. De Pisis, indeed, may have visited this exhibition, and one may wonder whether he briefly thought of Magnasco and Guardi as 'maestri sicuri e saldi' before proceeding 'oltre monte' at the earliest opportunity.

This raises the question of how far Ojetti achieved what we can call the 'political' aims of the exhibition – for, in its own way, it was as nationalist as those that had been devoted to the 'primitives' in Bruges, Paris, Barcelona and elsewhere some twenty years earlier. Ojetti did not only want to make it clear that Italian art of the seventeenth and eighteenth centuries had been of the highest quality – and in this he certainly succeeded – he was also arguing that Italian art of this period had 'anticipated' many far more famous, but far later works by French and English artists. He is absolutely explicit about this: the exhibition demonstrated, he

claimed,[20] that landscape painting of the nineteenth century sprang from the work of Venetian view painters of the eighteenth. He cited in particular two small pictures, Canaletto's *Ponte Rotto* (a work now doubted as autograph[21]) from London and Francesco Guardi's *Laguna* from the Museo Poldi Pezzoli (pl. 42).

Here already we find 'all the most beautiful and sincere and profound landscape painting by English and French artists between the end of the eighteenth and the middle of the nineteenth century. After this exhibition, will the historians of modern landscape be able any longer to neglect the Venetian predecessors of the French and English?' Surely nationalist rhetoric has here replaced sensitive observation. It in no way diminishes the great beauty of Guardi and Canaletto if we do not find their style reflected in 'the most beautiful and sincere and profound landscape painting' of the English and French in the first half of the nineteenth century – for this can refer only to Constable and Corot, whose attitudes and sources are very different.

This sort of approach would hardly have mattered, and would long ago have been forgotten, were it not for the fact that both the controversies leading up to the 1922 exhibition, and the discussions that followed it, bequeathed a most unfortunate legacy to Italian art-historical writing. The organisers were absolutely right to claim that a major dimension of European art had been lost as a consequence of the neglect of Italian baroque painting: for not only were these painters great masters in their own right, but, as is now realised even more than was appreciated in 1922, it is impossible to understand the development of such admired non-Italian painters as Rembrandt, Vermeer, Velázquez, Rubens, Van Dyck and Poussin without taking into full account the debt that they owed to Caravaggio, Gentileschi, Annibale Carracci, Guido Reni, Domenichino and others. But Ojetti and his colleagues wanted to go much further than this. To emphasise the value of the exhibition they tried to argue that their great masters of the seventeenth and eighteenth centuries had not only been of the utmost importance to their contemporaries in Spain, France, Flanders and Holland, but had also anticipated the 'modern movement' of the nineteenth century which had so regrettably confined itself to France and – to a very much lesser extent – to England. Bruised by the apparent marginalisation of modern Italian painting, Roberto Longhi (and his followers), just as much as Ojetti, exalted the seicento and settecento for having 'anticipated' (that

terrible and misleading word) not only Corot and Constable but also Courbet and Manet, and this is a tendency that, alas, has not yet disappeared.

Paris 1934

Rather curiously (at least at first sight), twelve years later Paris was to be the location of another exhibition of seventeenth-century art whose aims were, to some extent, diametrically opposed to those of the exhibition that had been so successful in Florence. *Les Peintres de la réalité* opened at the Musée de l'Orangerie on 24 November 1934 (rather later than had been planned) and closed on 15 March 1935 (after having been extended by a month). Despite the fact that only a few weeks before its inauguration some of the pictures that were eventually included (or excluded) had not even been known to the organisers,[22] this exhibition has always been looked upon as one of the most important ever held in France, and it still enjoys a very distinguished reputation. It is probably remembered above all for having introduced to the public an influential group of about a dozen pictures by, or attributed to, Georges de La Tour whose work had hitherto been known to no more than seven or eight specialists.[23] This was a major achievement, and it is hard to think of any other Old Master who has been awarded 'canonical status' since that time. But the significance of this exhibition extends far wider than that, although it is not easy to detect this merely by reading the catalogue.

The introductory letter by the director of the French museums, with which this catalogue opened, pointed out – in words that almost precisely echo similar phrases published in the Palazzo Pitti catalogue of 1922 – that 'its aim is to throw light on a chapter of the history of art that has been neglected for too long and to assign to their true rank artists of real originality who have been forgotten, ignored and misunderstood'.[24] This could have been said – and indeed it had been said – of Strozzi and Feti and Magnasco. The context was, however, very different.

The period was a difficult one. Earlier in the year France had seemed on the verge of a civil war, and after Communists and Fascists had clashed in the streets, the forces of the Left had agreed to join forces against the extreme Right – a decision that was to

lead, a year later, to the formation of the Front Populaire and to many radical changes in cultural policy. And although the purpose of the exhibition was not in any way directly political, it inevitably had political implications.

The words 'reality' and 'realism' applied to art were once again arousing strong emotions at this time,[25] and although it was mostly contemporary painting that was affected by the so-called 'querelle', the Old Masters did not escape the controversy altogether. Thus the Le Nain brothers, who, on their rediscovery in the 1840s and 1850s, had been acclaimed for having supposedly been social dissidents, had more recently, over a period of many years, been gradually 'cleansed' of all subversive associations (pl. 43). By the early 1930s they were celebrated, above all, for their 'Frenchness', and they were very fully represented in this exhibition, as they were in two other exhibitions held in the same year. Indeed, their incorporation into the very heart of the national tradition, along with Corot and a few others, including even Courbet,[26] was as acceptable to the Right as it was to the Left. However, it was at just about this time that the notion of realism was once more being given specific political connotations, even though there was no fundamental dispute between the parties about its intrinsic desirability. It was, for instance, in 1934 that the principles of socialist realism were being laid down in Soviet Russia. These had no direct bearing on art produced in seventeenth-century France, but they did appear to draw attention to some aspects of *Les Peintres de la réalité* that might have passed unnoticed a few years earlier. The Communist-inspired journal *La Commune*, for instance, raised the matter not in connection with the Le Nain brothers themselves, but with their closest follower, Jean Michelin, noting the effective contrast between Michelin's *Baker's Cart* (pl. 45) and Philippe de Champaigne's *Young Girl with a Falcon* (pl. 44) which hung beside it: 'The sad, authentic reality of the "grand siècle" resides in the patched-up misery of the poor', depicted in the former, whereas the young woman in the latter 'will live off the labour of those unfortunate wretches who are kept in ignorance by the Church so that they can be more easily enslaved to the will of the great and the powerful'.[27]

This sort of interpretation was certainly not what the organisers of the exhibition had in mind. They were concerned to convince the public of the quintessential 'Frenchness' of French realist art. For them this was as important an issue as the supposed anti-

cipation of modern art by Italian seventeenth- and eighteenth-century painting had been for Ojetti and his colleagues in 1922 – indeed, Charles Sterling later explained that the aim had been to 'make an exhibition of a movement, of whose existence I became aware in France, a realist movement that corresponded to the baroque movement in Italy'.[28] The only trouble was that it was impossible to ignore the fact that it had been an Italian who had led the way to this Frenchness. And this created considerable problems, as can be seen from studying the catalogue.

The preface was written by Paul Jamot, the recently appointed head of the Department of Paintings in the Louvre, who had started life as an archaeologist. He was now aged seventy-one and had assembled a remarkable private collection, much of which he bequeathed to the Louvre. He acknowledged the essential role played by Caravaggio, 'whose influence extended everywhere', but he then played this down as much as he could: 'Despite appearances, it was not the French who felt his attraction the most strongly.' They had, of course, been influenced by the illustrious Italian, but his art had never penetrated to the depth of their soul, and, if necessary, they could have managed without him. To understand the place of the Le Nain brothers one had to look not abroad and to the past but in their own country and to the future – to Chardin or Corot, for instance. And what had Caravaggio to do with them? As for Valentin, who really had been profoundly affected by Caravaggio, 'he is perhaps the only excellent French painter of whom it can be said that he lost his French virtues in Italy. He is the most Italian of our painters. He is an exception.'

Charles Sterling, who wrote the introduction to the catalogue as well as the individual entries and who had carried out most of the original research, was less than half Jamot's age. He had been born in Poland and had acquired French citizenship only in the year of the exhibition. He, too, was keen to stress the essential Frenchness of the painters exhibited, and he felt it necessary to end his introduction with the statement that 'if one day this exhibition is granted the great honour of being compared with that of the French Primitives of 1904, its purpose will have been achieved'. Nevertheless, his approach was far more international than that one had been and far more international also than that of his director, Jamot, with whom he sometimes seems to be in open disagreement. On his first page he declares forthrightly:

'Between 1610 and 1630 France had become empty . . . Every youthful spirit . . . had set off for Italy, where blazed the most astonishing artistic furnace known to history . . . Today we believe that there was an important school of French Caravaggesques. The exhibition should allow us to confirm this opinion and to answer many other questions.'

For all the important novelties it presented, and for all the innovatory research and scholarship for which it has remained famous, the exhibition itself, as well as the catalogue, presents certain anomalies of a rather disturbing kind. There is perhaps some justification for admitting early works by Claude Lorrain to this company but it is surely stretching the concept of realism rather too far to include Poussin's *Self-portrait* in the Louvre. What makes us feel uneasy is not the quality of these and other works in the exhibition, which is consistently very high, but the fact that, in a number of cases, pictures that may be distinctly uncharacteristic of their artists' styles or subjects are brought together in order to make a particular point about the spirit of French art in general.

It is, perhaps, even more difficult to see why a semi-mythological scene by that fascinating painter Vignon (*Croesus demanding Tribute from a Lydian Peasant* in the Musée de Tours) should have been included if, as Jamot claimed, French realism had not depended on Caravaggio, but needed 'only that deep love of nature, of truth, of life and of humanity that, from the dawn of history until our own day, has never, in one form or another, ceased to inspire the spirit of France'. It is surely easy enough to realise that a careful selection of Spanish or Dutch or, indeed, Italian pictures could be compiled to suggest an essentially similar point about the spirit of those countries.

It does, however, seem likely that it was not merely a sense of national vainglory – of a kind that had been so characteristic of the exhibitions of 'primitives' held throughout western Europe in the early years of the twentieth century – that prompted the renewed cult of Frenchness that is so evident in *Les Peintres de la réalité*. Jamot and his colleagues and supporters probably hoped that their exhibition would directly inspire living artists to restore French art to its former glory by rejecting surrealism and the last decaying remnants of modernism in order to return to traditional national virtues. And it soon appeared that this hope was not a vain one. We are told, by a contemporary,[29] that the exhibition

made a particular impact on 'young painters of the Ecole de Paris'; and, indeed, within a year of its opening, six of these had banded together to form a group called Forces Nouvelles which exhibited new work at an art gallery that had very close links to left wing politics.

These artists rejected 'impressionism and expressionism and deceitful draughtsmanship and overloaded impasto' and called instead for 'a return to Drawing, a return to the conscientious craftsmanship of Tradition in passionate contact with Nature'.[30] In themselves such demands were not new, but these artists made it absolutely clear that it was the *Peintres de la réalité* exhibition that had given them new potency. In the words of their leader, Henri Héraut, 'Le Nain and Georges de La Tour are, in my view, more powerful than Delacroix'.[31] And for their first exhibition Robert Humblot painted *The Card Players* (pl. 41) which is an explicit homage to one of the works by La Tour that had been shown at the Orangerie (*Le Tricheur*, now in the Louvre).

Forces Nouvelles won a great deal of support, and many people saw in it the possibility of a resurrection for French art, but, in the light of what has happened subsequently, the movement is more likely to strike us as a forceful, but ultimately impotent return to the past rather than as a platform for a new and exciting departure.

The exhibitions in Florence and Paris were both of real value and importance, however distorted were some of the values that they proclaimed. That value springs not only from their intrinsic merits but also from the impulse that they gave to others. What was achieved in Palazzo Pitti in 1922 made possible the innovatory exhibitions devoted to seventeenth- and eighteenth-century Italian art that were promoted in many Italian cities, both before the war (in Genoa, Naples, Venice and elsewhere), and, of course, after the downfall of the Fascist party, when Milan and Bologna led the way with a series of exhibitions that challenged nearly all the claims made by Ojetti and that not only influenced the movement of public taste but also set standards that have not yet been surpassed. The Orangerie exhibition of 1934–5 was followed two years later by the Exposition Universelle of 1937 which included, within the newly built Musée d'Art Moderne, the largest display of French art ever mounted, and then, after the war, by a major sequence of monographic exhibitions, which have included both the Le Nain brothers and Georges de La Tour, as well, of

course, as Poussin, Simon Vouet and many other masters – of *la réalité* and of every other style. And all these exhibitions have been marked almost as much by the seriousness of their scholarship (and weight of their catalogues) as by the extent of their loans.

The great loan exhibitions of the second half of the nineteenth century made possible the development of art history and, in a broader sense, helped to alter our understanding of the historical development of art. It must be questioned whether anything like this was achieved by many of the successors to such exhibitions, including the great Italian exhibition of 1930 to which the previous chapter was devoted. What is remarkable about the Palazzo Pitti and Orangerie exhibitions is not only the way in which they did alter people's understanding – and, of course, the way in which they promoted a certain misunderstanding – of the Old Masters of Italy and France, but the impact that this had on contemporary art and on larger intellectual circles. This has been less true of the monographic exhibitions that they made possible.

Chapter 9

Enduring Legacies

Two conclusions can safely be drawn from the history as it has been outlined so far. The first of these is that Old Master exhibitions breed more Old Master exhibitions; and the second is that each time some particularly spectacular one is put on, press and pundits will combine to predict that nothing of the kind will ever be seen again. On 9 September 1898 *The Times* (of London) wrote of the Rembrandt exhibition in Amsterdam that 'we may doubt whether it, or the like of it, can ever be repeated'. Less than four months later the same newspaper wrote of an exhibition of pictures by the same master held at the Royal Academy in London: 'It is as though we had regarded the Amsterdam exhibition of Rembrandt as a challenge, and had replied to it, "This is all very well, but we can do it better in England." '[1] In 1962 Sir Denis Mahon wrote that the Poussin exhibition that had been mounted in Paris two years earlier 'was a unique event, since nothing comparable is likely to be repeated during the lifetimes of any of the thousands of visitors to the Louvre on this historic occasion'.[2] Among those thousands of visitors were Sir Denis and myself, and both of us were able to make repeated pilgrimages to the still more comprehensive and important Poussin exhibitions held in London and Paris in 1994. I have shown how the Italian exhibition of 1930 was in some respects repeated in Paris soon afterwards. Nothing quite like it has been seen since, but the number of loan exhibitions has been increasing at an astonishing rate especially over the last decade.

It has already been mentioned how, gradually, after 1900, public museums that had been opposed to lending, and especially to lending abroad, began to change their policies, and the great

exhibitions discussed in the previous chapters – those held in Palazzo Pitti in 1922, at the Royal Academy in 1930 and at the Orangerie in 1934 – were possible only because of this. A good deal of reluctance was, however, discernible: not only did Mussolini have to force some Italian museums into allowing their pictures to travel across Europe, but the National Gallery in London was most reluctant to permit any of its holdings to travel even the short distance from Trafalgar Square to Piccadilly.

No one could have predicted the change that took place in the second half of the twentieth century when almost all the great museums and galleries of the world one by one came to organise or host loan exhibitions. Today these institutions are often associated in the minds of their visitors as much with ephemeral displays as with a 'permanent' collection. Those smaller institutions that have remained true to the explicit veto placed by their founders on the lending of works of art have been placed under great pressure – most notably in recent years the Barnes Foundation in Philadelphia and the Burrell in Glasgow have been forced to change their policies.[3] The trustees of the Wallace Collection have only with difficulty resisted the blackmail and bullying from larger institutions that once shared the same ideals. Amazingly, the British government Department of Media and Sport now requires that national institutions consider international loans as one of their 'targets' – as if museums were athletic clubs whose eminence would be best demonstrated by their members participating in international events.

Roberto Longhi, in one of the few previous attempts to review the history of Old Master exhibitions (an address at a conference on art exhibitions in Milan on 12 November 1959), had much to say in favour of them, especially in favour of the smaller monographic exhibitions that have, in the twentieth century, been an Italian speciality; but he shuddered at the horrific risks involved in the London exhibition of 1930 and perceived the threat of the glamorous, ill-organised international shows to the well-being of museums. He wrote at a time when the Council of Europe was encouraging ventures as terrifying and irresponsible as the exhibitions mounted between the wars. He recalled that the corporation of a small *comune* in northern Italy had telegrammed to the organisers of the great exhibition of Lombard art that they regretted they could not lend a precious manuscript in their possession, 'perché ne abbiamo uno solo' ('because we have only

one'). 'Wisdom of the people!', exclaimed Longhi. This was how Soprintendenti and directors of galleries should respond to requests to borrow Titian's *Sacred and Profane Love* and the *Unknown Englishman* and Bellini's *Pietà*, and such like masterpieces: 'Ci dispiace, impossibile, perché non ne abbiamo che un solo esemplare' ('We are sorry – it's impossible – we have only one of these').[4] It is, indeed, greatly to be desired that some such sense of responsibility for the irreparable and precious should be restored. But a further obstacle to its realisation has arisen. Longhi ended his paper by noting that one new Italian museum had its own exhibition space; recently, several Italian museums have acquired such,[5] although fewer than elsewhere in Europe. This development helps to ensure that masterpieces are lent. As I write, Titian's *Unknown Englishman* is in Chicago; in return Palazzo Pitti has secured a group of impressionist pictures.

It would be incorrect to claim that in the nineteenth century there had always been a division between the loan exhibition and the public museum or gallery. Some of the latter were founded in the wake of exhibitions and on the sites adapted or created for them. The Bargello in Florence is one example of this – it opened as the site of the national Dante celebrations in 1865, and the idea was to build on that temporary exhibition the foundations of a 'permanent museum in the style of those of Cluny and Kensington'. Another example is the M. H. de Young Memorial Museum in San Francisco which originated in the 'Midsummer International Exposition' of 1894. The fine arts pavilion and the surplus funds were passed to the exhibition's director, de Young, to form a city museum.[6] In the same city the California Palace of the Legion of Honor, dedicated to the dead of the First World War and opened in 1924, was inspired by the French pavilion at the Panama–Pacific International Exposition of 1915. The South Kensington Museum (today the Victoria and Albert Museum) regularly included, during the first half century of its existence, rooms full of loans, including substantial collections of Old Master paintings, and if these displays often remained for years rather than months, those at the Metropolitan Museum in New York or the Museum of Fine Arts in Boston – sometimes of private collections, sometimes of dealers' collections – were of shorter duration.[7] Nevertheless, the great public picture galleries of Florence, Madrid, Paris and London were conceived of as permanent repositories. They have all recently acquired space to put on

loan exhibitions, and it is not a coincidence that now one can be less sure than ever before that even the greatest masterpieces in these collections will be on display. Not only that: it is also now quite common to find that the rooms devoted to the 'permanent' collection – an expression that we may expect to be quietly buried in the near future – have been cleared to make space for a temporary display.

Success in a museum is measured today both by sponsors and by governments in terms of the publicity that only the opening of new galleries or the mounting of temporary exhibitions can stimulate. To acquire the space and means to mount such exhibitions is the first tonic prescribed for the quiet or impoverished institution. Once in the business of borrowing, an institution will not find it easy to refuse to lend. More and more exceptions are made to the lists of 'national treasures' or absolute masterpieces never to be lent, to the limits on the amount any work can travel, to the prohibition on the lending of works painted on wood. Rules become 'guide-lines' and are then regularly ignored. There is considerable reluctance to admit to this or to address the way in which the trend could be halted. The pressure to lend, which in the first half of the twentieth century was political, today comes from the demands of publicity and finance from within the museums themselves. The ideal modern director is likely to be someone well connected politically, with a flair for publicity, with enthusiasm, energy and 'vision' – in other words, a Lady Chamberlain. Deep commitment to the welfare of the works of art in their charge is no more likely to be a precondition for this position than scholarly knowledge of them.

Many museum curators are these days more involved in the organising of loan exhibitions than in any other task. Directors are judged less by purchases that they have made or gifts that they have attracted or for the skill with which they have displayed works in the 'permanent' collection, than for their success in mounting such exhibitions. This may be especially so in the United States of America, but the first museum director to have confessed to a preference for the intoxicating excitement of the temporary exhibition was perhaps Kenneth Clark (his involvement in the 1930 exhibition of Italian art in London has already been mentioned). In the seventh chapter of *Another Part of the Wood*, the first volume of his autobiography, he described the installation of the British art exhibition in the Louvre in 1938 and his good

relations with the *équipe* under his direction – 'all communists of the good old French school' who worked 'very quickly and were inconceivably reckless' – 'I found the risks taken with these National Treasures rather exhilarating. Thank God none of my colleagues [a reference to the careful custodians of the Old Masters in Trafalgar Square] was present.'[8] The passage is too self-consciously provocative to be called candid, but it was certainly honest to admit that the mounting of exhibitions entails risks – something that his successors regularly deny. The 'National Treasures', it should be noted, included Constable's *Haywain* and *Leaping Horse* and Turner's *Calais Pier* and *Evening Star*. They were lent by British institutions (including the National Gallery) that had not usually considered it safe to transport works abroad but that were virtually obliged to do so for an exhibition that had strong government support. *La Peinture anglaise: XVIII^e et XIX^e siècles* was not only exceptional in that it was hung by a director of the National Gallery in London, but in that the Louvre interrupted work on a 'definitive' rehanging of its holdings so that the exhibition could take place in rooms belonging to 'l'appartement des rois de France et de celui de Mazarin' rather than in 'notre petite Orangerie des Tuilleries'.[9] It must have been one of the first occasions on which a loan exhibition invaded the heart of a great European gallery of Old Masters.

To what extent works of art have actually been damaged by international travel is hard to assess. There was much anxiety on this score in the first decades of the nineteenth century when Goethe wrote a sad little poem about the damage suffered by paintings being sent to and fro ('kreuz und quer') across Europe: 'Was bleibt uns denn? Verdorbnes' ('What then endures? Damage'), it concludes.[10] Many of the English were convinced that the French had caused irreparable damage to the Italian paintings that had been removed to the Louvre – some of the greatest works were transfered from panel to canvas on this occasion – and although this was fiercely denied by the French decades later, the perils of transporting large paintings were frankly admitted and were, indeed, given as a reason for not returning Veronese's huge *Marriage Feast at Cana* to Venice.[11] It is not possible to explore this question further here beyond noting that many of the conservators best qualified to do so are obliged to comply with the policies of the museums that employ them and are very much more eloquent in private than in public.

The fascinating letters of the fourth marquis of Hertford to his agent, Samuel Mawson, are among the fullest documents there are of the attitude of a great collector to the dangers of loan exhibitions. 'Under the most favourable circumstances it is always dangerous removing, packing & unpacking, hanging &c so many paintings,' he observed of the 1857 Manchester *Art Treasures* exhibition. 'You say that "you do not consider that there is the least particle of risk in sending the Pictures to Manchester." You mention a minute after that the "only risk" is "by train" . . . Now my dear Friend accidents of every nature occur daily on all rail roads of the Empire & neither your presence [Mawson had proposed to escort them in person] or that of any other person can prevent them.' Lord Hertford insisted on his paintings being insured, and when the committee agreed to this he reluctantly kept his promise to lend, although his misgivings persisted: 'I am sure our Children will not all return as they departed.' His 'children' – all forty-four of them – were, at his insistence, displayed in a separate area and not integrated into the main part of the gallery.

Rumours later reached him of a man firing a gun in the exhibition, French visitors told him that 'the *damp* is dreadful', and he heard that one of his paintings was flaking. It is easy to ridicule him since no vandalism was recorded and no major accidents occured to his paintings in transport, but, in fact, on 4 July there was a freak thunderstorm and water entered the great glass palace, affecting especially the area where Hertford's paintings were hung – his pictures had to be hastily taken off the soaking walls. Even if Hertford's fear that they would all be destroyed was unjustified, damage – including, as he rightly surmised, damage that would not be immediately apparent – must have been caused: 'the paint will scale off & my only consolation will be to have had the honour, in my little way, to have contributed to the Manchester Exhibition'.[12] Even in this case it is not possible to be certain what the damage was, and that must often have been true. One may suspect also that, in the twentieth century, some damage was caused by the hasty cleaning and conservation of works of art in preparation for exhibitions. But this would be difficult to document.

If it is hard to assess the effect of Old Master exhibitions on paintings themselves, then it is no easier to measure the impact made by such exhibitions on artists, on scholars and on the general public. Lord Hertford's fear was that pictures that had survived

for centuries in fine condition had been sacrificed for an event that had left no real trace behind. In fact, of course, as has been shown, it made a great impact on art lovers (although some, including its strongest supporters, were dubious about whether it meant much to the less educated portion of the public). In 1912 Roger Fry claimed that the Manchester exhibition had 'changed the very face of things' and that, together with the writings of Ruskin, it had sounded the death-knell of Victorian philistinism. The plutocrat thereafter turned from modern art and 'decided that the only beauty he could buy was the dead beauty of the past. Thereupon set in the worship of *patine* and the age of forgery and the detection of forgery.'[13] A similar suggestion was made by the London dealers, Thomas Agnew and Son, that, from the 1870s onwards, the world-famous Old Master exhibitions held in Burlington House began to exert an influence on art collecting in general and encouraged taste to move away from contemporary art, which had dominated sales for well over a generation.[14] It is certainly true that dealers' exhibitions of Old Masters had never been so spectacular as they were at the beginning of the twentieth century, as can be appreciated if one considers that Agnews themselves in 1898 and in 1904 had on exhibition – and for sale – works of the quality of Fragonard's *Pursuit of Love* (Frick Collection, New York) and of Velázquez's *Rokeby Venus* (National Gallery, London).

But speculations of this kind can never be verified, and it is only through contemporary texts and accompanying illustrations that we can try to recreate for ourselves the lasting value of long-dismantled Old Master exhibitions. Indeed, in the second half of the twentieth century new techniques have ensured that there can be life after death for such exhibitions, for it is surely only recently that such necromantic powers have been acquired by the exhibition *catalogue*. There were, it is true, a few excellent ones towards the end of the nineteenth century – those sponsored by the Burlington Fine Arts Club, for instance, and a few of the more serious German ones of the period contain not only much valuable information but also photographic illustrations. But, as a rule, the photographic record was published in commemorative volumes – the folio publication entitled *The Art Treasures of the United Kingdom* with its colour lithographs made from photographs and the less luxurious but in its way pioneering *Gems of the Art Treasures Exhibition*, with its photographs by Caldesi

and Montecchi, published jointly by Colnaghi's and Agnew's, recording the Manchester exhibition of 1857, established a model that was to be followed for a century.

The catalogues themselves contained only such information as might be needed on the spot, and – as can be seen from their great rarity today, despite the thousands that were printed at the time – they were intended for immediate consumption. Thin, cheap, minimalist catalogues of this kind still serve a useful purpose for those scholars of our own day who try to track down the earlier history of pictures that interest them and to study the growth and dispersal of art collections or the history of taste and attributions; but they have long since sunk into even greater oblivion than the exhibitions that gave rise to them.

And then, for better or for worse, someone realised that there was good profit to be obtained from producing even the most scholarly of catalogues at a comparatively cheap price, provided that they could be disguised as luxuriously illustrated art books to be acquired, often at still cheaper prices, as one entered the exhibition. This revolution was established in Italy in the late 1950s or early 1960s.[15] It was made possible by the proliferation of photographic negatives. In 1900 exhibitions were the occasions on which the works loaned were photographed – many for the first time. By 1950 the majority of works requested for an exhibition had already been photographed, and major museums had their own photographic department. In addition to lavish illustrations, the modern exhibition catalogue has a scholarly apparatus borrowed from the *catalogue raisonné* of an artist's work or from the catalogue of a public or private collection. This must be owing at least in part to the increasing involvement of museums and museum curators in the organising of these exhibitions.

The exhibition catalogue is today both indispensable and something of a joke. Reviewers regularly weigh them and complain that they are too heavy to carry around the exhibitions that they are designed to illuminate. At the Watteau exhibition in Paris a few years ago it was forbidden to take one's catalogue into the galleries, on the grounds that it might bruise one of the thousands of visitors who were struggling to catch a brief glimpse of the pictures on the walls. More recently there was an exhibition in the United States,[16] where, although a handsome and manageable publication on the artist concerned had been produced for the

two sponsoring museums, it failed to give any indication at all of which were the pictures actually on display.

Anecdotes of this kind are endless; what is less noted, but much more disquieting, is the paradox that, in some ways, the higher the standard of the catalogue, the fuller the entries provided, the more interesting the general introductions specially commissioned from leading authorities and famous writers, and the more beautiful the colour plates with which it is embellished, the greater is the potential damage inflicted on scholarship. The reason for this is that no exhibition can ever contain the complete works of an artist, and so the erudite and fully illustrated catalogue produced for the occasion will inevitably fail to give us a full idea of his range, and yet may reduce the likelihood of another publication – a true, scholarly monograph – on the artist. If we need to know the current state of research on Poussin, we shall inevitably turn first to the splendid catalogue produced for the Paris exhibition of 1994 with its rich documentation and full bibliographies, but to obtain a scholarly opinion on those pictures *not* shown at the Grand Palais will involve a long, frustrating and sometimes fruitless search through learned journals. In France especially so much of the best art-historical scholarship is concentrated in the catalogues of Old Master exhibitions that it is important to emphasise the shortcomings of the genre. Their weight and authenticity and brilliant apparel conceals an imperfect whole. We are seldom reminded of what is not included because it could not be borrowed. Deadlines encourage hasty scholarship. For obvious reasons the condition – and sometimes also the status – of works borrowed from private collections will not be recorded with the accuracy to be expected elsewhere.

The polite – and prudent – convention of permitting the owner to describe his own work that was prevalent in the nineteenth century gradually fell from favour. The Spanish exhibition at the Royal Academy in 1920 represented a delicate compromise. Its preliminary notice warns that 'Due regard has been had in the headings to the merits attributed to the paintings by the owners. In very many instances, however, corrections have been introduced in the text' (that is, in the scholarly catalogue, entries by F. J. Sanchez Canton). Scholars, however, are not entirely free, and there is in modern Old Master exhibition catalogues a discreet prohibition on printing any observation likely to offend a lender.

For this reason the critical judgements essential to scholarship are stifled by the medium itself.

* * *

When the publications inspired by or associated with exhibitions are reviewed, it must be conceded that independent reviews are often of greater interest than the official catalogues. Some of the most important writing on modern art of the eighteenth and nineteenth centuries was made in response to art exhibitions. Exhibitions of Old Masters elicited much less of literary value, but one pamphlet that they did inspire must be acknowledged as of crucial significance for the history of connoisseurship.

In the winter of 1894 a London establishment in Regent Street called the New Gallery put on a loan exhibition of Venetian art which included some 300 paintings. The directors duly prefaced their sparse descriptive catalogue with the traditional caution: 'The works are catalogued under the names given to them by the Contributors. The Committee cannot be responsible for the attributions', and they must have been very relieved that they had done so when, a few months later, they read a pamphlet entitled *Venetian Painting, chiefly before Titian, at the Exhibition of Venetian Art. The New Gallery, 1895. By Bernhard Berenson.* Berenson was aged thirty at the time and extremely keen to make a name for himself as an infallible connoisseur, for although he had recently begun to publish articles, and even a general guide to Venetian painting as well as a masterly volume on Lorenzo Lotto, he was scarcely known to the general public or even to the distinguished collectors who had lent their possessions to the New Gallery; he was, however, a friend of Herbert Cook, a wealthy member of the committee for the exhibition, who very magnanimously (but perhaps also a little maliciously) sponsored publication of the pamphlet and even arranged for it to be put on sale at the gallery's premises.

Berenson's opening sentence was deceptively fulsome: 'Rarely have I seen a catalogue so accurate as well as tactful in its description of works of art as the official catalogue to the Venetian Exhibition at the New Gallery'; but this silky phrase (note his use of the word 'tactful') served only to make the one that followed it even more devastating: 'It has one and only one fault, that the attributions are, for the most part, unreliable.' This, Berenson

conceded, was not the fault of the committee, who had merely accepted the names supplied by their owners, but he then proceeded to demonstrate just how irresponsible they had been: 'To Titian, for example, thirty-three paintings are ascribed. Of these, only one is actually by the master'. Mercilessly he went through the 'Titians', pointing out that a number of them were merely copies of some of his most celebrated masterpieces. Eighteen or nineteen pictures in the exhibition were attributed to Giovanni Bellini, of which – claimed Berenson – only three were by him, and once again he ran through the paintings in turn and distributed them among various followers of the master. It was the third of the supreme masters of Venetian art who encouraged his most sarcastic comments:

> Coming, at last, to the centre point of Venetian art, to the shadowy, fluctuating, half-mythical figure of Giorgione, concerning whom there seems to be so little certainty that it may well be said: Every critic has his own private Giorgione – coming, at last, to him, we find that the catalogue, with becoming immodesty, ascribes to him no less than eighteen distinct items. Well, their private Giorgione is, I hasten to add, not mine . . .

Most of the so-called Giorgiones in the exhibition were, in fact, drawings, but it was a painting that attracted the greatest attention: the *Young Man with Skull* now in the Ashmolean Museum in Oxford and attributed to Licinio (pl. 46). The title given to this picture was *Portrait of a Lady Professor of Bologna*, to which Berenson dryly (but justifiably) retorted that it was not by Giorgione was 'neither of a lady, nor of a Professor, nor of Bologna'.[17]

In fact, Berenson's scathing account of the exhibition was by no means fair. Very often the lenders had openly acknowledged that their Titians and so on were only versions of famous originals in museums such as the Prado; and as Titian was known to have employed large numbers of assistants, it was not unreasonable to assume that their particular example could, at the very least, have been painted in his studio. Moreover, it was only then beginning to be evident to connoisseurs that when a Madonna and Child was inscribed with the name of Giovanni Bellini, this often meant no more than that it was a product of his workshop. But fairness is beside the point in this context. The fact remains that the

New Gallery Venetian exhibition of 1894–5 is one of the few Old Master exhibitions of the period that is still remembered – that has, as it were, achieved a form of immortality. And this has come about because of the withering scorn with which it was treated by an ambitious young man who happened to be the most brilliant connoisseur of his time.

Berenson, however, did more than ridicule the pretensions of the lenders to the exhibition. Again and again, he produced ingenious solutions to some of the puzzles presented by the over-ambitiously attributed pictures that he had been able to examine. In fact, he made use of the exhibition as a tool for proposing a tentative, but dogmatically expressed reconstruction of the styles of a number of early Venetian artists. A generation later, his example was to be followed with far greater panache and imagination by a connoisseur who at first aimed to be his disciple, but then became his rival and bitterest enemy.

Roberto Longhi's *Officina Ferrarese*, which today is widely accepted as a classic of twentieth-century art history, was published in 1934 as a sort of running commentary on the major exhibition of Ferrarese Renaissance painting that had been held in Ferrara the year before – 'running commentary' rather than 'extended review' because Longhi used the exhibition as a springboard for a general survey of Ferrarese art and did not confine himself to writing about what was to be seen in it, as becomes clear when his reconstruction of Dosso Dossi's early career on the basis of the Costabili polyptych (whose dating has been subect to so much controversy in recent years), or the decisive role he attributes to his great hero Ercole Roberti in the painting of the frescoes in Palazzo Schifanoia (a view not now generally accepted) are considered.[18] Such re-interpretations do not, of course, diminish the value of *Officina Ferrarese* as a whole, nor would there be any point in my trying to analyse its contents, which jump from biting jibes aimed at Berenson to some of the most eloquent descriptions of pictures ever penned. What is significant for my argument is the fact that precisely this approach had been adopted, some sixty years earlier, by Berenson's mentor, Giovanni Morelli, in his discussion of various German and Italian museums. Thus, Longhi's essay (it is not much more than a hundred pages long) demonstrates that the exhibition could at last take its place alongside the museum as a tool for creative research.

In 1945 Longhi did this once again, and this is worth mentioning because I suspect that it may have been the last time that

an Old Master exhibition served this purpose. The exhibition of *Cinque Secoli di Pittura Veneta*, consisting of some 200 pictures that had not been seen for five miserable years and that, just after the end of the war, were retrieved from storage in various hidden depots so as to be displayed for a brief period in the Procuratie Nuove, is now assured of a permanent art-historical footnote only because it gave rise to Longhi's thoughtful, wide-ranging, sparkling and provocative *Viatico per Cinque Secoli di Pittura Veneziana* – an essay that, among much else, attempted to cleanse, as it were, Venetian art of the very sort of association with Fascist opportunism that he himself had enjoyed. Hence his disparagement of Tiepolo who had exalted the princelings of his day, influenced meretricious modern artists and excited the approval of 'la critica ufficiosa', the semi-official line, the critical establishment, of the previous half century. Tiepolo had anticipated Romantic opera and Cecil B. de Mille, whereas Rosalba Carriera, as well as coming close to Watteau and producing portraits as serious as those by Chardin (pl. 47), presaged the work of Renoir.[19]

* * *

It is, fortunately, not only art historians who are in a position to grant some form of after-life to Old Master exhibitions. The power to do so belongs also to cultural historians and creative writers, and by a curious coincidence it was at almost exactly the same time that the greatest cultural historian and the greatest creative writer of the twentieth century made use of that power with unforgettable results.

As has already been mentioned, the extremely nationalist context within which the exhibition of Flemish 'primitives' was held in Bruges in 1902 gave a somewhat misleading slant to the evidence presented to the public. The organisers wanted to demonstrate, above all, that the deep piety and sincerity to be found in the paintings of Van Eyck, Memling, Gerard David and other fifteenth-century masters did not in any way conflict with a dominant concern for bold realism. In this respect, therefore, the genius of Flemish art of the period could be perceived as 'progressive' and as responsible for radically altering the course of painting throughout Europe: Van Eyck's *Eve*, for instance, was compared to works by Courbet. However, the effect on the thirty-year-old Johan Huizinga was entirely different.[20] As a budding historian from Holland, whose interests lay mainly in Indian religion

and philosophy and whose contacts with the visual arts were largely confined to the work of his contemporaries, he shared none of the nationalist concerns of Flemish scholars, and he came away from the exhibition with two insights that he was to develop only very slowly, but that in 1919 were to lead to the publication of his historical masterpiece, *The Autumn of the Middle Ages* (as it is now called).

In the first place, when Huizinga looked at the pictures shown at Bruges he found in them not true realism, but its opposite. Eve's body, for instance, had been distorted in order to impart an element of eroticism: her breasts were shown too small and too high, her arms were too long and too thin, and her belly was prominent in accordance with the taste in feminine beauty of Van Eyck's day. Other pictures by Van Eyck, some of which were seen by Huizinga only at a later date, seemed to confirm his view of the essentially artificial nature of the artist's so-called 'realism'. Thus, when discussing the *Virgin of the Chancellor Rolin* (Louvre, Paris) Huizinga paid little attention to the bulk and expressive power of the figures but concentrated instead on the crystalline clarity of the details, on 'the laborious exactness with which the materials of the dresses are painted, also the marbles of the tiles and the columns, the reflections of the window-panes, and the chancellor's breviary', and he concluded that the exaggerated finish that we find in the ornaments of the capitals, on which a whole series of biblical scenes is represented, is detrimental to the general effect. Similarly, when examining one of the panels of the Ghent altarpiece Huizinga commented on the 'heavy dresses of red and gold brocade, loaded with precious stones, those too expressive grimaces, the somewhat puerile decoration of the lectern'.

Much of this sort of analysis of what Huizinga considers to be characteristic of fifteenth-century Netherlandish painting in general could be challenged, for he was as selective in the pictures that he chose to discuss as the committee had been biased in their choice of pictures to exhibit. But it is worth pointing out that the more closely the nature of the exhibition itself is examined, the more explicable becomes Huizinga's interpretation of it. It would be pedantic – absurd in fact – to pursue this line of enquiry too far, because quite obviously he had plenty of opportunities to see Flemish pictures elsewhere, once he had already started work on his book; but as it is known that the first overwhelming revela-

tion came to him at the Bruges exhibition, it is interesting to explore what he could, or could not, have discovered there. Thus, only one certain, and very small, work – the *Virgin and Child by a Firescreen* (National Gallery, London) – was to be seen by the artist who is now usually called Robert Campin and who is recognised as one of the founders of the new Netherlandish painting – an artist whose domestic, almost ungainly 'realism' conveys so very different an image from the delicate and luxurious elegance of Van Eyck. And, although as many as seventeen pictures were attributed to Rogier van der Weyden in the catalogue, it was agreed that in none of these instances was the attribution wholly convincing, while it was, in any case, not possible to borrow from the Prado the large and dramatic *Deposition* which exemplifies just that boldness of conception and originality of design that Huizinga professed himself unable to discover in the art of the period. There were, on the other hand, two wings of an altarpiece showing no fewer than eight scenes from the legend of the martyrdom of St Ursula by an anonymous master of the second half of the fifteenth century (pl. 48). In fact, one has the impression that, although the stars of the exhibition were Van Eyck, Memling and Gerard David, it was appealing but relatively minor artists of this sort, combining picturesque architecture with eminently pretty, though slightly gaudy and awkward figures, engaged in scenes of ceremony and cruelty, that must have most excited visitors to the exhibition – and that help us to understand Huizinga's initial reaction to Netherlandish art and his subsequent book – devoted not only to art but to civilization.

Would it not be possible, he wondered, to explore the whole civilisation of the period by amplifying the inferences that he had drawn from the pictures to be seen at Bruges? And so, in 1910 – eight years, that is, after his visit to the exhibition – he began to read as much as possible of the Burgundian and French historians of the period, and it was on the basis of this and later researches that he produced the book that he at first planned to call *In the Mirror of Van Eyck*. That title would have made it immediately clear that his conclusions had been originally inspired by the visual arts – those arts that were first carefully studied by him at the beautiful Bruges exhibition of 1902 and that had inspired the organising committee to so many swaggeringly boastful claims. Would the committee members have been pleased, one wonders, if they had lived to read *The Autumn of the Middle Ages*, whose

primary thesis was that the Flemish–Burgundian civilisation of the fifteenth century was one of decline and decay rather than of ground-breaking progress?

It is, however, necessary to acknowledge that Huizinga's thesis has been repeatedly challenged by scholars in both Italy and France. In recent years two English historians[21] have gone out of their way to dispute Huizinga's claim – perhaps the most influential of all his claims – that by the fifteenth century the notion of chivalry, with its attendant enthusiasm for tournaments and displays of the most ritualised and extravagant nature, had lost its original purpose of training virtuous warriors to defend Christianity and had sunk into meaningless prodigality and dream-like evasion of reality. On the contrary, it is now asserted, the tournament retained its value as a preparation for actual warfare. Most devastating of all, perhaps, are the two pages in which that great French historian Lucien Febvre challenges the very notion of singling out some particular sentiment – the violent oscillation, for instance, between cruelty and tenderness, extreme hatred and extreme goodness, which exudes 'the mixed smell of blood and roses' – as having been characteristic of the decline of the Middle Ages. Cannot the same sentiment be detected just as clearly at the dawn of the Middle Ages – or, indeed, at the dawn of modern times?

Despite these and other pertinent criticisms, Huizinga's book, although not quite on the same level as the classics of Vasari, Gibbon and Burckhardt, will surely survive – as theirs do – as a masterpiece in its own right, for the inner consistency of its synthesis will continue to mesmerise even when the experts have persuaded the reader that it is frayed at the edges, and perhaps decayed at the core. And, although art historians have never openly accepted the validity of its thesis, it has surely had a crucial (though not necessarily beneficial) effect on one of the greatest art historians of our time.

In his very influential *Early Netherlandish Painting* of 1955 Erwin Panofsky argued that the conquest of natural appearances by Jan van Eyck and some of his contemporaries was so effective that it carried with it the supreme risk of destroying what had hitherto been the principal purpose of a picture: 'to instruct and arouse pious emotions and awaken memories'. A scene such as the one depicted in the portrait of Arnolfini and his wife might be thought of as devoid of meaning in that sense, and some way had, therefore, to be found of reconciling 'the new naturalism with a

thousand years of Christian tradition'. That way was to be the conscious application of symbolic interpretations 'to each and every object, man-made or natural'. Thus when we look at Van Eyck's '*Lucca Madonna*' (pl. 49) we – and still less fifteenth-century spectators – are not invited to be awe-struck by the apparently natural positioning of the Virgin and Child seated under a three-dimensional canopy in a simply furnished room, around which we could find our way without difficulty – in contrast to the stylised and artificial conventions adopted by Netherlandish artists in their depictions of similar scenes a generation or so earlier. Panofsky emphasises instead the significance of the candlestick, which supposedly denotes the Virgin (who supports her Child as the candlestick supports the candle); of the glass carafe and the basin, which serve for 'an indoors substitute for the most typical symbols of the Virgin's purity, "the fountain of gardens" and "well of living waters" of the Song of Songs'; and of the four lions on the armrests of the Virgin's throne which 'bring to mind' the Throne of Solomon, as described in The Book of Kings; and so on. The effect of all this is to neutralise the impact of Van Eyck's vivid and real novelty and to make his painting appear far more 'medieval' than it strikes us at first sight. Indeed, Panofsky points out that Van Eyck is still making use – though on a far more systematic and sophisticated basis – of the same type of symbolism that Broederlam had earlier employed in his *Annunciation*, where, for instance, the three windows on the cornice allude to the Trinity, and the circular structure behind the Virgin's shrine has been designed to look like a tower because this was a recognised symbol of chastity.

Although Panofsky confined his admiration of Huizinga to footnotes, one suspects that his claim that Van Eyck was not the 'realist' and hence 'progressive' painter so admired by the nineteenth century had been, consciously or unconsciously, inspired by Huizinga's *The Autumn of the Middle Ages*, and that – even if the whole concept of 'disguised symbolism' is now widely rejected – Panofsky's hypothesis can, none the less, be thought of as one of the 'enduring legacies' of the Bruges exhibition of nearly a century ago.

* * *

The final example of the lasting influence which can be exerted by an Old Master exhibition concerns the inspiration that they

can provide. A memorable example of such will always be asso-
ciated with an exhibition held in 1921 at the Jeu de Paume in
Paris. Early in that year the Dutch ambassador to France, sup-
ported by a commission made up of artists and art historians and
established by royal decree on 13 January, assembled a collection
of Dutch works of art to be sent to France. About a hundred of
these were paintings and drawings by Old Masters; there were
sixty or so by painters of The Hague school; and another forty
modern works, divided into 'period of transition' and contempor-
ary of which by far the most striking were eight by Van Gogh.
The purpose of the exhibition was to raise money in aid of the
regions in eastern France that had been devastated during the
recently concluded First World War. Most of the pictures came
from public and private collections in Holland, but a few were
lent from private collections in England, from France itself and
from elsewhere. The Dutch museums were not entirely enthusias-
tic. Van Riemsdijk, director general of the Rijksmuseum, was
anxious about the dangers, especially when the paintings were
packed up for return. Otto Bredius, the director of the Maurits-
huis, refused to lend Rembrandt's *Saul and David*, although he
volunteered to lend other works by the artist. There was also
consternation among supporters of the exhibition that some of
the paintings by Frans Hals were not coming from Haarlem.[22]
One superb Hals was, however, sent from New York (the *Family
Group* now in the Thyssen Collection), and it is worth pausing
for a moment over the significance of this loan, because it was
perhaps the first occasion on which a major work of art returned
to Europe from the United States, although smaller objects had
been sent to dealers' exhibitions in Paris during the years imme-
diately preceding the war.

It was in 1909 that an Old Master exhibition in New York had
first drawn public attention to the riches of Dutch art in America.
This, the earliest substantial and coherent exhibition of its kind
to be organised in the United States, was held in the Metropoli-
tan Museum in order to commemorate 'the tercentenary of the
discovery of the Hudson river by Henry Hudson in 1609, and the
centenary of the first use of steam in navigation of the said river
by Robert Fulton in the year 1807.' It consisted of two parts: one
devoted to American art, and the other to about 150 Dutch paint-
ings of the seventeenth century.[23] A few of these were from the
museum's own holdings, but most were lent from private collec-

tors, and, as can be seen from views of just two of the galleries (pls 50, 51), there were some very fine pictures among them. In one gallery, for instance, is the wonderful *Self-portrait* by Rembrandt, belonging to Henry Clay Frick and hanging in a place of honour at the centre of a side wall; and, in a corner, the *Man in a Fanciful Costume*, also by Rembrandt, which is now in the Metropolitan Museum. In the other gallery were the grandiose and striking pair of portraits by Frans Hals (now in the Yale University Art Gallery), and, although they are not visible in the photographs, there were superlative Vermeers and many other fine pictures from the Dutch golden age.

The fact, then, that of all the rich American collectors only one was prepared to lend a picture to the Paris exhibition suggests that international loans (or, at any rate, transatlantic loans) were still unusual, but lack of co-operation on the American side was more than compensated for elsewhere. In England, Lord Iveagh lent the magnificent Rembrandt *Self-portrait* that remains at Kenwood House, and in France the painter–collector Léon Bonnat sent a very fine and sometimes unusual selection of drawings by the same artist. But the most extraordinary pictures were, in fact, those that came from the anxious Dutch museums. Vermeer's *Milkmaid* had been a source of special anxiety to van Riemsdijk, but he lent it, and Bredius allowed both the *Head of a Young Girl* and the *View of Delft* (pl. 52) to leave the Mauritshuis. The latter work was one by which Marcel Proust had been entranced twenty years earlier. He was now determined to see it again, despite the fact that he was dangerously ill (and had little more than a year to live). At 9.15 on the morning of 24 May, instead of going to bed as he usually did at that time of day, after writing through the night, he sent a message to his friend Jean-Louis Vaudoyer, asking him to accompany him,[24] for Vaudoyer had recently written a series of articles on Vermeer – a painter who plays a crucial role at many stages in the course of *A la Recherche du temps perdu*. And so, feeling weak and giddy, he left his sick bed to venture out for almost the last time (pl. 53). When he returned home he drew on his experiences at the exhibition to add a marvellous page to the long book that he was desperately trying to finish. He turned to the passage describing the condition of Bergotte, the worldly and successful novelist, who had been dangerously ill for some time and was confined to bed, and he then continued as follows:

But a critic having written that in Vermeer's *View of Delft* (on loan from the museum at The Hague to an exhibition of Dutch art), a picture to which he was passionately attached and that he believed that he knew very well, there was a small patch of yellow wall (which he didn't recall) so finely painted that it possessed, if considered in isolation, the self-sufficient beauty of some precious Chinese work of art, Bergotte ate some potatoes, left home and went to the exhibition.

On the first steps that he had to climb he felt seized by giddiness. He passed in front of a number of paintings and was struck by the dryness and pointlessness of an art devoted to the counterfeit, worth so much less than the breeze and sunshine on a Venetian palace, on a simple seaside home. At last he was in front of the Vermeer, which he recalled as more startling, more different from everything else he knew, but where, thanks to the critic's article, he noticed for the first time some little figures in blue, the pink of the sand, eventually the exquisite substance of the very small patch of yellow wall. His dizziness grew worse; he fixed his gaze on that exquisite small patch of wall like a child on a yellow butterfly it wished to catch. 'That's how I should have written', he said. 'My last books are too dry, they could have done with several more glazes of colour, making my sentences exquisite in themselves, like this small patch of yellow wall.' At the same time the seriousness of his dizziness did not escape him. In a celestial balance he saw his own life as a weight on one scale, and on the other scale that small patch of wall so well painted in yellow. He felt that he had imprudently sacrificed the former for the latter. 'All the same,' he said to himself, 'I'd rather not become the news item about this exhibition in the evening papers.'

He repeated to himself, 'small patch of yellow wall with a porch roof, small patch of yellow wall – *petit pan de mur jaune.*' Meanwhile, he sank on to a circular settee. Quickly enough he stopped thinking that his life was at stake and, relapsing into optimism, told himself, 'It's simply indigestion brought on by those undercooked potatoes; it's nothing.' A new attack struck him, he rolled from the settee to the floor, where all the visitors and warders ran to him. He was dead. Dead forever? Who can say?[25]

And so the dying Proust allows the dying Bergotte not only an insight in to the painter's art but the chance to review his own

values as a writer. This was, however, made possible only by the holding of a beautiful but intrinsically pointless exhibition which – in my view – ought (like many others I have discussed in this book) never to have been encouraged. One could argue that Bergotte (or Proust) might have made a special effort to revisit a picture in a Parisian museum, but he would have been more inclined to defer such an expedition on the grounds that the picture would remain there. Moreover, a critic would have been less likely to write about it. The impermanence of the art exhibition induces a special excitement, epitomised by the conviction that it may never again be possible to see something that it offers – something from very far away, or from an impenetrable private collection, or a comparison between pictures, the reassembly of a group of them. It may be one's last chance, so one goes.

Does the illumination granted to Bergotte and, perhaps, in different forms, to countless other visitors to countless other exhibitions in various parts of the world, justify the ceaseless growth of a fashion about which we should, I believe, have serious doubts? 'Who can say?'

Notes

Abbreviations

AV Archivio Vecchio, Soprintendenza Beni Artistici e Storici, Milan
Chamberlain papers Chamberlain papers, University of Birmingham Library
Farington Diary *The Diary of Joseph Farington*, 16 vols, New Haven and London
 1978–84, and Index, New Haven and London 1998. Vols I–VI ed.
 Kenneth Garlick and Angus Macintyre; vols VII–XVI ed. Kathryn
 Cave; Index by Evelyn Newby.
V&A Victoria and Albert Museum, London (National Art Library)

Note

As explained in the Preface, the Notes have, for the most part, been expanded from references made by the author (F.H.). New material added by Nicholas Penny (N.P.) has been placed within square brackets.

Introduction

1 But see *Dosso's Fate: Painting and Court Culture in Renaissance Italy*, ed. Luisa
 Ciammitti, Steven F. Ostrow and Salvatore Settis, Los Angeles 1998, based on symposia held at the J. Paul Getty Museum in 1996 and 1997 – *before* the exhibitions of 1998–1999 – 'in order to generate discussion that might inform the exhibition catalog' (p. ix).
2 See Thomas E. Crow, *Painters and Public Life in Eighteenth-Century Paris*, New
 Haven and London 1985.
3 As will be pointed out from time to time, some exhibitions included both contemporary and Old Master paintings.
4 Among these were Michelangelo, Raphael, Andrea del Sarto, Rosso Fiorentino, Leonardo, Pontormo, Titian, Fra Bartolomeo, Sebastiano del Piombo, Correggio and Parmigianino. An exception was made for portraits, landscapes and small devotional works – 'da mettere a capo del letto' (Zygmunt Wázbínski, *L'Accademia medicea del disegno a Firenze nel cinquecento: idea e istituzione*, 2 vols, Florence 1987, vol. II, pp. 503–4).
5 'A Catalogue of the Superb Collection of Pictures . . . and Capital Drawings by Old Masters, the property of Signor Biondi, going abroad' (Christie and J. Ansell,

21 February 1777); information kindly supplied by Donata Levi. Paul Taylor informs me that in 1604 Van Mander sometimes employed the term 'oude meesters' condescendingly of Dutch artists working between 1400 and 1550, and Erin Griffey informs me that the contrast between old and new pictures by Dutch writers relates more to dress than to style.

6 See, for instance, *Farington Diary*, vol. III, pp. 839 and 840 (15 and 17 May 1797). Burton Fredericksen in a letter of 31 August 1998 notes the increasing use of the term in this period.

7 Janet Cox-Rearick, *Royal Treasures: The Collection of Francis I*, New York 1996, pp. 140–43 and 168–70, IV-1 and V-3.

8 W. Bürger, *Salon de 1861*, Paris 1901, p. 84.

9 Idem., *Trésors d'Art en Angleterre*, Paris 1857, Preface.

1 Feast Days and Salerooms

1 For this section see Francis Haskell, *Patrons and Painters: A Study in the Relations between Italian Art and Society in the Age of the Baroque*, rev. edn, New Haven and London 1980, pp. 125–9.

2 Guilia De Marchi (ed.), *Sebastiano e Guiseppe Ghezzi protagonisti del barocco*, exh. cat., Palazzo Pascali, Comunanza, 1999, p. ix.

3 This was suggested by Tomaso Montanari in 'Cristina di Svezia, il Cardinal Azzolino e le mostre di quadri a San Salvatore in Lauro' in the *Atti* of the convegno, 'La Regina Cristina di Svezia, il Cardinale Decio Azzolino e Fermo nell'arte e nella politica della seconda meta del seicento' held in Fermo in October 1995 (forthcoming).

4 De Marchi, *op. cit.*, pp. 22–5.

5 *Ibid.*, pp. 88ff.

6 *Ibid.*, pp. 233ff.

7 *Ibid.*, p. 327.

8 *Ibid.*, p. 346. The Poussin was probably the painting now in the Kunsthalle in Zürich.

9 *Ibid.*, pp. 190–91. These pictures were presumably small copies of the great altarpieces (or parts of them), the *Martyrdom of Placidus, Flavia and Other Saints* and the *Lamentation*, both originally in S. Giovanni Evangelista in Parma and now in the Galleria Nazionale there. It is tempting to relate the *Pietà* to the painting of that subject by (or after) Correggio in the Courtauld Institute Galleries in London, which may – like the exhibited *Pietà* – have belonged to the marchese del Carpio.

10 For this section see Haskell, *Patrons and Painters*, also Fabia Borroni Salvadori, 'Le esposizioni d'arte a Firenze dal 1674 al 1767', *Mitteilungen des Kunsthistoriches Instituts in Florenz*, XVIII, 1974, pp. 1–166. See also Zygmunt Wázbínski, *L'Accademia medicea del disegno a Firenze nel cinquecento: idea e istituzione*, 2 vols, Florence 1987. For exhibitions of contemporary art in Venice see Francis Haskell and Michael Levey, 'Art Exhibitions in Eighteenth-century Venice', *Arte Veneta*, 1958, pp. 179–85, and for those in Naples see Riccardo Lattuada, 'Luca Giordano e i maestri napoletani di natura morta nelle tele per la Festa del Corpus Domini del 1684', in *Capolavori in Festa – Effemero barocco a largo di Palazzo (1683–1759)*, Naples 1997.

11 Preface to the catalogue of 1767 entitled *Il Trionfo delle Bell'Arti renduto gloriosissimo sotto gli auspici delle LL.AA.RR. Pietro Leopoldo d'Austria . . . e Maria Luisa di Borbone d'Austria . . . SS Nonziata in Firenze*. For further details of this rare publication, see Borroni Savaldori, *op. cit.*, n. 25.

12 Haskell, *Patrons and Painters*, pp. 228–41.

13 Borroni Salvadori *op. cit.*, p. 11.

14 It should be admitted that, when the Venetian pictures lent by the grand prince can be traced, their quality is seen to be not very high – certainly by comparison with

what was available to him. Thus the *Bacchanal* by Titian was a seventeenth-century copy of part of the *Bacchus and Ariadne* now in the National Gallery, London (Pitti, inv. 1912, no. 157; see *Tiziano nelle Gallerie Fiorentine*, exh. cat., Florence 1978, no. 15).

15 *Il Trionfo, op. cit.*, p. vi.

16 For bibliographical references see De Marchi, *op. cit.*, pp. viii–ix, nn 9 and 10.

17 The picture was sold by Lucas van Uffelen; see E. Maurice Bloch, 'Rembrandt and the Lopez collection', *Gazette des Beaux-Arts*, XXIX, 1946, pp. 175–86. John Shearman has argued that Rembrandt's drawing (now in the Albertina, Vienna) was made after the auction when the Raphael was with Lopez, but his reasons are not decisive ('Le portrait de Baldassare Castiglione par Raphael', *La Revue du Louvre*, 1979, pp. 261–70).

18 Emile Dacier, *Catalogues de ventes et livrets de salons illustrés par Gabriel de Saint-Aubin*, 6 vols (13 parts), Paris 1909–21.

19 Paul de Roux (ed.), *Mémoires de Madame Roland*, Paris 1766, p. 287.

20 See, for instance, J.-P. Brissot, *Mémoires*, ed. C. Perroud, 2 vols, Paris 1910, vol. I, pp. 191–2.

21 See Jean Cailleux, advertising supplement in *Burlington Magazine*, 1971, pp. 92–5, also Georges de Lastic, 'Nicolas de Largillière: heures et malheurs d'un chef d'oeuvre', *L'Oeil*, December 1985, pp. 36–45, who writes that 'on peut présumer que tous étaient à vendre', in the exhibiton of Old and Modern Masters, despite the, admittedly inconclusive, fact that not one of those that can be identified was sold. I am encouraged that Colin Bailey (to whom I am indebted for information on this matter) agrees with me that the exhibitions were not commercial.

22 Brissot, *op. cit.*

23 For all the following see, where not otherwise indicated, F. Rabbe, 'Pahin de la Blancherie et le Salon de la Correspondance', *Bulletin de la Société historique du VIe arrondissement de Paris*, II, 1899, pp. 30–52, and Emile Bellier de la Chavignerie, 'Les artistes français du XVIII siècle oubliés ou dédaignés', *La Revue universelle des arts*, XIX, 1864, and Pahin's own writings in the *Nouvelles de la république des lettres*.

24 Maurice Tourneux (ed.), *Correspondance littéraire par Grimm, Diderot, Raynal etc.*, 16 vols, Paris 1877–82, vol. XII, pp. 101–3 (May 1778).

25 Bellier de la Chavignerie, *op. cit.*, p. 206.

26 *Ibid.*, pp. 211–13.

27 *Nouvelles de la république des lettres*, 1782, XXVI, 10 July, p. 203; XXVII, 17 July, p. 213; XXVIII, 24 July, p. 221; XXIX, 31 July, p. 229. See Nicole Willk-Brocard, *Une Dynastie: Les Hallé*, Paris 1995, pp. 20 and 77, for the relationship between the Jouvenet, Restout and Hallé families, and pp. 276 (C24) and 361 (N12) for Claude Hallé's *Finding of Moses* (now in a private collection) and an engraving of Noel Hallé's (lost) *Hercules and Omphale*, which Pahin had already exhibited in March.

28 Despite what is often claimed – and despite their real novelty – the small showings of the Restout and Hallé family pictures (never more than nine in all) cannot legitimately be described as such in the context of this book.

29 Curiously this exhibition does not seem to have been discussed in the Vernet literature – e.g., Léon Lagrange, *Joseph Vernet et peinture au XVIIIe siècle*, Paris 1864; Florence Ingersoll-Smouse, *Joseph Vernet: peintre e marine 1714–1789*, 2 vols, Paris 1926 – or the more recent studies.

30 See Lagrange, *op. cit.*, pp. 321–74 (*Livre de Vérité*).

31 *Ibid.*, p. 267.

32 See Bellier de la Chavignerie, *op. cit.*, pp. 177–8.

33 See Lagrange, *op. cit.*, p. 272.

34 For a list of the works shown (with brief descriptions) see *Nouvelles de la république des lettres*, 26 March 1783, supplement to vol. XIII (following p. 103). The brevity of the description, the repetitive nature of Vernet's subjects and the inadequacy of scholarly literature combine to obstruct identification of the pictures exhibited, despite our knowledge of their owners.

35 It is tempting to suggest that these were the four overdoors of the *Four Times of Day* painted for his father's library in the 1760s which are once more in Versailles, after being in the Louvre during much of the nineteenth century, but the subjects, although similar, do not correspond with those listed by Pahin; see Ingersoll-Smouse, *op. cit.*, vol. I, p. 95, nos 763–6 and figs 194–7.

36 Bellier de la Chavignerie, *op. cit.*, p. 180. Pahin claimed that there had been too many 'éloges en vers et en prose' for it to be practicable to publish them in the *Nouvelles de la république des lettres* (XIV, 2 April 1783, p. 113).

37 Bellier de la Chavignerie, *op. cit.*, p. 217.

38 Pahin's embarrassment is revealed in a phrase from Delafosse's encomium in the *Nouvelles de la république des lettres* (Bellier de la Chavignerie, *op. cit.*, p. 181 and note 21): 'Quelle douce satisfaction doit avoir M. Vernet! (Car c'est là sûrement le sentiment de son coeur).' And for Vernet's 'modesty', see *Nouvelles de la république des lettres*, XIII, 26 March 1783, p. 103.

39 Bellier de la Chavignerie, *op. cit.*, p. 217.

40 It may, however, be worth mentioning that the meagre evidence available to us suggests that the great majority of the works shown were recent productions which were being increasingly criticised for their repetitive character – a failing that would have been particularly apparent when a group of them was assembled.

41 Delafosse (the engraver) in *Nouvelles de la république des lettres*, XIII, 26 March 1783, reprinted in Bellier de la Chavignerie, *op. cit.*, p. 181.

42 *Ibid.*, p. 161.

43 *Ibid.*, p. 297 for the last reference.

44 The catalogue was published in *Nouvelles de la république des lettres*, XXV, 1 July 1783. It was reprinted in 1790 as *Essai d'un tableau historique des peintres de l'école française, depuis Jean Cousin, en 1500, jusqu'en 1783 inclusivement, avec le catalogue des ouvrages des mêmes Maîtres qui sont offerts à présent à l'émulation & aux hommages du Public, dans le Salon de la Correspondance. Sous la direction & par les soins de M. de la Blancherie, Agent Général de Correspondance pour les Sciences et les Arts*. The numeration may suggest that 194 pictures were exhibited, but on three occasions two pictures were given the same number and one of them distinguished by a *'bis'*.

45 See Pahin, *Nouvelles de la république des lettres*, XXI, 21 May 1783, p. 163, and cat. no. 2 where Callot's name is followed by an asterisk, beneath which is listed 'un portement de Croix' lent by M. Bachelier, Peintre du Roi.

46 John Ingamells, *The Wallace Collection: Catalogue of Pictures, French before 1815*, 1989, vol. III pp. 170–75, P122, as 'French School c. 1715–20'.

47 See Lettre XIII in *Année Littéraire*, 1783, V, pp. 199–206.

48 See the discussion of this by Henri Zerner, *L'Art de la Renaissance en France: l'invention du classicisme*, Paris 1996, pp. 210–16.

49 Rabbe, *op. cit.*, pp. 43–6.

50 Bellier de la Chavignerie, *op. cit.*, p. 217.

51 *Ibid.*, pp. 218–19.

52 See, for instance, the pictures sent to London for auction in 1776 from the academy in Glasgow which had been founded by Robert Foulis and his brother Andrew. Among the most important were 'Raphael's SAINT CECILIA – an original picture with improvements on the one at Bologna' (Foulis had earlier claimed that it was 'prior to the famous picture at Bologna') and the 'TRANSFIGURATION, on cloth, prior to

the larger picture on the altar belonging to the monastery of Montorio in Rome', as well as some thirty-six other Raphaels, about twelve Correggios, nearly thirty Guido Renis, and so on (V&A, Press Cuttings, PP 17.4., vol. I, p. 139).

53 Casimir Stryienski, *La Galerie du régent Philippe, duc d'Orléans*, Paris 1913 (limited edition), p. 132.

54 [F.H. intended to refer to letters concerning Christie's involvement in a proposal to purchase the Orléans collection, but it is not clear where these were published.]

55 Stryienski, *op. cit.*, p. 132.

56 English newspapers had earlier reported that the National Assembly had tried to retain the pictures in France, but that it had not been able to match the sum offered to the duke by potential British purchasers (V&A, Press Cuttings, PP 17.4., vol. II, pp. 546, 548, 578, 581).

57 Stryienski, *op. cit.*, p. 137.

58 See *ibid.*, also, William Buchanan, *Memoirs of Painting*, 2 vols, London 1824, vol. I, pp. 322–7; Michael Levey, 'An English Commission to Guardi', *Burlington Magazine*, CII, August 1960, pp. 365–6; John Ingamells, *A Dictionary of British and Irish Travellers in Italy 1701–1800, compiled from the Brinsley Ford Archive*, New Haven and London 1997, pp. 863–4.

59 As correctly noted in Jordana Pomeroy, 'The Orléans Collection: Its Impact on the British Art World', *Apollo*, February 1997, pp. 26–31, the exhibition opened in March (this is confirmed by contemporary diaries), although the date of April is given in the catalogue and often repeated. On their arrival in England the pictures had been displayed for several months in Slade's home at Chatham (Buchanan, *op. cit.*, vol. I, pp. 163–4). [There is some confusion as to whether the acquisition was made in 1791 or 1792. Slade recalled arriving in Paris on the day the King fled, in June 1791. On that occasion he almost purchased the entire collection. He must have returned in 1792 and succeeded in acquiring the German, Flemish and Dutch works in that year.]

60 Sidney C. Hutchison, *The History of the Royal Academy*, London 1968, pp. 51–62.

61 *Survey of London*, vol. XXIX, pt. 1, London 1960, pp. 346–8.

62 National Gallery of Art, Washington, D.C.

63 Rijksmuseum, Amsterdam, now attributed to Rembrandt's studio.

64 National Gallery, London (NG 194).

65 Royal Collection, U.K.

66 Buchanan, *op. cit.*, vol. I, p. 164. Purchasers of pictures or of the guinea subscription ticket could make unlimited visits (see the sale catalogue, p. x).

67 Pomeroy, *op. cit.*, p. 27, quoting the *Morning Chronicle*, 27 April 1793.

68 Buchanan, *op. cit.*, vol. I, p. 164.

69 Stryienski, *op. cit.*, pp. 137–8. The great majority of items listed in the second half of the catalogue cannot be traced to the Orléans collection.

70 Sale catalogue, p. vii.

71 Stryienski, *op. cit.*, pp. 138–9.

72 *Farington Diary*, vol. II, p. 590, vol. III, pp. 793 and 850 (26 June 1796, 11 March and 6 June 1797). It is not clear where the pictures were kept, as few London mansions would have been large enough to accommodate them all, and it seems probable that many must have been stored in a warehouse.

73 *Ibid.*, vol. II, p. 590; vol. IV, p. 1132 (26 June 1796, 11 January 1799).

74 *Ibid.*, vol. III, p. 846 (30 May 1797).

75 *Ibid.*, vol. IV, p. 1132 (11 January 1799).

76 See the entry in the *Dictionary of National Biography*.

77 These special conditions are outlined in the sale catalogue.

78 *Survey of London*, vol. XXIX, pt 1, London 1960, pp. 375–6.

79 A plan is provided by Farington in the drawings now in the special collections of the Getty Research Institute, Los Angeles, 880391.

80 Howard Colvin, *A Biographical Dictionary of British Architects, 1600–1840*, 2nd edn, London 1975, p. 609.

81 Apart from the contents listed in the catalogue see *Farington Diary*, vol. IV, pp. 1130 (8 January 1799).

82 *Ibid.*, vol. IV, p. 1259. The catalogues and drawings are cited in note 79, above. The impulse to record the arrangement was perhaps similar to his obsessional recording of the seating plan of even the smallest dinner party he attended.

83 Mary Berry, *Extracts of the Journals and Correspondence of Miss Berry*, 3 vols, ed. Lady Theresa Lewis, London 1856, vol. II, pp. 86–7 (5 March 1799), also Lady Annabel Yorke, manuscript diaries, vol. XVII, p. 280 (the diaries are in the West Yorkshire Archives, Leeds. I am grateful to Humphrey Wine for references to this source).

84 The great painting by Orazio Gentileschi recently sold from Castle Howard and now in an English private collection.

85 Now in the museum of Grenoble. It seems, unusually, to have returned rapidly to France and by 1806 was with the dealer Lebrun.

86 Fitzwilliam Museum, Cambridge, and Frick Collection, New York.

87 Wallace Collection, London, and Isabella Stewart Gardner Museum, Boston.

88 Formerly Bridgewater House, destroyed in the Second World War.

89 National Gallery, London (NG 1318, 1324–6).

90 Again, in fact, by Orazio Gentileschi.

91 The former as in note 88; the latter Villa Borghese, Rome.

92 Ashmolean Museum, Oxford, and Fogg Art Museum, Cambridge, Mass.

93 National Gallery, London (NG 1).

94 Duke of Sutherland, on loan to the National Gallery of Scotland, Edinburgh.

95 Perhaps the large sketch, recently discovered, and apparently without provenance, now in the Thyssen-Bornemisza Museum, Madrid.

96 Castle Museum, Nottingham.

97 Waterhouse notes that this picture was by Serodine. [*La Galerie du Palais-Royale*, edited by Jacques Couché and consisting of 352 plates, reproducing 396 paintings, was originally available in fasicules to subscribers from 1 February 1786 until it was discontinued under the Terror. Work resumed in 1806, and the three volumes appeared in 1808. The engravers used drawings made before the sales.]

98 Duke of Sutherland, on loan to the National Gallery of Scotland, Edinburgh.

99 National Gallery, London (NG 2923). For the admiration aroused by this picture see (in addition to published evidence) Lady Annabel Yorke's manuscript diaries (*op. cit.*).

100 *Farington Diary*, vol. IV, p. 1124 (1 January 1799).

101 C. R. Leslie, *Memoirs of the Life of John Constable, Esq. R.A.*, London 1845, p. 124.

102 *Farington Diary*, vol. IV, p. 1144 (22 January 1799).

103 Harold E. Wethey, *The Paintings of Titian*, 3 vols, London 1969–75, vol. I, X-14, copy no. 4.

104 *Farington Diary*, vol. IV, p. 1345 (6 January 1800). For other views of the condition of the pictures see Pomeroy, *op. cit.*, pp. 28–9.

105 *Farington Diary*, vol. IV, p. 1127 (4 January 1799).

106 *Ibid.*, vol. III, p. 793 (11 March 1797).

107 *Ibid.*, vol. II, p. 590 (26 June 1796).

108 *Ibid.*, vol. IV, p. 1237 (12 June 1799). Beaumont qualified this by adding 'of its size'.

109 *Ibid.*, p. 1127 (4 January 1799) and vol. III, pp. 1121–2 (4 December 1798).

110 *Ibid.*, vol. IV, p. 1127 (4 January 1799).

111 *Ibid.*, p. 1228 (25 May 1799).

112 Ralph N. Wornum (ed.), *Lectures on Painting by the Royal Academicians*, London 1848, p. 389.
113 Berry, *op. cit.*, vol. II, p. 87.
114 Lady Annabel Yorke's manuscript diaries, *op. cit.*, vol. I, pp. 276, 279–80.
115 Pomeroy (*op. cit.*) records that the average numbers of daily visitors was only twenty-nine.
116 Buchanan, *op. cit.*, vol. I, pp. 222–4.
117 William Hazlitt, 'On the Pleasure of Painting', *London Magazine*, December 1820, reprinted in *Collected Works*, ed. A.R. Walker and Arnold Glover, 12 vols, London 1902–6, vol. VI, 1903, pp. 5–21 (esp. p. 14).

2 *Tribute and Triumph*

1 Alphonse Jean Joseph Marquet de Vasselot, *Répertoire des catalogues du Musée du Louvre (1793–1917), suivi de la liste des directeurs et conservateurs du musée*, Paris 1917, no. 256. For what follows see *L'An V*, Paris 1988, the catalogue of the exhibition held at the Musée du Louvre (Cabinet des Dessins); Andrew McClellan, *Inventing the Louvre: Art, Politics and the Origins of the Modern Museum in Eighteenth-Century Paris*, Cambridge 1994, pp. 127–9; and the catalogue of the recent exhibition *Dominique-Vivant Denon* held at the Musée du Louvre 1999 [of the last mentioned of these F.H. was able to make only limited use].
2 George Duplessis, *Catalogue de la collection de pièces sur les Beaux-Arts*, Paris 1881, vol. XIX (Deloynes), no. 503.
3 A general impression of the arrangement can be gauged from the drawing by Constantin Bourgeois even if – as is suggested in *L'An V*, p. 26, n. 26 – it may represent the exhibition held five years later.
4 Duplessis, *op. cit.*, p. 502.
5 Marquet de Vasselot, *op. cit.*, no. 90.
6 Cecil Gould, *Trophy of Conquest: The Musée Napoléon and the Creation of the Louvre*, London 1965, p. 73; Yveline Cantarel-Besson, *La Naissance du musée du Louvre: la politique muséologique sous la Révolution d'apres les archives des musées nationaux*, 2 vols, Paris 1981, vol. II, pp. 139, 140, 142.
7 Gould, *op. cit.*, p. 70.
8 Marquet de Vasselot, *op. cit.*, no. 89; Cantarel-Besson, *op. cit.*, vol. II, p. 247 (PA 70).
9 Cantarel-Besson, *op. cit.*, vol. I, pp. xxxii, 92, 93, 96–7. As the paintings by Rubens included two of his most celebrated masterpieces – the central panel from the *Descent from the Cross* and the *Crucifixion (Coup de Lance)* – it is unlikely that many art-lovers (as distinct from artists and bureaucrats) would have been too bothered that modern competition entries had had to be displaced.
10 *Ibid.*, vol. II, p. 135.
11 Yveline Cantarel-Besson, *Musée du Louvre (janvier 1797–juin 1798): Procès-verbaux du Conseil d'aministration du 'Musée' central des arts'*, Paris 1992, p. 117, and McClellan, *op. cit.*, p. 131.
12 *Duplessis, op. cit.*, vol. XIX, nos 515 (letter to *Journal de Paris*, 16 May 1797) and 516.
13 Cantarel-Besson, *Musée du Louvre*, pp. 193ff, and McClellan, *op. cit.*, pp. 131–2.
14 Cantarel-Bessson, *La Naissance du musée du Louvre*, vol. II, p. 16, and Marquet de Vasselot, *op. cit.*, no. 90.
15 See the very full documentation in Cantarel-Besson, *Musée du Louvre*.
16 *Ibid.*, p. 225; McClellan, *op. cit.*, p. 121.
17 McClellan's interesting suggestions (*ibid.*, p. 134) are based on the arrangement in the catalogue rather than that on the walls.

18 Although the French had – according to Bonaparte – thought of removing some fifty pictures from Bologna when they captured the town in June 1796, in fact they took only thirty-two (Marie-Louise Blumer, 'La Mission de Denon en Italie (1811)', *Revue des Etudes Napoléoniennes*, XXXVIII, 1934, pp. 237–57). Only two of these were by Annibale Carracci and neither was exhibited.

19 I owe this point to McClellan, *op. cit.*, p. 135.

20 Cantarel-Besson, *La Naissance du Musée du Louvre*, vol. I, pp. 32–3, and McClellan, *op. cit.*, pp. 111–13.

21 Duplessis, *op. cit.*, vol. XIX (Deloynes), no. 521; J.-B.-P. Lebrun, *Examen historique et critique des tableaux exposés provisoirement venant des premier et second envois de Milan, Crémone, Parme . . .* , Paris an VI, pp. 15–16.

22 *Ibid.*, no. 522, Duval.

23 The letter is published in Jane Van Nimmen, *Responses to Raphael's Paintings at the Louvre, 1798–1848*, Ann Arbor, Michigan 1987, pp. 66–8.

24 Duplessis, *op. cit.*, vol. XIX (Deloynes), no. 521.

25 Gould, *op. cit.*, p. 43.

26 *Ibid.*, p. 54.

27 Francesca Valli, 'Florilegio ragionato della fortuna critica', in *L'Estasi di Santa Cecilia di Raffaello di Urbino*, exh. cat., Bologna 1983, pp. 265–6.

28 Van Nimmen, *op. cit.*, p. 67.

29 See, for example, the very interesting extract from the *Descrizione dei quadri restituiti a Bologna dai Francesi che occuparono l'Italia nel* MDCCXCVI, Bologna n.d., quoted in Sandra Costa, 'Il Gusto dei bolognesi: l'arte emiliana in Francia dalle requisizioni al 1815', in *Pio VI Braschi e Pio VII Chiaramonti*, ed. A. Emiliani *et al.*, Bologna 1998, acts of an international conference held May 1997, pp. 77–154 (this ref. is p. 132). The returned pictures, 'benissimo conservate, e ripulite in Francia', were exhibited for some days in the Church of Santo Spirito, which was adapted and decorated for the occasion and visited by enthusiastic crowds from all sections of society.

30 Van Nimmen, *op. cit.*, p. 111.

31 Cantarel-Besson, *La Naissance du Musée du Louvre*, II, p. 66.

32 *L'An V*, p. 14 but with no specific reference, and I cannot find one in Cantarel-Besson.

33 This is clear from the overwhelming majority of the responses recorded in the catalogue of the Deloynes collection compiled by Duplessis (*op. cit.*).

34 *Notice des principaux tableaux recueillis en Italie*, troisième partie (Marquet de Vasselot, *op. cit.*, no. 94), no. 14.

35 Duplessis, *op. cit.*, vol. XXII (Deloynes), no. 615.

36 *Ibid.*, no. 613, Beaudouin fils.

37 The catalogue was apparently drawn up by the staff of the Musée Napoléon in a great hurry while the works themselves had often not yet been removed from their packing cases. This doubtless explains its deficiencies (letter to author from Daniela Gallo, 27 May 1999).

38 Blumer, *op. cit.* [For the rediscovery of the 'primitives' generally, see Francis Haskell, *Rediscoveries in Art: Some Aspects of Taste, Fashion and Collecting in England and France*, London 1976, especially chapters 3 and 4.]

39 Eugène Müntz, 'Les Invasions de 1814–1815 et le Spoliation de nos musées (Épisodes d'histoire diplomatique)', *Nouvelle revue*, 1897, pp. 193–207, 420–39, 703–16 (for this episode, see p. 707).

40 Ilse Hempel Lipschutz, *Spanish Painting and the French Romantics*, Cambridge, Mass. 1972, p. 51.

41 *Ibid.*, p. 51; W. R. de Villa-Urratia, *Algunos cuadros del Museo del Prado*, Paris and Buenos Aires 1914.

42 A fourth Murillo, sent to the Museum from the Royal Palace in Madrid as part of Joseph's gift to Napoleon, was the *Adoration of the Shepherds* (Prado, no. 961)

which was returned to Spain in 1818. It may also have been only in that year that the Ribera (*Magdalena Ventura with her Husband and Son*) was sent back.

43 Henry Milton, *Letters on the Fine Arts, written from Paris in the year 1815*, London 1816, pp. 36–9. By the time that Milton visited the Louvre in 1815 some of the pictures seem to have been rearranged, as he describes pictures that are recorded as being in the Salon Carré by the catalogue as rather in the first two rooms before the Grande Galerie (pp. 21–2).

44 *Ibid.*, pp. 30–33.

45 Blumer, *op. cit.*, p. 241. From the same source he took a number of other pictures and a bas-relief by Giovanni Pisano which, along with two sculptures attributed to Luca della Robbia, were also exhibited.

46 See catalogue, p. ii (Marquet de Vasselot, *op. cit.*, no. 115).

47 Daniela Gallo to author, 27 May 1999.

48 Gould, *op. cit.*, p. 112.

49 [For this project see Stephen Lloyd, *Richard and Marin Cosway: Regency Artists of Taste and Fashion*, exh. cat., Edinburgh and London 1995, pp. 89–91, and the entry by Monica Preti Hamard in *Dominique-Vivant Denon: L'Oeil de Napoléon*, exh. cat., Musée du Louvre, Paris 1999, p. 198, no. 185.]

3 The First Exhibitions of the British Institution

1 See, for instance, Prince Hoare, *Epochs of the Arts*, London 1813, pp. 17–18: 'When Mr Fox, in the summer of 1802, met the present President of our Academy [Benjamin West] in the Gallery of the Louvre at Paris, he assured him, that from the sight of the objects around him, and from their conversation on the subject of Fine Arts, his mind had been awakened to a new estimate of their favour, if he should ever again succeed to power'.

2 *Farington Diary*, vol. VI, p. 2230 (1 February 1804), p. 2235 (7 February 1804); Martin Archer Shee, *Elements of Art: A Poem in Six Cantos; with Notes and a Preface*, London 1809, pp. 24–5; David Watkin, *Thomas Hope 1769–1831 and the Neo-Classical Idea*, London 1968, pp. 10 and 100.

3 *Farington Diary*, vol. VII, p. 2768 (21 May 1806); Shee, *op. cit.*, pp. 24–5.

4 Shee, *op. cit.*, pp. 24–5.

5 J.-D. Passavant, *Tour of a German Artist in England with Notices of Private Galleries and Remarks on the State of Art*, London 1836, p. 59.

6 Unless otherwise indicated the sources of this account of the British Institution are Thomas Smith, *Recollections of the British Institution*, London 1860; Peter Fullerton, 'Patronage and Pedagogy: The British Institution in the Early Nineteenth Century', *Art History*, v, no.1, March 1982, pp. 59–72, and William T. Whitley, *Art in England, 1800–1820*, Cambridge 1928.

7 V & A, English MSS, RCV 11 (vol. 1 of the British Institution Minute Books), pp. 125–6 (8 May 1806).

8 Whitley, *op. cit.*, pp. 208–9. The portraits in question (of Johnson, Goldsmith, Baretti and Burney) lent in 1813 may already have been destined for sale (they were sold three years later).

9 Fullerton, *op. cit.*

10 V & A, English MSS, RCV 11 (vol. 1), p. 206 (2 June 1807); Smith, *op. cit.*, p. 38.

11 Fullerton, *op. cit.*, n. 46.

12 See comments in an unidentified newspaper in V & A, Press Cuttings, IV, p. 1009.

13 V & A, English MSS, RCV 12 (vol. 2), p. 8 (13 July 1807).

14 *Ibid.*, RCV 11 (vol. 1), pp 146–7 (19 June 1806).

15 Now in the J. Paul Getty Museum, Los Angeles.

16 *Saint Michael and the Angels* by Guido Reni. Burton Fredericksen has plausibly proposed to me that this may be the Luca Giordano in the Gemäldegalerie in Berlin, a picture, inspired by Reni's famous altarpiece of this subject, which was in Sir Francis Baring's collection, although neither dimensions nor inscription corresponds with those in the 1888 Northbrook (Baring) collection.

17 The Mola is in the National Gallery in London and the Rosa, in the Museum of Fine Arts, Montreal.

18 V & A, English MSS, RCV 11 (vol. 1), pp. 198–9 (4 May 1807, request to Kinnaird), p. 215 (8 June 1807, request to Carlisle), and RCV 12 (vol. 2), p. 3 (23 June 1807, Carlisle's regret and proposed replacement). Both pictures are now in the National Gallery, London. The list of loans recorded in the Minute Books does not correspond precisely with that published in Smith, *op. cit.*, p. 40.

19 V & A, English MSS, RCV 12 (vol. 2), pp. 34 and 45–6 (9 and 31 May 1808).

20 Smith, *op. cit.*, pp. 39 and 41.

21 *Ibid.*, p. 4 for the by-laws of 1805.

22 Felicity Owen and David Brown, with a catalogue by John Leighton, '*Noble and Patriotic': The Beaumont Gift 1828*, exh. cat., National Gallery, London 1988, p. 154.

23 *Ibid.*, p. 178.

24 Joseph Severn in 1822, quoted in *ibid.*, p. 3. It was in 1812, after nearly two years of planning, that Beaumont erected in the grounds of Coleorton Hall the monument to Reynolds with an inscription by Wordsworth. It was painted by Constable in 1836, for which see Judy Egerton, *National Gallery Catalogues: The British School*, London 1998, pp. 58–63. Hoare (*op. cit.*, p. xiv) claims, with tantalising vagueness, that 'the proposal for this singular commemoration was first suggested at the Anniversary Dinner of the Royal Academy in 1811, by a distinguished lover of the Arts'.

25 Pahin de la Blancherie's homage to the Restout family cannot be compared with it.

26 *Catalogue of Pictures by the Late Sir Joshua Reynolds*, London 1813, Preface. For the attribution of the preface to Richard Payne Knight see *Farington Diary*, vol. XII, p. 4335 (14 May 1813), and Smith, *op. cit.*, p. 141.

27 V & A, English MSS, RCV 13 (vol. 3), fol. 9 (10 February 1812).

28 Egerton, *op. cit.*, pp. 399–405.

29 R. B. Beckett (ed.), *John Constable's Correspondence*, 6 vols, 1962–6, vol. VI, p. 149: Constable to John Fisher, 17 January 1824.

30 Egerton, *op. cit.*, p. 400.

31 V & A, English MSS, RCV 13 (vol. 3), fols 11–13 (10 February 1812).

32 *Ibid.*, fols 60–62 (26 February 1813).

33 *Ibid.*, fol. 72 (5 April 1813).

34 *Ibid.*, fols 72, 5 April 1813; 78, 26 April 1813; 83, 27 April 1813 (a rejected late proposal); 85, 29 April 1813 (a late acceptance); 86, 3 May 1813 (a very late request); 91, 5 May 1813; 102, 1 June 1813 (temporary closure).

35 For this episode see *Farington*, vol. XII, pp. 4269–74 (23–31 December 1812).

36 *Catalogue of Pictures . . . by . . . Reynolds*, p. 21. As has already been mentioned, changes were made to the exhibition (and also to the catalogue), and it is not always easy to be sure how many paintings (or which ones) were on display on any particular date. The issue is not of significance here, and reference is confined to the first version.

37 V & A, English MSS, RCV 13 (vol. 3), fols 82–3 (27 April 1813).

38 *Ibid.*, RCV 13 (vol. 3), fols 70–71 (22 March 1813); and fols 79–81 (26 April 1813).

39 Beckett, *op. cit.*, vol. II, pp. 105–6: Constable to Maria Bicknell, 13 May 1813.

40 *Farington Diary*, vol. XII, pp. 4371–2 (16 June 1813), for one visitor's impression that the excellence of Reynolds's pictures 'pressed hard upon those at the Royal

Academy' and the view of academicians (Thomson and Robert Smirke) that it was 'calculated to operate against the Artists of the present time'.

41 *Ibid.*, pp. 4343–6 (8 May 1813); Joseph Farington, in the Memoir appended to the fifth edition of Edward Malone, *The Literary Works of Sir Joshua Reynolds*, 3 vols, 1819, vol. III, pp. 244–6 (for 144–6); Whitley, *op. cit.*, pp. 205–8.

42 See, for example, 'R. H.' (Robert Hunt) in the *Examiner*, no. 282, p. 344, 23 May 1813: 'The bringing together the greater portion of a Painter's works many years after his decease, so as to form a public Exhibition, is a new circumstance in the history of the Arts. It is a valuable one . . .', and Hoare, *op. cit.*, p. xix: 'It presents an example of respect, never before paid to any Painter, in any age or country.'

43 Farington, in Malone, *op. cit.*, p. 246 (for 146); Hoare, *op. cit.*, pp. xvii–xviii.

44 *Survey of London*, vol. XXIX, pt. 1, 1960, pp. 337–8.

45 Not identifiable.

46 Deduced from catalogue numbers.

47 See *Farington Diary*, vol. XII, p. 4345 (8 May 1813). This had also been discussed by Payne Knight in his Preface to the catalogue.

48 See Whitley, *op. cit.*, p. 208.

49 *Observer*, 16 May 1813. See Farington in Malone, *op. cit.*, pp. cclxxi–cclxxii.

50 *Examiner*, no. 282 (23 May 1813), p. 33.

51 Lamb, *op. cit.*, pp. 335–6.

52 Willard Bissell Pope (ed.), *Diary of Benjamin Robert Haydon*, 5 vols, 1960–63, vol. I, pp. 306–10.

53 P. P. Howe (ed.), *The Complete Works of William Hazlitt*, 21 vols, London and Toronto 1930–34, vol. XVIII, 1934, pp. 51–62. 'The Character of Sir Joshua Reynolds', appeared first in the *Champion* on 30 October and 6 November 1814.

54 *Farington Diary*, vol. XII, pp. 4350 (15 May 1813, for high attendance), and p. 4384 (2 July 1813, for one of the evening openings). See also the *Morning Post* of 23 August 1803 (for 1813) in Farington in Malone, *op. cit.*, p. 253, for its closure at the beginning of the previous week.

55 *Farington Diary*, vol. XVI, p. 5666 (22 May 1821).

56 Martin Postle, *Sir Joshua Reynolds: The Subject Pictures*, Cambridge 1995, pp. 304–311.

57 V & A, English MSS, RCV 13 (vol. 3) fol. 120 (8 July 1813).

58 C. R. Leslie, *Memoirs of the Life of John Constable, Esq. R. A.*, London 1845, p. 105.

59 Martin Arthur Shee, *The Commemoration of Reynolds, in two parts, with notes and other poems*, London 1814, Preface, p. xiii.

60 *Morning Post*, 23 August 1803 (for 1813), in Farington in Malone, *op. cit.*, p. 259.

61 V & A, English MSS, RCV 13 (vol. 3), fols 104–7 (1 June 1813). [This was the date of the annual meeting of the governors, and the text, dated 10 May, served as a sonorous annual report.]

62 V & A, English MSS, RCV 13 (vol. 3), fol. 111. Stubbs, it is worth noting, was never considered, and this cannot have been only on account of his recent death (in 1808), since Zoffany outlived him by two years.

63 *Farington Diary*, vol. XII, p. 4370 (15 June 1813). On the other hand, West had no success when he urged the directors of the British Institution to include some paintings by George Barrett in their forthcoming exhibition (*ibid.*, p. 4374 (17 June 1813)).

64 *Ibid.*, pp. 4370 (15 June 1813) and 4396 (13 July 1813).

65 The directors, however, failed to contact Gainsborough's daughter as they had hoped (V & A, English MSS, RCV 13 (vol. 3), unpaginated (6 January 1814) and Whitley, *op. cit.*, p. 226). Nothing came of a proposal to include further works by Reynolds

from among those that had not been shown in 1813 (V & A, English MSS, RCV 13 (vol. 3) (8 July 1813)).

66 As late as 20 April 1814 the very well-informed Farington referred to the presence of only Wilson, Gainsborough and Hogarth in the forthcoming exhibition – three days later he added the name of Zoffany as though his work were already hanging (vol. XIII, pp. 4493, 4495–6). Last-minute changes could certainly be made, and as only ten Zoffanys were borrowed from four owners the logistical problems would not have been very great. Richard Payne Knight's objection that Zoffany was not a British painter was overruled since he had resided most of his life in England and painted 'English subjects particularly those of a theatrical kind.'

67 *Farington Diary*, vol. XIII, pp. 4495 (23 April 1814) and 4497 (25 April 1814).

68 Hazlitt, *op. cit.*, vol. XVIII, pp. 21–8 – 'the British Institution: Hogarth, Wilson, etc.' first published in the *Morning Chronicle*, 7 and 10 May 1814. Hazlitt omits Zoffany's name among the other exhibitors, but it is not clear whether any significance should be attached to this.

69 Beckett, *op. cit.*, vol. II, p. 122: Constable to Maria, 4 May 1814.

70 'Constable called at breakfast time; and said a great deal of what had been expressed by several Artists respecting the landscapes by Wilson at the British Institution' (*Farington*, vol. XIII, p. 4503).

71 Wilkie to his friend Perry Nursey, 9 May 1814, quoted in Whitley, *op. cit.*, pp. 228–9.

72 Hazlitt, *op. cit.*, vol. XVIII, p. 23 (see note 68, above).

73 See, for instance, *Farington*, vol. XIII, pp. 4590–91 (5 October 1814), 4593–4 (9 October 1814) and 4616 (8 December 1814).

74 Hazlitt, *op. cit.*, vol. XVIII, pp. 24–8: 'Wilson's Landscapes at the British Institution', first published in the *Champion*, 17 July 1814.

75 *Ibid.*, vol. XVIII, p. 24 (see note 68, above).

76 *Ibid.*, vol. XVIII, pp. 34–7: 'On Gainsborough's pictures', first published in the *Champion*, 31 July 1814.

77 Whitley (*op. cit.*, p. 228) writes of 'universal praise' but mentions only one example.

78 *Ibid.*, citing Wilkie's letter mentioned in n. 71, above.

79 *Examiner*, no. 332, 8 May 1814, p. 302.

80 One critic was surprised to find he occupied such an 'elevated rank' as a colourist, singling out *The Lady's Last Stake* as a 'delightful and brilliant specimen of the richness which dwelt upon his palette' (V & A, Press Cuttings, III, p. 902).

81 Hazlitt, *op. cit.*, vol. IV, 1930, pp. 25–31: 'On Hogarth's Marriage à La Mode', first published in the *Examiner*, 5 June 1814.

82 Whitley, *op. cit.*, pp. 228–9: Wilkie to Perry Nursey, 9 May 1814.

83 *Farington Diary*, vol. XIII, pp. 4528 (31 May 1814), and 4540 (28 June 1814).

84 *Ibid.*, p. 4503 (3 May 1814).

85 *Ibid.*, p. 4525 (27 May 1814) for John Julius Angerstein's unfavourable opinion of Wilson.

86 V & A, English MSS, RCV 13 (vol. 3), unpaginated.

4 The Old Master Exhibition Established

1 Preface to the catalogue of the British Institution's exhibition of 1815.

2 V & A, English MSS, RCV 13 (vol. 3), unpaginated (22 November 1814, Long and Stafford agree to approach the prince; other requests were made as late as March 1815).

3 By far the best and most balanced assessment of Seguier's activities is given in Judy Egerton, *National Gallery Catalogues: The British School*, pp. 388–99. The Minute Books suggest that his role in the artistic life of the day was even greater than Egerton implies, although this role was often indirect.

4 Now National Gallery, London (NG 1172).

5 Now National Gallery, London (NG 6518 and 4889).

6 Now National Gallery, London (NG 4815).

7 Now Courtauld Institute Galleries, London.

8 Collection of the duke of Westminster.

9 National Gallery of Art, Washington, D.C.

10 Cornelis Hofstede de Groot, *A Catalogue Raisonné of the Works of the Most Eminent Dutch Painters of the Seventeenth Century based on the Work of John Smith*, London vol. 1907–27, vol. I, 1907, no. 1196; now in a North American private collection and (I am informed by Christopher Brown and Ronnie Baer) esteemed as a work of outstanding quality.

11 Egerton, *op. cit.*, p. 45.

12 *Farington Diary*, vol. XIII, p. 4500 (30 April 1814).

13 *Ibid.*, pp. 4465–6 (13 March 1814).

14 *Ibid.*, vol. XIV, p. 4912 (24 October 1816).

15 *Ibid.*, vol. XIII, p. 4642 (9 June 1815).

16 Anon., *A Catalogue Raisonné of the Pictures now exhibiting at the British Institution, Printed with a Sincere Desire to assist the . . . Directors in turning the Public Attention to those Pieces . . .* , London 1815. Judy Egerton has kindly pointed out to me that the British Library Catalogue attributes the pamphlet to Robert Smirke junior, and Peter Fullerton in his article on the British Institution ('Patronage and Pedagogy: The British Institution in the Early Nineteenth Century', Art History, v, no. 1, March 1982, pp. 59–72) notes that this tradition can be traced back to the *Memoirs and Recollections of Abraham Raimbach*, London 1843, p. 35n, but he concludes that the 'case is by no means proven'.

17 *Farington Diary*, vol. XIII, p. 4650 (21 June 1815).

18 *Ibid.*

19 *Ibid.*, vol. XIII, p. 4692 (11 August 1815).

20 Thomas Smith, *Recollections of the British Institution*, London 1860, p. 214.

21 There are frequent references in *Farington Diary*.

22 *Farington Diary*, vol. XIV, p. 5021 (21 May 1817).

23 Benjamin Robert Haydon, *The Autobiography and Memoirs*, ed. T. Taylor, London 1926, p. 256.

24 V & A, English MSS, RCV 13 (vol. 3) (28 May 1816).

25 [A conclusion drawn by F.H. from his notes but without specific reference.]

26 Exhibited 1829.

27 *Annals of the Fine Arts*, 1819, pp. 298–300.

28 *A Catalogue Raisonné of the Pictures now exhibiting in Pall Mall*, pt 2, London 1816, p. 12.

29 P. P. Howe (ed.), *The Complete Works of William Hazlitt*, 21 vols, London and Toronto 1930–34, vol. IV, 1930, pp. 140–51, and notes on pp. 384–7. The articles appeared in the *Examiner* on 10 and 17 November 1816.

30 [Details to be published by N.P. in his forthcoming catalogue of Venetian sixteenth-century paintings in the National Gallery.]

31 *Ibid.*

32 Lorne Campbell, *National Gallery Catalogues: The Fifteenth-Century Netherlandish Schools*, London 1998, p. 176.

33 Paintings by Filippo Lippi, Crivelli and Ortolano (NG 667, 668 and 669); see n. 30. [In addition, Fosters, the auctioneer in Pall Mall, advertised a Murillo they were selling on 21 July 1855 as 'now exhibiting at the British Institution'.]

34 [The *Thirty Pieces of Silver* was in 1938 in Lord Moyne's collection (having formerly belonged to Lord Iveagh) and attributed to Bol when Isherwood Kay suggested it should be cleaned. It was then published as a Rembrandt by C. H. Collins Baker in

the *Burlington Magazine*, LXXV, November 1939, pp. 179–180, after Kay's death and citing his research.]

35 V & A, English MSS, RCV 17, fols 54r–56v (letters of 18 and 19 May read at the meeting on 22 May 1867).

36 *Survey of London*, vol. XXIX, pt 1, London 1960, pp. 343–44. [There has been some confusion as to the date at which the British Institution expired. Its last meeting was held on 17 July 1869. It rejected the overtures of the younger Burlington Fine Arts Club on 22 June 1869. The directors were aware on 21 March 1867 that the lease would be extended only 'till Michaelmas next'. The last exhibition of Old Masters opened in May 1867. The Marlborough Club purchased the freehold in May 1868.]

37 V & A, English MSS, RCV 17, fol. 57r–57v (9 July 1867).

38 *Ibid.*, fol. 49r (9 February 1867 seems to be the date of this letter, but its content was approved at a meeting on 6 February).

39 *The Times*, 3 January 1870.

40 Royal Academy catalogue.

41 Getty Research Institute, Brentwood, Special Collections, 870091-17 (for Rothschild and for Kingston Lacy).

42 *Ibid.*, 870091-16.

43 *Ibid.*, 870091-17 (this is presumably a slip for the duc d'Aumale).

44 *Ibid.*

45 *Ibid.*

46 *Ibid.*, 870091-16.

47 *Ibid.*, 870091-50.

48 *Ibid.*, 870091-20.

49 *Ibid.*, 870091-10.

50 *Ibid.*, 870091-11.

51 *Ibid.*, 870091-12.

52 *Ibid.*, 870091-24. I have been unable to identify this picture: it is not recorded by Waagen.

53 *Ibid.*, 870091-31.

54 *Ibid.*, 870091-13. A *Descent from the Cross* by Jouvenet.

55 See, for example, the *Daily Telegraph*, 31 December 1869, and *The Times*, 3 January 1870.

56 Sidney Hutchison, *A History of the Royal Academy 1768–1968*, London 1968, p. 130.

57 *The Academy*, 15 January 1871, p. 90.

58 Getty Special Collections, 870091-23.

59 *The Academy*, 15 January 1871, p. 90.

60 Henry James, 'The Picture season in London', *Galaxy*, XXIV, 24 July 1877, reprinted in Peter Rawlings, *Henry James: Essays on Art and Drama*, Cambridge 1996, p. 250.

61 'An Occasional Correspondent' [Henry James], 'The Old Masters at Burlington House', *The Nation*, XXVI, 31 January 1878, reprinted in Rawlings, *op. cit.*, p. 265.

62 *The Academy*, 1 February 1871, p. 111.

63 *Daily Telegraph*, 31 December 1869.

64 *Daily Telegraph*, 30 December 1871.

65 *Ibid.*

5 German Scholarship in Manchester and Dresden

1 W. Bürger, *Trésors d'Art en Angleterre*, Paris, 1857, pp. v–vi.

2 So Scharf believed, although they were not among the pictures that Lord Ellesmere originally offered (George Scharf, 'On the Manchester Art-Treasures Exhibition,

1857', *Transactions of the Historic Society of Lancashire and Cheshire*, vol. x, London 1858, p. 275). This paper – a very long one (pp. 269–331 of the volume of *Transactions...*) was originally read by Scharf on 15 April 1858. It is a highly unusual document: candour as to the conditions in which exhibitions are mounted and even the slightest qualifications in accounts of their success are very rare in the official reports or even unofficial recollections of those responsible for their organisation.

3 Ulrich Finke, 'The Art-Treasures Exhibition', in John H. G. Archer (ed.), *Art and Architecture in Victorian Manchester*, Manchester 1985, pp. 102–26 (p. 105 for this quotation).

4 Giles Waterfield and Florian Illies, 'Waagen in England', *Jahrbuch der Berliner Museen*, XXXVII, 1995, pp. 48–59 (p. 50); see also Florian Illies, 'Gustav Friedrich Waagen, Prinz Albert und die Manchester Art Treasures Exhibition von 1857', in Franz Bosbach and Frank Büttner (eds), *Kunstlerische Beziehungen zwischen England und Deutschland in der Viktorianischen Epoche*, Munich 1998.

5 *Exhibition of Art Treasures of the United Kingdon held at Manchester in 1857, Report of the Executive Committee*, Manchester and London 1859, p. 18. Also Waterfield and Illies, *op. cit.*, p. 58.

6 *Exhibition of Art Treasures ... Report*, pp. 16–17.

7 *Ibid.*, p. 34.

8 *Dictionary of National Biography.*

9 National Portrait Gallery, London, archives, Scharf notebook 45, p. 103.

10 Donata Levi, *Cavalcaselle: il pioniere della conservazione dell'arte italiana*, Turin 1988, figs 19–20.

11 Jones's design was exhibited by the Fine Art Society in 1997. He declined the committee's payment for it. See the *Builder*, xv, 1857, pp. 105–6, 162, 264–5, 287.

12 Scharf, 'On the Manchester Art-Treasures Exhibition', p. 317.

13 *Ibid.*, p. 217.

14 *Ibid.*, p. 283n.

15 *Ibid.*, p. 279n.

16 *Ibid.*, p. 292.

17 *Ibid.*, pp. 314, 315–16.

18 *Ibid.*, pp. 303, 313.

19 [*Ibid.*, pp. 325–26. The curious dialect publications are not easily explained save as entertainment for more or less educated artisans who found the bewilderment of less literate Lancastrians comic.]

20 *Exhibition of Art Treasures ... Report*, p. 42, for charges; Appendix XIV, for sticks etc.

21 *Ibid.*, p. 38.

22 *Ibid.*, p. 37; Finke, *op. cit.*, p. 36.

23 *Palais des Champs-Elysées, Exposition Retrospective.*

24 [Scharf, 'On the Manchester Art-Treasures Exhibition', p. 285. Lorne Campbell informs me that the copies of the Ghent altarpiece from the collection of Karl and Eliza Aders which Crabb Robinson had offered in vain to the National Gallery are now in the Museum of Fine Arts, Brussels.]

25 *Art Journal*, 1871, p. 210.

26 Gustave Fichner, *Achtheitsfrage*, 1871 (Bericht 1972), pp. iii, 1, 21.

27 By Hirt; see *ibid.*, pp. 19 and 114.

28 *Art Journal*, 1872, p. 37; but see Alfred Woltmann, *Holbein and his Time*, trans. F. E. Bunnett, London 1872, p. 149. [Bunnett's translation differs from Woltmann's first edition of 1866–8 in respects of which the latter presumably approved. Woltmann's second edition of 1874–6 expanded on the question of the exhibition, providing a devastating criticism of the claim of the Dresden version. It is clear from his

notes that F.H. intended to offer a fuller discussion of the scholarly dispute, discussing Woltmann's part in it and that of Ralph Nicholson Wornum (whose monograph appeared in 1867), making use of the interesting study of the controversy by Oskar Bätschmann and Pascal Griener, *Hans Holbein d. J. Die Darmstädter Madonna: Original gegen Fälschung*, Frankfurt am Main 1998.]

29 Alfred Woltmann, *Holbein und seine Zeit*, 2 vols, Leipzig 1874–6, vol. I, p. 299.
30 Fichner, *op. cit.*, p. 5.
31 Woltmann, *Holbein and his Time*, p. 147.
32 Ralph Wornum quoted in the *Art Journal*, 1872, p. 37.
33 Woltmann, *Holbein and his Time*, p. 152.
34 Fichner, *op. cit.*, p. 5.
35 'An Occasional Correspondent' [Henry James], 'The Old Masters at Burlington House', *The Nation*, XXVI, 31 January 1878, reprinted in Peter Rawlings, *Henry James: Essays on Art and Drama*, Cambridge 1996, pp. 268–9.
36 Henri Lehmann, 'Les Madones de Darmstadt et de Dresde', *Gazette des Beaux-Arts*, IV, 1870–71, 1 December 1871, pp. 516–19. Henri and his brother, Rudolf, favoured the idea that the Dresden picture was an autograph replica. Bode was among those who believed it to be a copy.
37 I owe this suggestion to Pascal Griener.
38 Paragraph in the column 'Minor Topics of the Month', *Art Journal*, 1868, p. 161. The implication is that 'more zeal and activity' might be expected from a body less dominated by people of 'high position and great wealth'.
39 Royal Academy catalogue, 1881, no. 206.
40 Burlington Fine Arts Club catalogue, 1912, no. 21.
41 *Revue Critique d'Histoire et de la littérature*, n.s., XXXIX, 1895, pp. 348–52. [F.H. expanded on this in a lecture at the Kunsthistoriches Institut, Florence 1997.]
42 For Benson see Jehanne Wake, *Kleinwort Benson: The History of Two Families in Banking*, Oxford 1997, and for his collection, Charles Sebag-Montefiore, 'R. H. Benson as a Collector', Appendix 3 in *ibid.*, pp. 481–7.
43 Fritz Harck in the section 'Austellung und Versteigerungen' in *Repertorium für Kunstwissenschaft*, vol. XVII, 1894, pp. 312–19.
44 V&A, MS 86, KK 37, minutes for meeting of the Burlington Fine Arts Club, 28 May 1895 (unpaginated).

6 Patriotism and the Art Exhibition

1 Jan Bialostocki, *Dürer and his Critics 1500–1671*, Baden-Baden 1986, p. 105 and fig. 38.
2 *Ibid.*, p. 119 and fig. 42.
3 *Art Union*, 1840, pp. 147–8.
4 *De Roem van Rubens*, exh. cat., Archief en Museum voor het Vlaamse Cultuurleven, Antwerp 1977, fig. 101.
5 C. Dionisotti, quoted in Stefano Corsi, 'Cronaca di un Centenario', in *Michelangelo nell'Ottocento, il centenario del 1875*, exh. cat., Casa Buonarotti, Florence 1994, p. 13.
6 Stephen Bann, *Delaroche: A History Painted*, London 1997, p. 16.
7 *Michelangelo nell'Ottocento*, pp. 15–16, and fig. 4.
8 Louis Gonse, 'Les Fêtes du Centenaire de Michel-Ange', *Gazette des Beaux-Arts*, XII, 1875, p. 383. The article (pp. 375–84) takes the form of letters dated 11, 12 and 13 September and includes the speeches made by Meissonnier and Charles Blanc.
9 *Ibid.*, p. 376.
10 *Ibid.*, p. 378.

11 *Michelangelo nell'Ottocento*, p. 20.
12 *Ibid.*, p. 18.
13 *Ibid.*, p. 19; but cf. Gonse, *op. cit.*, p. 383.
14 *Michelangelo nell'Ottocento*, fig. 10.
15 *Ibid.*, figs 46 and 43.
16 Gonse, *op. cit.*, p. 383.
17 C. Parrini, *Relazione del Centenario di Michelangelo Buonarrotti nel Settembre del 1875 in Firenze*, Florence 1876, p. 18.
18 Gonse, *op. cit.*, p. 384.
19 The parallel with Florence is drawn by Athol Mayhew in the *Art Journal*, n.s., XVI, 1877, p. 360. Mayhew's article, 'The Rubens Tercentenary at Antwerp', was in two parts (*ibid.*, pp. 359–60 and XVII, 1878, pp. 9–12).
20 *Ibid.*
21 Mayhew, *op. cit.*
22 See *Rubens and Printmaking*, exh. cat., Fitzwilliam Museum, Cambridge 1990.
23 *L'Oeuvre de P.P. Rubens: Catalogue de l'exposition organisée sous les auspices de l'administration communale d'Anvers par l'Académie d'Archéologie de Belgique*, Antwerp 1877.
24 *The Times*, 9 September 1898.
25 *The Academy*, 12 November 1898, p. 259.
26 P. J. J. Thiel, 'De Rembrandts – tentoonstellung van 1898', *Bulletin van het Rijksmuseum*, Jaargang 40, 1992, I, pp. 11–93.
27 *The Times*, 9 September 1898.
28 For this and what follows see Francis Haskell, *History and its Images: Art and the Interpretation of the Past*, New Haven and London 1993, pp. 445–68.
29 Mauro Natale and Claude Ritschard, *Falsifications, Manipulations, Pastiches – l'art d'imiter*, exh. cat., Musée d'Art et d'Histoire, Geneva 1997.
30 Haskell, *op. cit.*, p. 465.

7 Botticelli in the Service of Fascism

1 [*Exhibition of Spanish Painting at the Royal Academy of Arts*, London 1920. The entries for Old Master paintings in the first section of the catalogue were by F. J. Sánchez Cotán.]
2 Salvador de Madariaga in *La Libertad*, 19 and 24 November 1920.
3 Aggelio Echarri in *El Liberal*, 13 November 1920.
4 *The Times*, 9 November 1920, p. 10.
5 'Commenti', *Dedalo*, I, iii, 1921, p. 960.
6 *Ibid.*, II, i, 1921, p. 148.
7 [*Royal Academy of Arts: Exhibition of Works by Swedish Artists 1880–1900*, Stockholm 1924. Not only was the catalogue published in Sweden but the patrons and the committee included no Royal Academicians. The exhibition opened on 15 January and closed a month later.]
8 [*Exhibitions of Flemish and Belgian Art 1300–1900*, London 1927. The quotations are from the Introduction by Robert Witt (p. ix). The exhibition opened on 8 January and closed early in March.]
9 Interview in *La Nazione*, 4 December 1929.
10 Sir Austen Chamberlain, *Seen in Passing*, foreword by Lady Chamberlain, London 1937. See also Ugo Ojetti, *I Taccuini*, Florence 1954, pp. 314–15, 4 April 1929.
11 See Richard Lamb, *Mussolini and the British*, London 1997, p. 84.
12 Archivio Centrale dello Stato, Rome, EUR, PCM 1928–30, busta 315, fasc. 14/I, n. 2960.

13 Roberto Longhi, 'Mostre e Musei (un avvertimento del 1959)', reprinted in *Critica d'Arte e Buongoverno 1938–1969*, Florence 1985, p. 62.

14 See nn. 20 and 21 below.

15 Royal Academy of Arts, London, RAC/5/61–68, minutes of meeting, 19 December 1927.

16 *Ibid.*, letter from Sir Frank Dicksee to Lady Chamberlain, 22 November 1927.

17 *Ibid.*, letter from the secretary to Sir Robert Witt, 3 March 1928.

18 *Ibid.*, letter from Lady Chamberlain and Sir Robert Kindersley to the secretary of the Academy, 18 June 1929; the sentiment was echoed by other correspondents.

19 Letter of 23 February 1930, reprinted in the *Annual Report of the Council of the Royal Academy . . . for the Year 1930*, London 1931, pp. 32–4.

20 AV, fasc. 4/383 *bis* (2), letter from Modigliani in Milan to Chiaramonte-Bordonaro, the Italian ambassador in London, 1 September 1927, which refers to 'Le persone che Ella mi ha menzionata circa la qualità e i limiti della mostra'.

21 *Ibid.*, Chiaramonte-Bordonaro replying to Modigliani, 6 September 1927: 'La nostra progettata esposizione'.

22 Royal Academy of Arts, London, RAC/5/61–68, letter from Sir Robert Witt to secretary of the Academy, 23 February 1928.

23 T. W. Earp, 'The Italian Exhibition', *The New Statesman*, 4 January 1930, pp. 414–15.

24 See the extensive documentation provided by himself and his supporters when he was disgraced in 1935, filed with AV, fasc. 4/383 E, carte misc. His allegiance to fascism is not mentioned in these papers which suggests that he was not a member of the party.

25 See notes 20 and 21, also Nello Forti Grazzini, *Arazzi*, Museo d'Arti applicate, Milan 1984, pp. 50–65.

26 See the many references to this issue in the correspondence of August 1929 in AV, fasc. 4/383 *bis*. The new *notifiche* came into effect on 24 February 1930 (documentation kindly provided by Silvana Pettenati).

27 AV, fasc. 4/383 *bis* (2), letter from Modigliani, 6 April 1929.

28 *Ibid.*, letter from Modigliani, 2 February 1929.

29 *Ibid.*, letter from Modigliani, 6 April 1929.

30 Archivio delle Gallerie, Florence, Correspondenza con Milano, letter from Modigliani to Nello Tarchiani, director of the Florence galleries, 18 September 1929.

31 AV, fasc. 4/383 *bis* (2), letter from an unidentified official to Mussolini, 20 March 1929.

32 *The Times*, 14 February 1928.

33 Archivio Centrale dello Stato, Rome, EUR, PCM 1928–30, busta 315, fasc. 14/1, n. 2960, letter from Bodrero to Mussolini, 4 June 1928.

34 *Ibid.*, letter from Colasanti to Guido Beer, 19 June 1928.

35 *Ibid.*, also memo for Mussolini of 22 June 1928.

36 *Ibid.*, draft memo from Guido Beer to Mussolini of 15 February 1929. Colasanti had by then left his post, although he remained an influential figure in the administration.

37 Chamberlain papers, AC 6/7/2, letter from Grandi to Lady Chamberlain, 26 February 1929.

38 Archivio delle Gallerie, Florence, Correspondenza con Milano, fasc. Comune di Prato and fasc. Comune di Pisa. The circular may be found in many other archives.

39 AV, fasc. 4/383 *bis*, letter from the prefect of Milan to Mussolini, 16 August 1929. See also *Museo Poldi-Pezzoli: Dipinti* (Musei e Gallerie di Milano), published for Banca Commerciale Italiana, 1982, p. 48.

40 *Ibid.*, letter from Mussolini to the prefect of Milan, 29 August 1929.

41 *Ibid.*, letter from the prefect of Milan to Mussolini, 24 October 1929; also Chamberlain papers, AC 6/7/12 and AC 6/7/13, letters from Grandi to Lady Chamberlain, 24 October 1929.

42 Susanna Sarti informs me that there are no records in the Uffizi gallery or in Palazzo Pitti of controversies relating to loans, but many documents were lost in the flood of 1966 and in the bombing of 1993.

43 [For the *Saint Lucy* altarpiece and its predella, see the illustrations and the entry (by Giulietta Chelazzi Dini) in Luciano Bellosi (ed.), *Una Scuola per Piero*, exh. cat., Galleria degli Uffizi, Florence 1992–3, pp. 94–107.]

44 Roger Fry, 'Notes on the Italian Exhibition at Burlington House: 1 and 2', *Burlington Magazine*, February 1930, p. 83.

45 Chamberlain papers, AC 6/7/18, letter from Sir Horace Rumbold to Lady Chamberlain, 7 November 1929. See also p. xv of the Introduction to the London catalogue.

46 For this aspect of her social life, see Kenneth Clark, *Another Part of the Wood*, London 1974, p. 215; but Clark's suggestion (p. 183) that she took him up partly to secure tickets for the exhibition is puzzling since she was, like him, a committee member.

47 This is specifically mentioned in Lord Parmoor's speech at the farewell dinner given by the Government, reported in *The Times*, 31 March 1930.

48 Chamberlain papers, AC 6/7/5, letter from the duke of Alba to Lady Chamberlain, 15 July 1929.

49 *Ibid.*, AC 6/7/1, undated draft of a letter to Cardinal Gasparri.

50 Royal Academy of Arts, London, RAC/5/61–68, letter from Lady Chamberlain and Sir Robert Kindersley to the secretary of the Royal Academy, 18 August 1929.

51 National Gallery, London, Minutes of Board Meetings, 10, pp. 92–3, 9 July 1929.

52 *Ibid.*, Trustees' Correspondence, NG/36.

53 Chamberlain papers, AC 6/7/6, letter from Grandi to Lady Chamberlain, 23 June 1929.

54 *Ibid.*, AC 6/7/8, letter from H. G. Milton, British legate to the Holy See, to Lady Chamberlain, 15 August 1929.

55 *Ibid.*, AC 6/7/11, letter from Cardinal Gasparri to Lady Chamberlain, 12 September 1929.

56 *Ibid.*, AC 6/7/12, draft of letter from Lady Chamberlain to Cardinal Gasparri, 21 October 1929.

57 National Gallery, London, Trustees' Correspondence, NG 26/123, letter from Sir Robert Witt to Sir Augustus Daniel.

58 The first reference to the copy occurs in Sir Robert Witt's letter of 11 November (*ibid.*); on 5 December the *Daily Telegraph* repeated that it was nearly complete and was to be presented to the National Gallery.

59 National Gallery, London, Minutes of Board Meetings, 10, p. 109, 10 December 1929.

60 *Ibid.*, Trustees' Correspondence, NG 26/26, letter from Augustus Daniel to Lord Crawford, 27 December 1929.

61 *Ibid.*, NG 26/123, letter from Sir Robert Witt to Augustus Daniel, 30 December 1929: 'Signor Modigliani, for reasons which I need not enter into here, is unwilling to exhibit the Brera wings with the Vatican copy. Consequently it has been decided not to exhibit the Brera wings, and of course as a result the whole purpose of the National Gallery lending their centre falls to the ground.'

62 National Gallery, London, miscellaneous file, NG 16/290.41 A–S 1929, letter from Alec W. G. Randall of the British Legation to the Holy See to W. G. Constable, 23 December 1929.

63 Chamberlain papers, AC 6/7/21, letter from H. G. Milton, British legate to the Holy See, to Lady Chamberlain, 2 December 1929 – but this early date may be a mistake.

64 See *Dipinti toscani e oggetti d'arte della collezione Giorgio Cini*, exh. cat., ed. Federico Zeri, Mauro Natale and Alessandra Mottola Molfino, Venice 1984, pp. 24–6 and pl. 29.

65 AV, fasc. 4/383 *bis* (2), letter of Villamarina, 9 September 1929, and from Modigliani to Pellati, 14 October 1929. Chamberlain papers, AC 6/7/14, letter from Grandi to Lady Chamberlain, 24 October 1929; *ibid.*, AC 6/7/16, letter from Mussolini to Lady Chamberlain, 29 October 1929.

66 AV, fasc. 4/383 *bis*, letter from Modigliani to Pellati, 14 September 1929; Chamberlain papers, AC 6/7/14, letter from Grandi to Lady Chamberlain, 24 October 1929.

67 Ojetti, *op. cit.*, p. 331.

68 AV, fasc. 4/383 *bis*, letter from Modigliani to the prefect of Turin, 20 October 1929.

69 Chamberlain papers, AC 6/7/19, letter from Sir Robert Graham to Lady Chamberlain, 11 November 1929.

70 *Ibid.*, AC 6/7/20, letter from Sir Robert Graham to Lady Chamberlain, 27 December 1929.

71 *Annual Report of the Council of the Royal Academy . . . for the Year 1930*, London 1931, p. 13.

72 See for instance *Candide*, 16 May 1935.

73 [The 1935 Petit Palais exhibition was the subject of a fascinating paper given on 25 February 2000 at the annual conference of the College Art Association of America entitled 'Old Masters, New Fascists: Exhibitions of Italian Art Abroad', by Emily Braun of Hunter College (City University of New York). She will be expanding on this paper in a forthcoming article and exploring its connections with the 1934–5 agreements between Mussolini and Pierre Laval.]

74 *Twenty-Seventh Annual Report (1930) of the National Art-Collections Fund*, London 1931, income and expenditure account.

75 *Ibid.*, speech by Sir Robert Witt, p. 11.

76 Fry, *op. cit.*, p. 72.

77 T. W. Earp, 'The Italian Exhibition', *The New Statesman*, 4 January 1930, pp. 414–15.

78 AV, fasc. 4/383 *bis*, letter from Modigliani to the minister of national education, 6 November 1929.

79 Clark, *op. cit.*, pp. 177–86.

80 National Gallery, London, Minutes of Board Meetings, 10, p. 88, 11 June 1929.

81 Letter to the author from Alessandra Mottola Molfino, 27 January 1998. I should add that anyone less vain than the W. G. Constable whom I used to meet many years later would be very hard to imagine.

82 AV, fasc. 4/383 E, carte misc., undated draft of a letter, nine pages long, from Modigliani to an unidentified 'Eccellenza'. Modigliani claims he is the victim of an intrigue organised by some enemy whose illegal activities (such as the unauthorised export of a work of art) he may have hindered; *ibid.*, a letter of 30 April 1935, marked 'riservatissima', from Modigliani to Carlo Calzecchi-Onesti, Soprintendente at Bologna, refers to 'mia opposizione a dar mano libera al Trivulzio (e lei poi ha visto dai giornali lo scandalo)'; *ibid.*, a petition on his behalf, dated 8 October 1935, addressed to Mussolini, signed by many leading citizens of Milan speaks also of calumny and alludes to a forthcoming trial – but gives no details.

83 *The Listener*, 8 January 1930, pp. 49–51.

84 Fry, *op. cit.*, pp. 72–89 and 129–36.

85 Lionello Venturi, 'L'esposizione d'arte italiana a Londra', *L'Arte*, 1930, pp. 300–03.

86 *The Times*, 3 January 1930, for a translation of this article.

87 AV, fasc. 4/383 E, carte. misc., letter from Dino Grandi to Francesco Ercole, Ministro dell'Educazione Nazionale, 9 May 1934. This letter is full of unbounded

enthusiasm for Modigliani for whom he was then trying to procure an honour, but in *Il mio paese* (Bologna 1985), the 'ricordi autobiografici' that he wrote after the war, he discussed the redecoration of the embassy (pp. 368–70) but failed to make any mention at all of Modigliani. It is true that Modigliani had been disgraced, but by then so had Grandi himself.

8 *The Redirection of Taste in Florence and Paris*

1 Francis Haskell, *History and its Images: Art and the Interpretation of the Past*, New Haven and London 1993, p. 458.

2 Jacques Foucart, 'Louis Dimier, admirateur critique du Louvre et des Musées. A propos de ses chroniques de l'Action Francaise', *Bulletin de la société de l'histoire de l'art français*, 1996 (1997), pp. 249–77.

3 [Information kindly supplied to N.P. by Pierre Rosenberg.]

4 U. Ojetti, L. Dami, N. Tarchiani, *La pittura italiana del seicento e del settecento alla mostra di Palazzo Pitti*, Milan and Rome 1924.

5 Maurice W. Brockwell, 'The Exhibition of Seventeenth- and Eighteenth-Century Paintings in Florence', *Connoisseur*, July 1922, pp. 127–35 (p. 128 for the relevant passage).

6 Fernando Mazzocca, 'La mostra fiorentina del 1922 e la polemica sul seicento', *Annali della Scuola Normale Superiore di Pisa*, v, 2, 1975, pp. 837–901.

7 Ojetti, Dami and Tarchiani, *op. cit.*, Introduction. [In the text of the lecture upon which this chapter is based, F.H. noted parenthetically that, for similar reasons, when working on his first book *Patrons and Painters*, he decided to extend its coverage to the eighteenth century.]

8 De Chirico, quoted in Mazzocca, *op. cit.*, p. 844.

9 Ojetti, Dami and Tarchiani, *op. cit.*, Introduction, p. 12.

10 Mazzocca, *op. cit.*, p. 871.

11 Brockwell, *op. cit.*, p. 128.

12 Longhi, 'Note in margine al catalogo della mostra sei–settecentesca del 1922', *Opere complete*, vol. 1: *Scritti giovanile 1912–22*, pt 1, Florence 1956, p. 494.

13 Matteo Marangoni, 'Note sul Caravaggio alla mostra del sei e settecento', *Bollettino d'Arte*, ii, 1922–3, pp. 217–29.

14 *Alessandro Magnasco, 1667–1749*, exh. cat., Palazzo Reale, Milan, 1996, pp. 41–3.

15 Osbert Sitwell (with assistance from John Gere), 'The Magnasco Society', *Apollo*, May 1964, pp. 378–90.

16 [*Burlington Fine Arts Club: Catalogue of an Exhibition of Italian Art of the Seventeenth Century*, London 1925, pp. 39–45 (p. 44 for this quotation).]

17 [*Ibid.*, pp. 7–15 (pp. 14–15 for this quotation).]

18 [British Empire Exhibition, Palace of Arts, Wembley, 1924, Illustrated Souvenir, p. 93 (no. U.40).]

19 Ojetti, Dami and Tarchiani, *op. cit.*, p. 12.

20 *Ibid.*

21 W. G. Constable and J. G. Links, *Constable*, 2 vols, Oxford 1976, vol. ii, p. 404, no. 406, as 'whereabouts unknown', 'attributed to', and with a revised title.

22 Archives des Musées Nationaux, Louvre, Paris, Ordre de mission 15 September 1934. Although the idea for the exhibition was Paul Jamot's, it was Charles Sterling, then 'attaché au Département des Peintures du Musée du Louvre', who was in charge of organising it.

23 Sterling claimed that Jamot had not been one of these specialists; see Nicole Reynaud, *Hommage à Charles Stirling: des primitifs à Matisse*, exh. cat., Musée du Louvre, Paris, April–June 1992, p. 63 (interview with Michel Laclotte). Also Jean-Pierre

Cuzin and Dimitri Salmon, *Georges de la Tour: histoire d'une redécouverte*, Paris 1997, p. 43.

24 Introduction by Jamot to *Les Peintres de la réalité en France au XVII^e siècle*, exh. cat., Musée de l'Orangerie, Paris 1934, p. xiii.

25 Louis Aragon *et al.*, *La Querelle du réalisme*, ed. Serge Fauchereau (editions sociales internationales, Paris 1936), Paris 1987.

26 Romy Golan, *Modernity and Nostalgia: Art and Politics in France between the Wars*, New Haven and London 1995, especially pp. 123–5.

27 *Commune*, February 1935, pp. 646–7.

28 Reynaud, *op. cit.*, p. 63.

29 Pierre Worms, Introduction to *Forces Nouvelles 1935–1939*, exh. cat., Musée d'art moderne de la ville de Paris, 1980.

30 Fauchereau, *op. cit.*, pp. 20–21.

31 *L'Amour de l'art*, no. 6, 1936, quoted in *ibid.*, p. 20.

9 Enduring Legacies

1 *The Times*, 31 December 1898.

2 Denis Mahon, *Poussiniana: Afterthoughts arising from the Exhibition* (originally published in the *Gazette des Beaux-Arts*), London 1962, p. 1.

3 [The website for the Barnes Foundation explains that the trustees have challenged the Foundation's 1922 Indenture of Trust and US by-laws in order to increase 'public access', raise the admission fee, use the gallery for 'social functions', sell some of the paintings and send 'a large group of paintings on a world tour'. The world tour commenced in 1993. See the article in the *Art Newspaper* by David D'Avey (no. 20, July–September 1992, p. 7) for the attempt to stop it. A controversial but very well-informed account of these proceedings has recently been given by Richard Feigen in *Tales from the Art Crypt: The Painters, the Museums, the Curators, the Collectors, the Auctions, the Art*, New York 2000. Sir William Burrell's bequest to the City of Glasgow in 1944 stipulated that no item in his collection could be loaned abroad. After an eighteen-day hearing (commencing 29 September 1997) a parliamentary commission of four peers agreed that Sir William's conditions could be overruled by the director of Glasgow's Museums and Galleries, Julian Spalding, and Glasgow City Council. Informative articles include those in *The Times* (20 August 1997), the *Sunday Telegraph* (28 September 1997), the *Glasgow Herald* (15 October 1997) and above all the *Art Newspaper* by Cameron Simpson (no. 76, December 1997, p. 7). The chief argument for change was to enable Glasgow to lend more in order to mount its own exhibitions: as the director of the National Gallery in London (a key witness) observed, 'The more you are able to lend, the more you are able to borrow...' Another witness, the director of the packers and shippers Wingare and Johnston, correctly noted that the 'focus of the art world' was increasingly on the 'touring international exhibition'. Such exhibitions were common enough in Burrell's day and had he wanted his bequest to participate in them he surely would have said so.]

4 Roberto Longhi, 'Mostre e Musei (un avvertimento del 1959)', reprinted in *Critica d'Arte e Buongoverno 1938–1969*, Florence 1985, pp. 59–74 (p. 74 for this quotation).

5 Most notably the Uffizi galleries.

6 [For the Bargello, see I. B. Supino, *Catalogo del R. Museo Nazionale di Firenze*, Rome 1989, pp. 13–14. For San Francisco, see the foreword by Walter Heil in *The M. H. de Young Memorial Museum: Illustrations of Selected Works*, San Francisco 1950, pp. 5–6; and *California Palace of the Legion of Honor Illustrated Handbook*, 1942, pp. 5–6.]

7 [Both Sir Henry Layard's collection of Renaissance paintings and that of Lord Elcho were displayed as loans in South Kensington for a number of years. The Museum of Fine Arts in Boston, founded in 1870, was the offspring of the Boston Athenaeum which had mounted loan exhibitions since 1827. The inaugural attraction of its new building in Copley Square in 1876 was the loan exhibition of the duc de Montpensier's collection of Old Master paintings from Seville. The opening of the Evans Wing in 1915 included a loan exhibition of 110 paintings from 35 Bostonian collectors. For all this see Carol Troyen and Pamela S. Tabbaa, *The Great Boston Collectors*, exh. cat., Museum of Fine Arts, Boston 1984, especially pp. 11–25. The Metropolitan Museum of Art in New York was founded in 1870 also. Under the directorship of General Cesnola it included during the 1880s large loans of antiquities made by the Castellani family. Neither loans (nor the still more important casts and reproductions) are given much emphasis by Howard Hibbard in the introductory history in his *The Metropolitan Museum of Art* (London and Boston 1980, pp. 7–16). One of the major attractions of the museum when its first great stone building was opened on the Central Park site in 1905 was the loan of 135 modern paintings from the collection formed by William H. Vanderbilt – a loan made in 1902; the paintings had formerly been shown in the family mansion at 640 Fifth Avenue (see George H. Storey, *Illustrated Catalogue of Paintings in the Metropolitan Museum of Art*, New York n. d. [1905], pp. 195–244).]

8 Kenneth Clark, *Another Part of the Wood*, London 1974, ch. 7.

9 *La Peinture anglaise: XVIIIᵉ et XIXᵉ siècles*, Palais du Louvre 1938, Preface, pp. xix and xxi.

10 Goethe, 'An den Museen, April 1816', in *Gedenkausgabe der Werke, Briefe und Gespräche*, 27 vols, Zurich 1950–71, I (1950), p. 540.

11 [For rumours of damage to paintings in Paris, see diary of Emmanuele Antonio Cicogna, Biblioteca Correr, Venice, MS 2844, fol. 3051; MS 2845, fols 4266 and 4319. For a defence of the French treatment of the *Madonna di Foligno*, see H. de Triqueti, *Les Trois Musées de Londres*, Paris 1861, p. 46.]

12 John Ingamells (ed.), *The Hertford–Mawson letters: The Fourth Marquess of Hertford to his Agent Samuel Mawson*, London 1981.

13 [Roger Fry, 'Art and Socialism', *Vision and Design*, Harmondsworth 1937, p. 55 (the book was published in 1920 but the essay first appeared in 1912 in somewhat different form).]

14 [Geoffrey Agnew], *Agnews 1817–1967*, London 1967, p. 32.

15 The catalogue, edited by Giovanni Paccagnini and published by Neri Pozza of Venice, of the Mantegna exhibition at Palazzo Ducale, Mantua, in 1961 struck people at the time as splendid and substantial in a novel way. It had 215 pages of text and 168 black and white plates as well as some colour reproductions.

16 Susan L. Siegfried, *The Art of Louis-Léopold Boilly: Modern Life in Napoleonic France*, New Haven and London 1995: in association with the Kimbell Art Museum, Fort Worth, and the National Gallery of Art, Washington, D.C.

17 Bernhard Berenson, *Venetian Painting, chiefly before Titian, at the Exhibition of Venetian Art*, London 1895, p. 36, reprinted in *The Study and Critiscism of Italian Art*, London 1901, pp. 137–9. The painting is A721; see Christopher Lloyd, *A Catalogue of the Earlier Italian Paintings in the Ashmolean Museum*, Oxford 1977, pp. 98–100, and plate 71. [It is notable that William Bell Scott, reviewing the winter exhibition of the Royal Academy in 1871 in which the painting was also included, had placed an exclamation mark after the title although he did not question the attribution (*The Academy*, II, 1 February 1871, pp. 110 and 111).]

18 Roberto Longhi, *Opera completa*, vol. v: *Officina ferrarese, 1934*, Florence 1968, pp. 36–8.

19 *Ibid.*, vol. x: *Ricerche sulla pittura veneta, 1946–1969*, Florence 1978, pp. 3–63. (first published as *Viatico per cinque secoli di pittura Veneziana*, Florence 1946).

20 Much of what follows is developed from the discussion of Huizinga in Francis Haskell, *History and its Images: Art and the Interpretation of the Past*, New Haven and London 1993, pp. 431–95. [*Further reflections on Huizinga's* fortuna *will be published in an essay by F. H. contributed to* History and Images, *edited by Axel Bolvig and Phillip Lindley.*]

21 Malcolm Vale, *War and Chivalry*, London 1981, and Maurice Keen, 'Huizinga, Kilgour and the Decline of Chivalry' in *Medievalia et Humanistica*, n.s. 8, Cambridge 1977, pp. 1–20.

22 Documentation concerning these exhibitions was kindly supplied by Dr Everherd Korthals Altes in December 1999. [*Dr Axel Ruger kindly supplied N.P. with summaries and translations.*]

23 *Metropolitan Museum Bulletin*, IV, no. 10, 1909.

24 George Painter, *Marcel Proust*, 2 vols, London 1959–65, vol. II, pp. 319–20.

25 Marcel Proust, *La Prisonnière* (vol. IX of *A la Recherche du Temps Perdu*). [*This translation is by N.P.*]

Index

Photographic Acknowledgements

AKG, London 4, 29; Archivi Alinari 38, 39, 42; Foto Stedelijk Museum, Amsterdam 25, 26; © Cameraphoto-Arte, Venice 33, 47; © Ursula Edelmann 49; The Fine Art Society, London 14; Central Library, Manchester 16, 17; Bildarchiv Foto Marburg 22; © National Gallery 8, 10, 19, 20, 40; Nicoló Orsi Battaglini 34; © Photo RMN 36, 37, 43, 44; Sotheby's Picture Library 23.